D1645506

MOVIE POSTER

MOVIE POSTER

EMILY KING

MITCHELL BEAZLEY

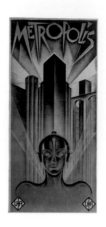

Contents

First published in Great Britain in 2003
by Mitchell Beazley, an imprint of
Octopus Publishing Group Ltd,
2–4 Heron Quays, London E14 4JP

Copyright © Octopus Publishing Group Ltd 2003
Reprinted 2004.

Commissioning Editor: Mark Fletcher
Managing Editor: Hannah Barnes-Murphy
Executive Art Editor: Christie Cooper
Project Editor: Emily Asquith
Copy Editor: Kirsty Seymour-Ure
Designed by Lovelock & Co.
Picture Research: Giulia Hetherington
Production: Gary Hayes
Indexer: Sandra Shotter

ISBN 1 84000 653 6

To order this book as a gift or incentive contact
Mitchell Beazley on 020 7531 8481

A CIP record for this book is available from
the British Library

Set in Trade Gothic and Impact
Produced by Toppan Printing Co., (HK) Ltd
Printed and bound in China

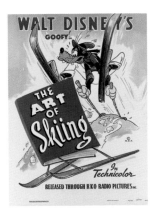
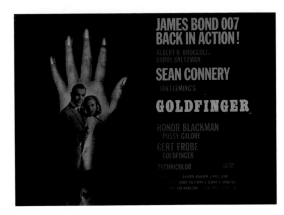

Introduction

RIGHT *Les Vacances de Monsieur Hulot*, **Jacques Tati, 1953.** POSTER René Peron, France By portraying M. Hulot in a 1930s graphic style, this poster implies that he is a throwback to a previous era. This theme was emphasized in *Mon Oncle* (1958), which shows Hulot battling with technology.

MIDDLE *Funny Face* (*Cenerentola a Parigi*), **Stanley Donen, 1957.** POSTER Ercole Brini, Italy The Italian title for this film means "Cinderella in Paris". Ercole Brini's beautifully painted, artfully cropped image presents Hepburn as the epitome of unspoilt loveliness.

FAR RIGHT *The Man with the Golden Arm*, **Otto Preminger, 1955.** POSTER Saul Bass, USA The centrepiece of the poster is Bass's twisted-arm logo, used throughout the promotion of the film. The interlocking bars that form the rest of the composition are a visual echo of the movie's jazz score.

IT IS OFTEN SAID that movie posters communicate the essence of film. This is not entirely true. In some cases poster and film are tied closely together and speak with one voice, the former summarizing the latter. In others, they are utterly separate, created by unallied bodies and sending out related but not identical messages. Instinctively the former situation would seem more satisfactory than the latter – indeed I tend to judge contemporary posters on their fidelity to cinematic style – but in the fullness of time, the film poster takes on a life of its own. More than echoing the evolution of cinema, the independent trajectory of the film poster reflects the changing nature of the audience. Posters are primarily advertisements and their task is to connect with the people on the street, not with the images on the screen.

To some, the distribution of films might seem to be the grubby commercial end of a creative endeavour, but once explored in any depth it is less easily written off. The history of the film poster is the ongoing story of the link between cinema and society.

Of course movie-poster design is not always the province of distant marketers. In some cases the relationship between product and advertisement is very close. Famously, the maverick independent producer/director Otto Preminger hired graphic designer Saul Bass to create posters and title sequences for his features, starting with the 1955 movie *The Man with the Golden Arm*. Armed with a coherent graphic package, Preminger then did his best to patrol the promotion of his movies, right down to the awnings of individual theatres. This

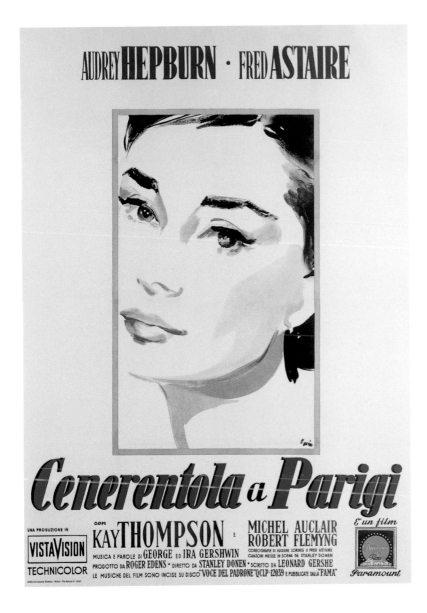

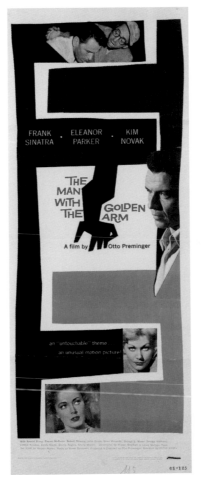

director's desire to exert ownership at every stage of production and distribution is legendary. There is a famous quip, possibly apocryphal, attributed to an anonymous Hollywood tour guide: "There's Otto Preminger's house. I'm sorry, I mean there's 'A House by Otto Preminger'."

It would be unfair, however, to imply that an interest in posters on the part of a director implies nothing but a massive ego. I am sure that Preminger fully appreciated the cultural worth of Bass's pioneering work. Equally, there are several other cases of flourishing director/ designer partnerships, where a natural instinct for branding on the part of the director is tempered by a sophisticated understanding of design. In the early 1970s, Clint Eastwood formed a professional relationship with the designer Bill Gold that would last for more than two decades and give rise to one of the best teaser campaigns ever, that for Eastwood's 1992 movie *Unforgiven*. More recently, the collaboration between director Pedro Almodóvar and designer Juan Gatti has produced some of the most entertaining title sequences and graphically surprising posters of the last ten years.

The movie director best known for matching an unerring instinct for design with a skill for self-promotion (a skill that led to a late career in pure showmanship) is Alfred Hitchcock. Quick to catch on to the value of Bass's work for Preminger, Hitchcock hired the designer to create titles and promotional graphics for his own movie *Vertigo* (1958) and two subsequent films, *North by Northwest* (1959) and *Psycho* (1960). Posters for

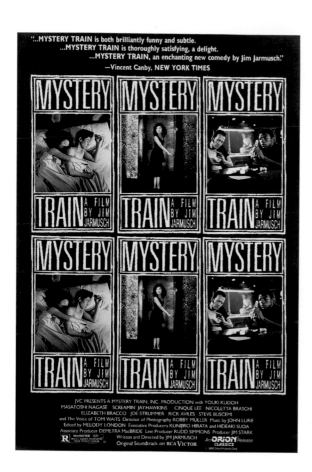

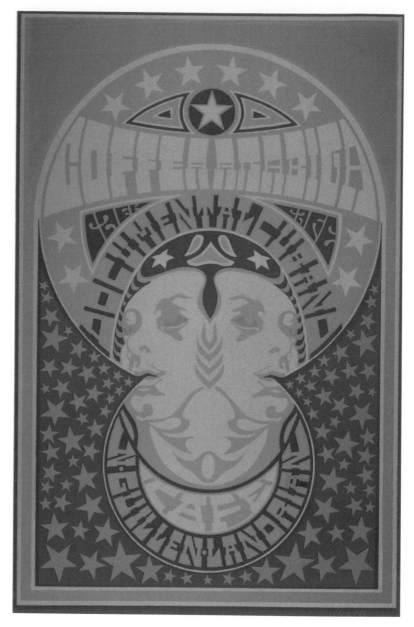

other Hitchcock films tend not to be as pleasing as those designed by Bass, but they are all uniformly engaging and unfailingly direct, even to the extent of showing the director appealing in person to the audience. Taken together these images are fascinating, and it is no surprise that there are several collectors who devote themselves solely to Hitchcock ephemera. But these first-run posters are far from the end of the story. Way out of Hitchcock's reach, in countries where Hollywood once seemed as distant as the moon, a whole separate body of Hitchcock images came into being. Posters promoting the director's films in Eastern European or Asian countries are no less fascinating than the indigenous American advertisements. Although they have nothing to do with the director's wishes, they are

central to the story of 20th-century cinema, a tale that concerns migration and assimilation in every sense.

Evidence of the global variation in the reception of cinema is one of the most interesting aspects to emerge from any international survey of movie posters. During the 1950s and 1960s Hollywood films were worldwide currency, but cultural exchange rates varied dramatically. Some nations, particularly the French, picked up American directors who had enjoyed relatively little success on their home turf. Others embraced big Hollywood hits, but seemed to view them in a totally different light: see, for example, the melancholy Czechoslovakian poster for Billy Wilder's comedy *The Seven Year Itch* (1955). Such diversity is currently under threat and regional distributors now almost

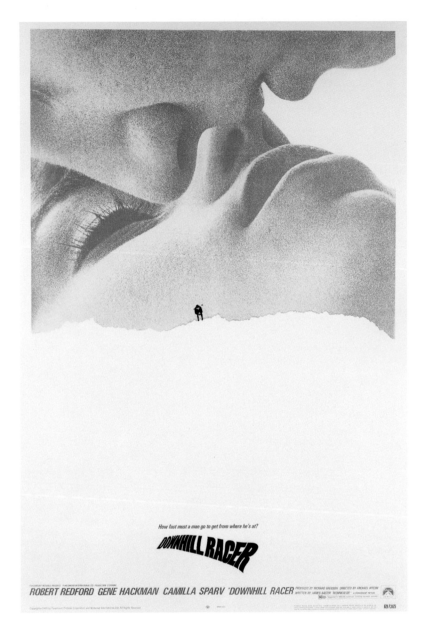

FAR LEFT *Mystery Train*, **Jim Jarmusch, 1989.** POSTER **USA** The film intertwines three stories, the common element being the seedy hotel in which all the characters are staying. This poster represents each of these stories with a doubled image.

MIDDLE *Coffee Arabica*, **Guillen Landria, 1968.** POSTER **Raúl Oliva, Cuba** The influence of graphic psychedelia was very short-lived but utterly international. Designed a year after the explosion of the style in British and American graphics, Oliva's composition is among the most elegant examples of its kind.

LEFT *Downhill Racer*, **Michael Ritchie, 1969.** POSTER **Steve Franfurt, USA** In this image Franfurt reprises the dramatic distortion of scale that he employed to great effect in the *Rosemary's Baby* poster. The loneliness of the skier is emphasized by the outsize romance on the horizon.

always choose to adopt first-run artwork rather than creating their own. All the designers I spoke to regretted the encroachment of uniformity, although perhaps it is an unavoidable symptom of a homogenous worldwide movie audience. Whatever the cause, the passing of the local film poster is a huge loss to the medium.

Film posters represent the intersection of a number of different stories: those of production and distribution, of creative impulse and spontaneous reaction, and of celebrity, egotism, and power. Reading any poster is a complex business, and a stress on one aspect tends to come at the expense of others. This book is arranged in a rough chronology and posters are grouped variously by director, designer, actor, genre, or in some cases by single film. The discussion in each section is led by the

organizing principle. As with most writing about film, if looked at as a whole this book highlights the role of the director above all else. This inclination leads to interesting debates about the relationship, or more often lack of it, between film-making and graphic style, but it is not the bias that I would have chosen. I would have preferred to put more emphasis on the work of named designers, but movie-poster design is a field beset by anonymity and the hunt for designer names can prove frustrating. With one or two notable exceptions, even the dealers have little time for such niceties. I encourage any designer who recognizes his or her work, or that of others, to come forward and enable future publications of this sort to give credit where it is due.

01 The Birth of Cinema

RIGHT *L'Arroseur Arrosé*, **Cinématographe Lumière, 1885.** POSTER **France** The present-day equivalent of this poster's portrayal of gleeful audience reaction is a short enthusiastic quote from an established critic. In portraying an amused public, the Lumière brothers adopted a much more direct approach.

MIDDLE *Sidewalks of New York*, **Zion Myers and Jules White, 1931.** POSTER **USA** Buster Keaton nearly always appears as a cartoon character in posters for his films. This mode of representation reflected his acting style, which was influenced by his early career performing stunts.

FAR RIGHT *Journey to Mars*, **William Neill, 1923.** POSTER **Nikolai Prusakov and Grigori Borisov, USSR** This is the original-release Russian poster (*c.* 1926) for a silent era American science-fiction film. The illustration shows an inventor who, bent on making radio contact with Mars, dreams of a journey to the Red Planet.

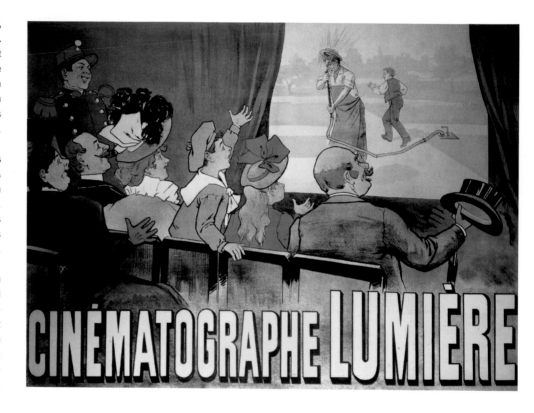

THE VERY ORIGINS of cinema are uncertain. During the mid-1890s a number enterprising inventors were amazing the public with moving pictures, but no single one of them can be considered cinema's sole parent. Thomas Edison in the United States, the Lumière brothers in France, Max Skladanowsky in Germany, and William Friese-Greene in Great Britain all contributed to the development of film, but the birth of the medium owed more to the coming together of various technologies and materials, such as precise engineering and celluloid, than to any single inventive moment.

Cinema's first 30 years were a period of extraordinary expansion. Movies went from being novelties, often less than a minute long and included on the bill with variety acts, to feature-length spectacles shown in specialist theatres. From the outset cinema was an international medium, with films shipped around the world. During the late 19th and early 20th centuries the French dominated the international market, with the Lumière brothers showing a considerable talent for publicity, and later the Pathé Company outstripping its rivals in terms of worldwide expansion and acquisition. It was only with the onset of the First World War and the virtual destruction of the European film industry that American film, and more significantly Hollywood film, began to dominate.

For the first decade or so the form of the cinema industry remained unfixed. The roles of mechanic, cameraman, projectionist, and even actor were fluid. All this began to change in around 1910. Large numbers of specialist movie theatres were being built and audiences

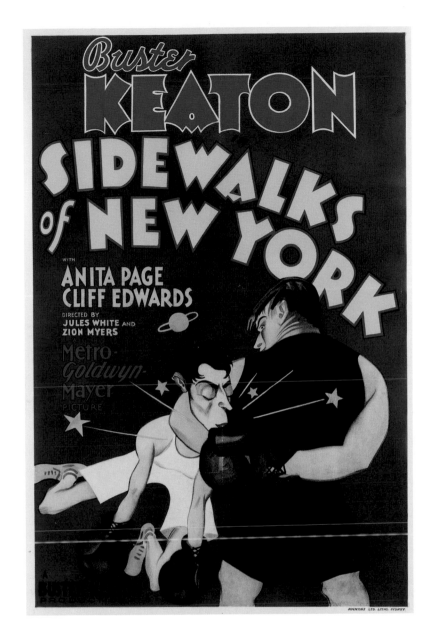

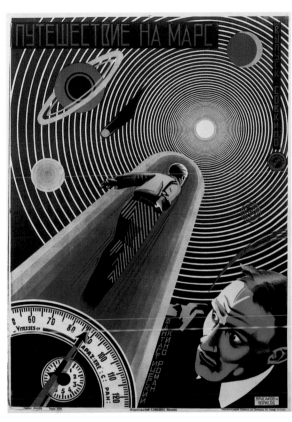

needed tempting with more substantial fare: films of at least an hour long with something like a storyline. To satisfy such demands, the film industry had to organize itself. Production and distribution began to separate and the figure of the director emerged for the first time. When the first 90-minute films were made in 1913 the movie business resembled any other capitalist industry.

Around the same time, the star system began to flourish. It became apparent that nothing attracted an audience more surely than a familiar face. The twinned emergence of feature films and recognizable stars promoted the development of the movie poster. As publicity became a specialist business, printed images, usually focusing on a single, well-known figure, became an established part of the cycle of movie promotion. By

the end of the First World War the 90-minute, celebrity-led film had emerged as the standard form. Popular film remains more or less unchanged to this day.

Although Hollywood film achieved a dominant position during the First World War, national film traditions were never entirely extinguished. During and in the immediate aftermath of the war, Germany began to develop its own film industry in isolation from its European neighbours and from the United States. Initially a means of propaganda (the largest production company, the Universum-Film Aktiengesellschaft, UFA, was secretly funded by the state), later the industry focused on confronting the US hegemony through both protectionism and international expansion. The films made in Germany during the Weimar years (1918–28)

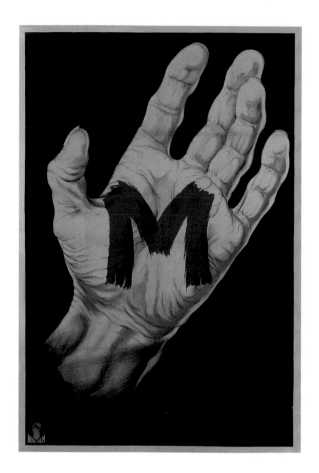

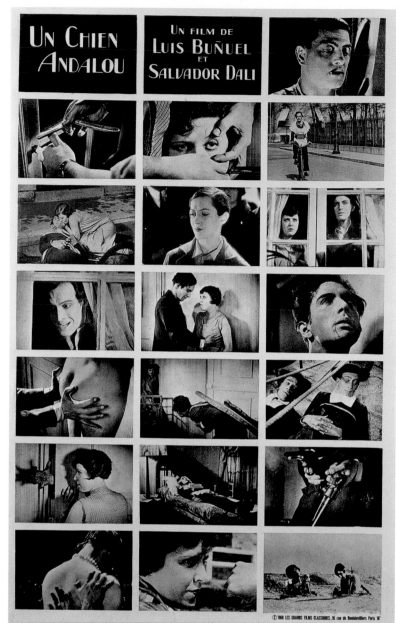

are often considered part of a "golden age" of cinema, although some feel they are stilted and overly formulaic.

Another national cinema that thrived in the face of Hollywood is that of the Soviet Union. Isolated from the distribution networks of the rest of the world, the Soviets officially nationalized film production in 1919. Cinema became an important means of asserting the Soviet identity and this role was supported not only by the government but also by those who worked in the industry. In 1924 a group of film-makers led by Sergei Eisenstein and Lev Kuleshov formed the Association of Revolutionary Cinema (ARC), whose purpose was to assert ideological control over the film-making process; soon there were branches of the ARC in almost every studio. In spite of ideological restrictions, in terms of style the cinema of

1920s Russia was extremely innovative. The technique of montage, most associated with Eisenstein, remains among cinema's most important aesthetic experiments.

In parallel with the development of the mass movie was the emergence of a cinematic avant-garde. This is a broad term used to envelop all whose interests are not directly commercial, from artist/film-makers to the German Expressionists and the Soviet exponents of montage. Broadly speaking early avant-garde film-makers pursued one of two directions: that of abstract film, an absolute film of pure graphic form; or a parody of mainstream film, an absurdist take on recently developed cinematic conventions. These film-makers are not well-represented in this survey as their films were not part of the commercial mainstream and so were not promoted

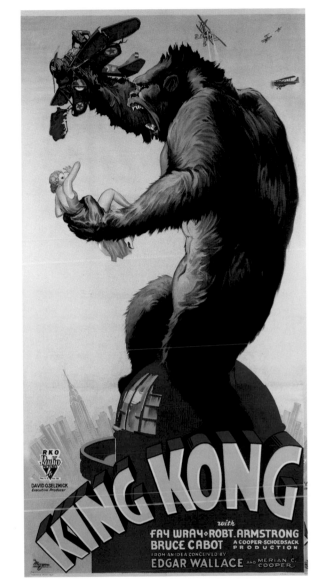

FAR LEFT *M*, Fritz Lang, 1931.
POSTER Germany Lang's thriller deals with
the highly charged subject of child murder.
Showing only the film's title smeared in
blood on the palm of the murderer's hand,
the power of this simple and effective
image is undimmed by the decades.

LEFT *Un Chien Andalou*, Luis Buñuel, 1929.
POSTER 1968, France Using various stills
from Buñuel's début film, this re-release
poster shows the scenes leading up to the
famous eyeball slash but shies away from
the gore of the incident itself. The type apes
that of the silent-film title card.

RIGHT *King Kong*, Merian C. Cooper and
Ernest B. Schoedsack, 1933. POSTER USA
This is the most famous image generated by
the *King Kong* campaign. Its combination of
jaunty type, artfully skewed landscape, and
raging monster have made it among the best
loved of all movie posters.

with large-scale posters. All the same it is important to remember individuals such as Luis Buñuel, Jean Vigo, René Clair, Hans Richter, and Oskar Fischinger (among many others), all powerhouses of cinematic experiment.

In the late 1920s the movies began to speak. The technology of sound, first applied to newsreels, changed the landscape of film-making. Immediately it challenged the pre-eminence of Hollywood. No longer could American films travel unhindered across national boundaries. In tandem with the Great Depression of the late 1920s, this development threw the Hollywood studios into a crisis from which it took several years to recover. The introduction of sound prompted a wave of musicals, an eternally popular genre that is not so dependent on a national tongue. A longer-term solution

was translation, and by the early 1930s the studios had developed a serviceable dubbing technology. The late 1920s hiccup in the expansion of Hollywood cinema proved only temporary and a decade later the US industry was in a stronger position than ever before.

In the late 1920s, as well as wiring their theatres for sound, many cinema owners introduced air-conditioning. Cinema-going in the US became a summer-time activity and movie distributors began showing films first in the US during the summer and then taking them to Europe once the weather turned cooler. Like the feature film, this convention survives to this day. Although much has changed in the last 75 years, it is remarkable the extent to which the form and the reception of movies were fixed in their first few decades.

The Man with the Movie Camera

In the early 1920s the Russian documentary film-maker Dziga Vertov (1896–1954) declared that the narrative cinema of his time – movies made by the likes of D.W. Griffith – was a betrayal of the film medium. With his cinematographer brother Mikhail Kaufman and his editor wife Yelizavota Svilova, he formed the Moscow-based "*kinoki*" or "cine-eye" group. Their aim was to promote film as a means of recording the reality of everyday life, and *The Man with the Movie Camera* (*Chelovek s Kinoapparatom*) was their collective masterpiece. The movie opens with a sequence in which the cameraman appears to be run over, a self-reflexive acknowledgment of the trickery implicit in all film-making, and then follows the course of a single, urban day, from dawn to dusk. Eschewing conventional structure, it is built from a series of passages that are almost musical in nature.

The posters promoting *The Man with the Movie Camera* reflect the radical nature of the film. The best known of these is by the Sternberg brothers who, in keeping with the style of the movie, broke conventional images to create a set of disparate but compelling fragments. Meanwhile, the German poster for the film adopted a Futurist style of representation, suggesting the speed and dynamism of city life.

RIGHT *Chelovek s Kinoapparatom* (*Der Mann mit der Kamera*), Dziga Vertov, 1929. POSTER Kupfer Sachs, Germany This poster is built from several intercutting planes of representation, a mode borrowed from Futurist artists such as F.T. Marinetti. By the end of the First World War artistic Futurism was a spent force, but its mainstream influence lasted much longer.

RIGHT *Chelovek s Kinoapparatom*, Dziga Vertov, 1929. POSTER Georgii and Vladimir Sternberg, Russia This poster is a literal representation of Vertov's "cine-eye", the all-seeing camera whose task is reporting reality. We also see fragments of the cameraman and one of the incidental characters.

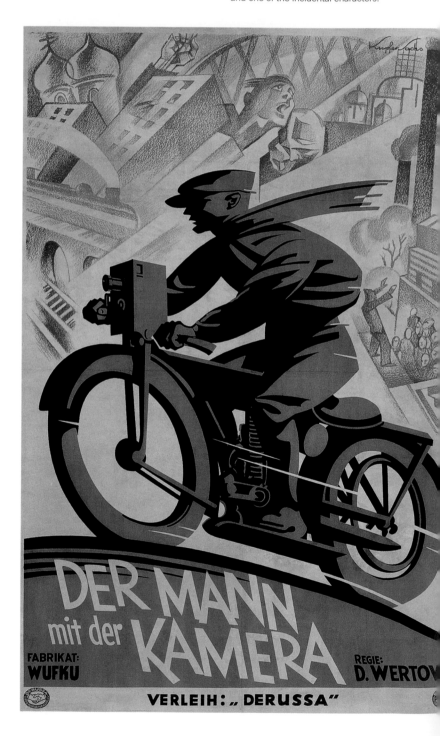

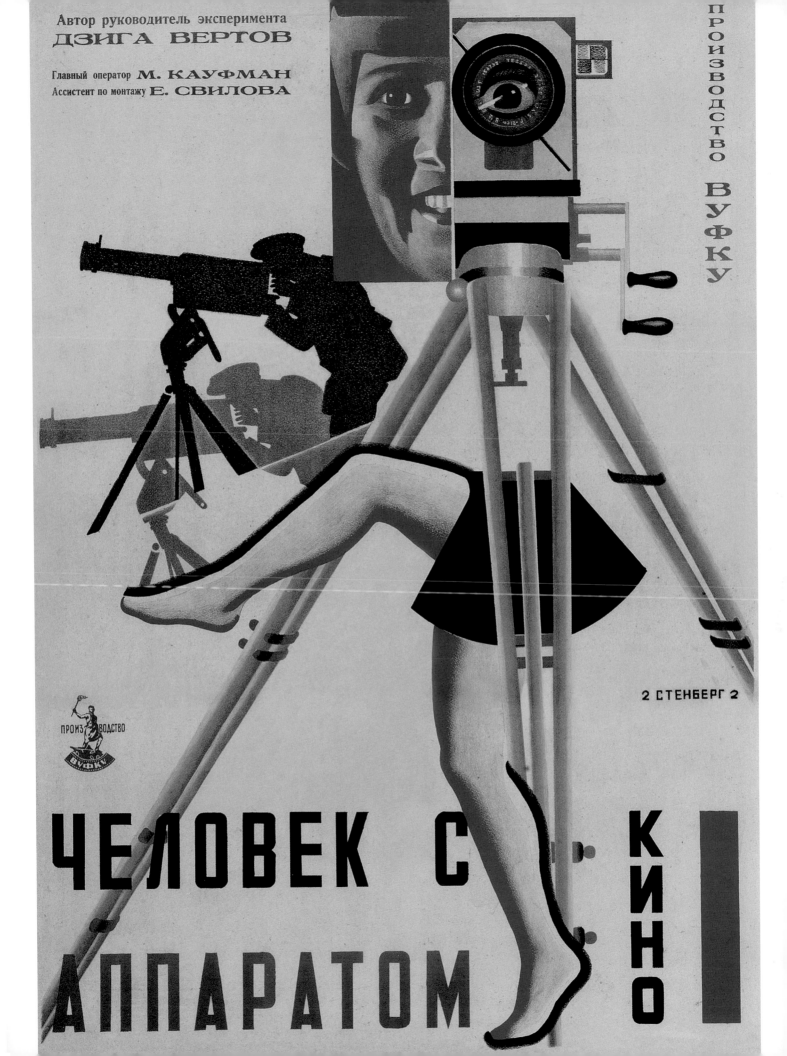

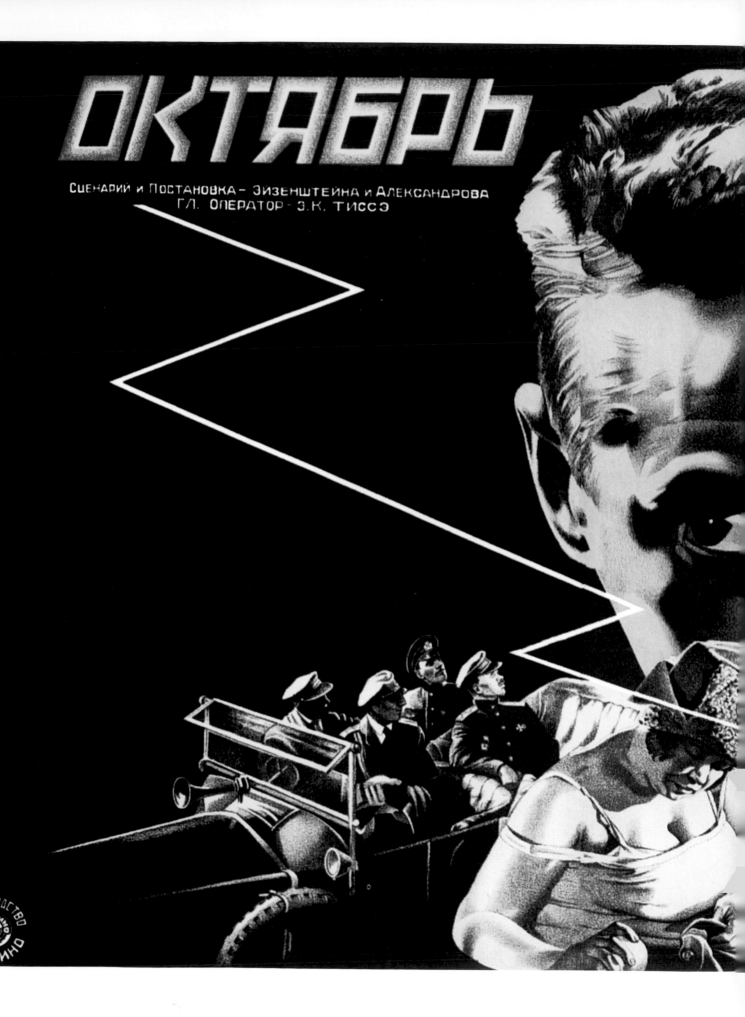

October

October was one of a number of films commissioned by the Soviet Government in celebration of the tenth anniversary of the 1917 Revolution. Directed by Sergei Eisenstein (1898–1948), the film recounts events in Russia from the fall of the monarchy in February 1917 to the defeat of Kerensky's provisional government in October of the same year. Eisenstein adopted a quasi-documentary style, but tempered realism with experimental cinematic technique. Epic scenes such as the storming of the Winter Palace were filmed using vast crowds of extras, many of whom had been involved in the original event. Rather than standing back and simply recording these staged events, however, Eisenstein's camera homed in on details, which were edited to create a sense of rhythm and establish communication through metaphor.

The face in the background of this poster is that of Leon Trotsky, a Russian revolutionary leader who played an important role in the events of 1917 and featured large in the first cut of Eisenstein's film. In the short period between the making and the release of *October*, however, the political complexion of the fledgling Soviet Union shifted substantially. By the time the public were invited to see the film, Trotsky's image had been entirely expunged, an edit that cost Eisenstein 25 per cent of his footage. Voronov and Evstafiev's poster was also lost to Soviet audiences, banned from ownership or display in any part of the USSR.

In its reworked, Stalin-friendly form, *October* became an important building block of the Soviet myth. The film is said to have alienated 1920s audiences through its jumpy editing and unconventional story-telling style; nonetheless it created a series of compelling images that justified the very existence of the Soviet Union and heroized all those concerned with its foundation (except Trotsky, of course).

LEFT *Oktabyr* (*October*), **Sergei Eisenstein, 1927.** POSTER **Leonid A. Voronov and Evstafiev, Russia** This collage poster is suggestive of Eisenstein's film-making style. The disparate images juxtaposed at unlikely scales are the graphic equivalent of montage editing. The jagged line that slashes from top left to bottom right could likewise be seen as a metaphor for the film's non-straightforward story-telling style.

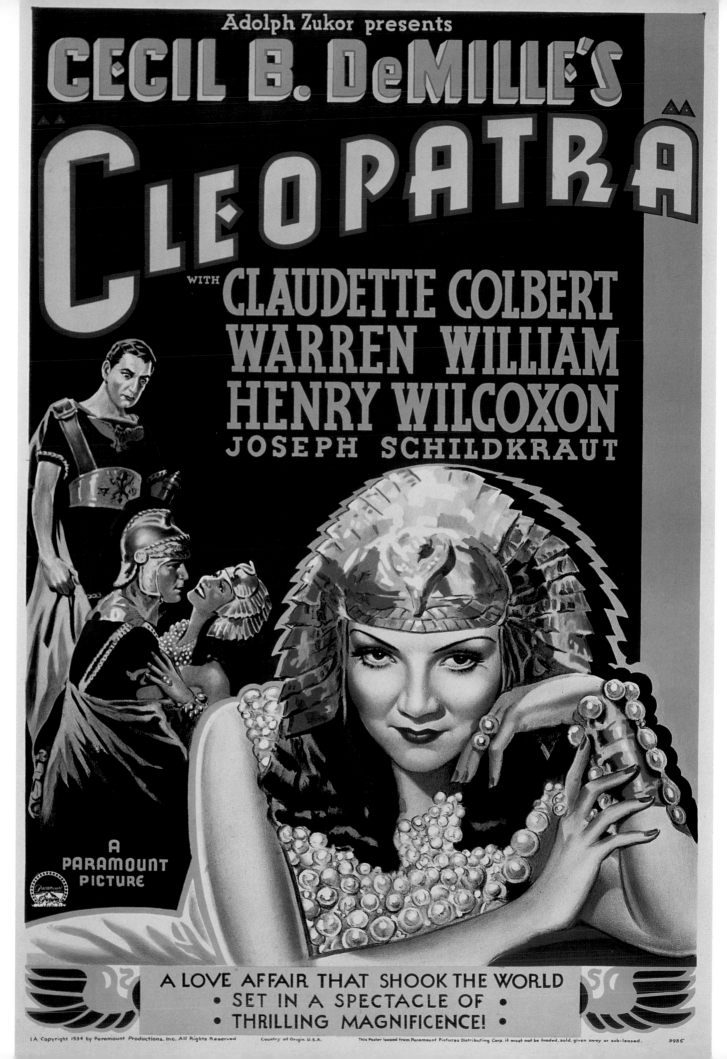

D.W. Griffith & Cecil B. de Mille

D.W. Griffith (1875–1948) is often credited with the invention of the feature film. Starting out as a director in 1908, he made the 12-reel *The Birth of a Nation* in 1915, which at 190 minutes was the longest film made in the United States to date. Not only did this work encourage the production of longer movies, it also promoted the exploration of serious social issues in the cinema. Cecil B. de Mille (1881–1959) is also associated with the dawning of present-day filmic convention. His 1914 début *The Squaw Man* was the first feature-length film made in the United States, and most of his subsequent output adopted a similar format. Longer films such as those produced by Griffith and de Mille require higher budgets and must be justified by greater box-office returns. These epics were heavily promoted, by early 20th-century standards, and the development of the feature film went hand in hand with that of the film poster.

Griffith made his most important films in the 1910s, a trio composed of *The Birth of a Nation*, *Intolerance* (1916), and *Broken Blossoms* (1919). Each was widely promoted with a number of different illustrated poster styles. In spite of this profitable run, Griffith's career took a downward turn in the early 1920s and never recovered. De Mille's success was more sustained, although it is often argued that, having started out with artistic ambition, he ended up a straightforward entertainer. From the early 1930s de Mille made large-scale but increasingly old-fashioned epics. Beginning with *Cleopatra* and ending with *The Ten Commandments* (1959), many of these movies left the critics cold, but most found an audience.

FAR LEFT *Cleopatra*, Cecil B. de Mille, **1934**. POSTER USA In the 1920s de Mille concentrated on religious epics, but in this movie the focus was all on sex. Claudette Colbert's Cleopatra locks the viewer's gaze, allowing only a quick peek at the shenanigans over her shoulder. The style of the design reflects the Art Deco setting of the film itself.

LEFT *The Birth of a Nation*, D.W. Griffith, **1915**. POSTER USA This film dealt head-on with some of America's most explosive issues. The poster adopts the style of a news magazine, with a short caption describing the dramatically illustrated event. The text on the poster promises a "mighty spectacle" – a significant draw for the audience of the era.

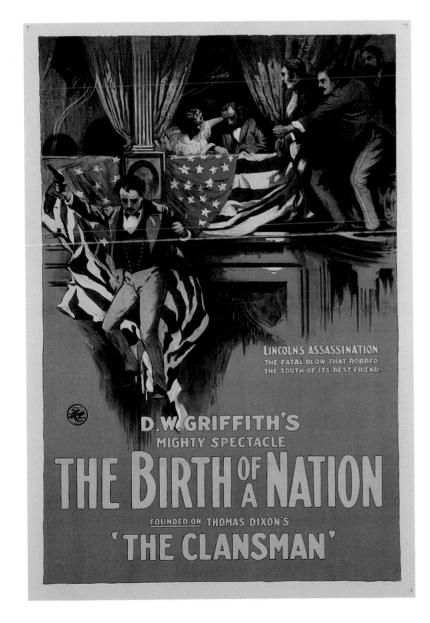

LINCOLN'S ASSASSINATION.
THE FATAL BLOW THAT ROBBED THE SOUTH OF ITS BEST FRIEND.

D.W. GRIFFITH'S
MIGHTY SPECTACLE
THE BIRTH OF A NATION
FOUNDED ON THOMAS DIXON'S
'THE CLANSMAN'

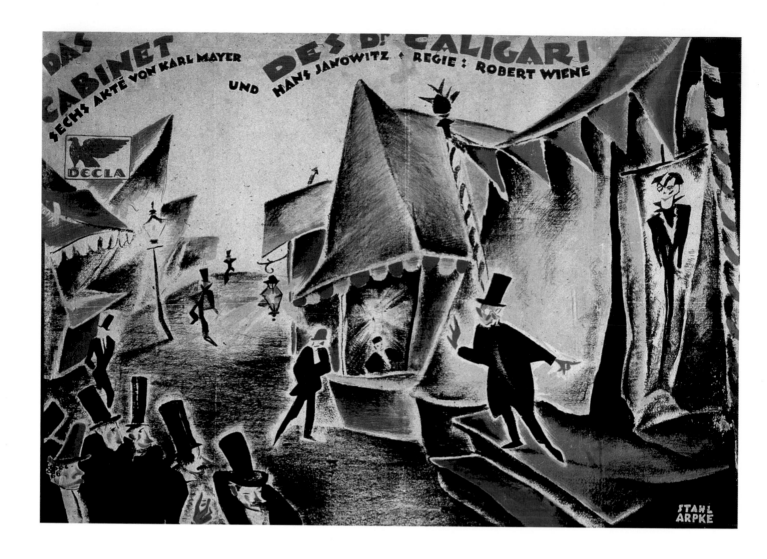

German Expressionist Film

Largely owing to a ban on imported productions, the First World War had the effect of boosting the German film industry. A particularly Teutonic form of cinema arose: non-naturalistic films in which elements of traditional folk tales were combined with tropes borrowed from highbrow literary and artistic experimentation. The most successful production to emerge was Robert Wiene's *The Cabinet of Dr Caligari* (*Das Cabinet des Dr Caligari*), a film that enjoyed success not only domestically but also in France and the USA. In many ways *Dr Caligari* is quite unlike its fellows, its Expressionist décor in particular being unique; all the same it became emblematic of German cinema of the era. Posters tend to illustrate its extraordinary set.

Made several years later, *Metropolis* by Fritz Lang (1890–1976) is often viewed as the masterpiece of Expressionist film, although it shares little with the other works gathered under this banner except exaggerated contrasts between darkness and light, the definitive tonal scheme of Expressionism. The futuristic world of the film was extremely expensive to create and nearly bankrupted the Universum-film Aktiengesellschaft (the state-owned film-making consortium). On its first release the film met with mixed reviews; although critics were amazed by Lang's landscape, they were unimpressed by writer Thea von Harbou's screenplay. Since then, however, it has been recognized as the forerunner of modern science fiction. The *Metropolis* poster image is probably even better known than the movie itself. Lang's attractive female robot has been the model for many subsequent sexy and not so sexy automatons, including *Star Wars*' C-3PO.

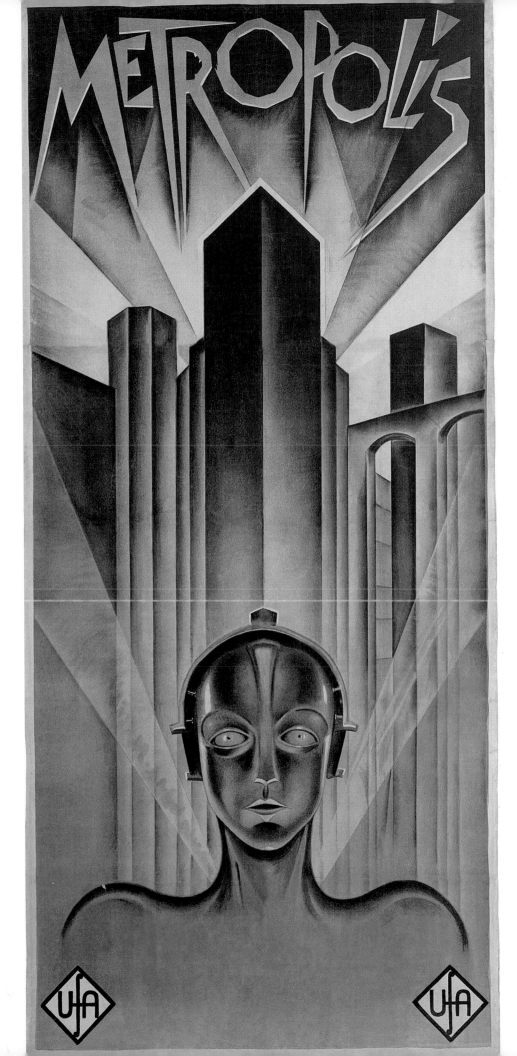

FAR LEFT *Das Cabinet des Dr Caligari*,
Robert Wiene, 1920. POSTER Stahl-Arpke,
Germany This poster suffuses the set of
Dr Caligari with an imagined colour scheme
of red, orange, and yellow. The film itself is
intensely black and white and these colours
certainly would not suggest themselves to
a contemporary audience. The design raises
intriguing questions about assumptions
regarding colour in its absence.

LEFT *Metropolis*, **Fritz Lang, 1926.** POSTER
Heinz Schulz-Neudamm, Germany Lang's
futuristic world, dated 2026, was inspired by
a visit to New York City. The buildings on this
poster are highly suggestive of the city's Art
Deco skyscrapers and equally, with the
addition of a little blusher, the robot Maria
could be America's modern woman.

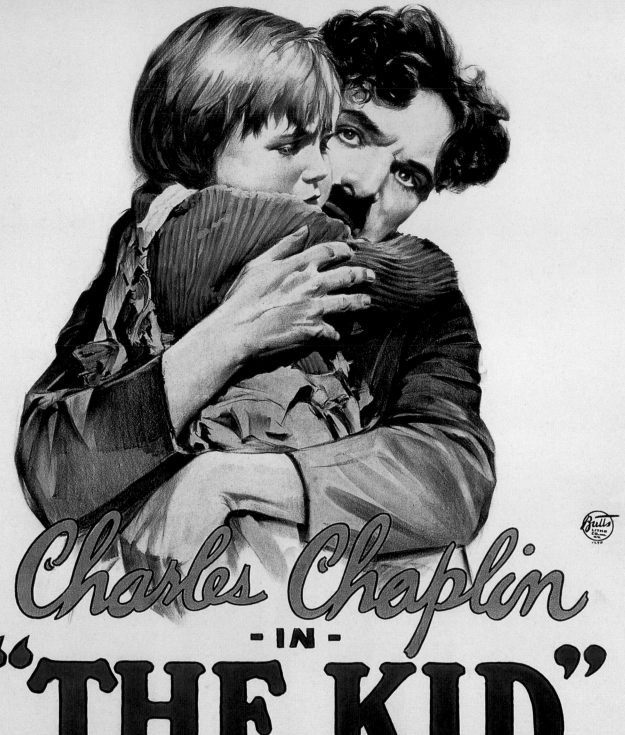

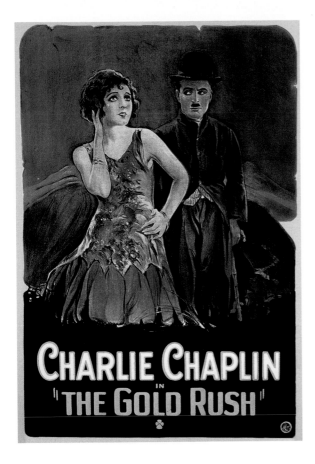

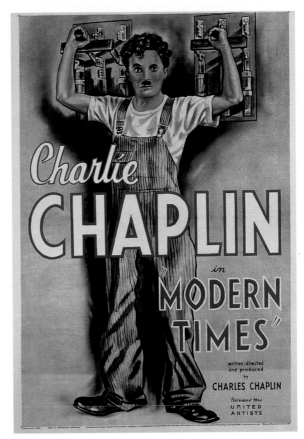

LEFT *The Kid*, Charlie Chaplin, 1921. POSTER USA The emphasis of this poster is on the kid's tousled hair and tattered clothes and the tramp's threadbare sleeves and bony, exposed wrists. Tenderly realized, the pair represent love's triumph over despair.

ABOVE LEFT *The Gold Rush*, Charlie Chaplin, 1925. POSTER USA The film made fun of Klondike prospectors, who endured extreme hardship while dreaming of gold. Behind are the mountains of Alaska, in the foreground wealth's apparent prize, a pretty girl.

ABOVE *Modern Times*, Charlie Chaplin, 1936. POSTER USA This was Chaplin's last silent film, made with sound effects but no dialogue. A satire on the machine age, the movie could be read as a personal protest against mid-century cinematic developments.

Charlie Chaplin

The comic persona of Charlie Chaplin (1889–1977) was born early in 1914. Legend has it that the comic went to the wardrobe shack at Keystone Studios in search of a new character for a one-reel film. Putting together a moustache and a bowler hat, he emerged, near fully formed, as the "Little Tramp". Over the last century Chaplin's tramp has become a filmic icon, an immediately recognizable symbol of comic cinema. But, as his image has acquired universality, his representation has become more and more reduced. It is possible to indicate Chaplin with the sparest of graphic symbols: a bowler hat and a rectangular moustache will do. With this in mind, the posters for the comedian's films come as something of a surprise. Present-day media may have whittled Chaplin down to a shuffling caricature, but early 20th-century audiences saw him as a fully-realized personality. Executed in the illustrative style of their day, these posters invest Chaplin with hope and despair as well as humour.

Raised in London, Chaplin was the son of music-hall artists. His father came to an early, alcoholic end and his mother was prone to mental instability, often being confined to institutions. The poverty and pathos of many of Chaplin's films reflect his experience. Produced at his own studio, *The Kid* is his most successful, if a somewhat sentimental, exploration of childhood hardship. In 1919 Chaplin co-founded United Artists with several other Hollywood stars and from 1923 all his films were released through this studio. Including *The Gold Rush*, *City Lights* (1931), *Modern Times*, and *The Great Dictator* (1940), Chaplin's mature films mix comedy with topical satire.

WARNER BROS.
SUPREME TRIUMPH

AL JOLSON IN "THE JA

The Jazz Singer

"Wait a minute. Wait a minute. You ain't heard nothing yet!" These are the first words spoken by Al Jolson, playing aspirant entertainer Jackie Rabinowitz, in the film *The Jazz Singer*. Although the film is only part talkie, with sound-synchronized musical numbers and some dialogue, Jolson's opening utterances have secured it its place in the history of talking pictures. Contrary to cinema lore, *The Jazz Singer* was not in fact the début of sound-synchronized film, but it was the first time that music and spoken dialogue had been used with significant dramatic effect. Jolson was announcing a new age of cinema. Barred from competing against silent movies, *The Jazz Singer* was given a special Oscar. But the novelty of sound was short-lived. The commercial success of the Jolson film spawned more sound productions and in a few years talkies became commonplace.

This poster is a B-style image, the more conventional A-style showing a scene in which Jackie Rabinowitz improvises on the piano before his adoring mother. Depicting Jolson in blackface with exaggerated hands and features, this image picks up on early 20th-century associations between jazz music and primitivism. According to the film's opening title cards, the New York ghetto throbbed "to that rhythm of music which is older than civilization". The supposed connection between ancient cultures and contemporary urban life also informed the European Modern art movement and led to the reductive yet exaggerated forms of representation employed by the Cubist painters. In its simple graphic representation, the *Jazz Singer* poster displays the long-standing influence of these experiments and reinvigorates the idea of a link between modernity and the latterly repressed spirit of primitive man.

LEFT *The Jazz Singer*, **Alan Crosland, 1927.** POSTER USA This black-and-white poster has displaced the more conventional A-style campaign as the image most associated with the film. Its lasting success is derived from its simplicity.

02 The Rise and Fall of the Studios

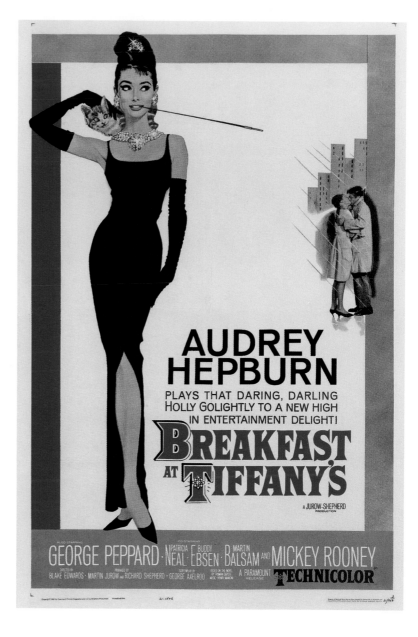

RIGHT *Breakfast at Tiffany's*, **Blake Edwards, 1961.** POSTER USA Audrey Hepburn's Holly Golightly is an enduring style icon, and this poster shows exactly why. Of barely more girth than her cigarette holder, the actress embodies an image as irresistible as it is unattainable.

MIDDLE *Gone with the Wind*, **Victor Fleming, 1939.** POSTER USA The best-known first-release poster for this film shows the famous Clark Gable/Vivien Leigh kiss. In this 1961 re-release advertisement, Leigh slumps in Gable's arms, creating another classic image of movie romance.

FAR RIGHT *42nd Street*, **Lloyd Bacon, 1933.** POSTER Hubbard G. Robinson and Joseph Tisman, USA This glossy, expensive musical was intended to attract a global audience. The quirky off-centre composition of the poster reflects Busby Berkeley's peerlessly innovative choreography.

BY THE MID-1920S Hollywood movie-making had settled into a studio system. The major studios consisted of the big five – Fox, MGM, Paramount, RKO, and Warner Brothers – and the little three – Columbia, United Artists, and Universal. In 1930 these studios enjoyed their best year ever and began to brag that they were resilient to the effects of the Great Depression, which had hit the rest of the country a year earlier. But what appeared to be recession-proofing turned out only to be a temporary buffer. In the early 1930s the strain of the economic downturn was being felt very strongly and by 1935 around a third of America's movie theatres had closed their doors. The impact of the Depression varied from studio to studio. Those with a great deal invested in strings of movie theatres fared the worst (four out of

the big five: Paramount, Fox, RKO, and Warner Brothers), while their rivals with relatively few theatres did much better (MGM, and the little three).

Although the Great Depression shook the Hollywood studios, its long-term effect was to strengthen their position. The government came to the aid of film-makers and with its help the studios introduced various codes regulating cinema production and distribution that were to secure their position over the next two decades. At their height in the late 1930s, each of the studios relied on its stable of stars, that of MGM being the most impressive (the studio boasted that it had "more stars than there are in the heavens"). The best known of these spawned their own genre of films, such as the series of vehicles produced by Paramount for Marlene Dietrich.

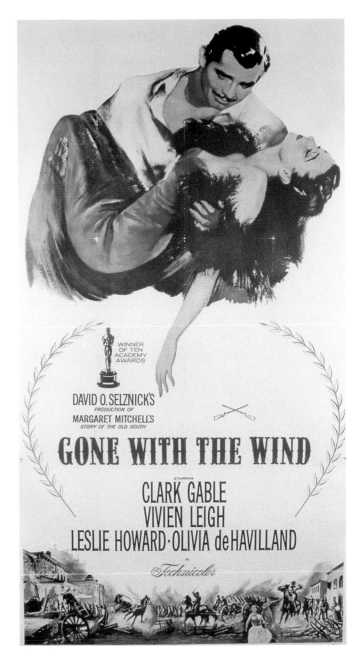

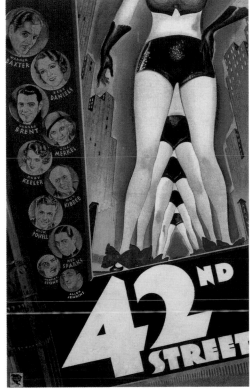

The studios also developed their own house style, largely derived from the properties of their house stars. Although this might seem like a recipe for formulaic films, in fact the studios were very responsive to the market and their commercial success led to the production of a large number of well-resourced, artistically exciting movies. Nineteen thirty-nine is often held up as a peak year in the history of film production. Candidates for the Oscar for best picture that year included *Gone with the Wind*, *Stagecoach*, and *The Wizard of Oz*.

After the 1939 high point the studios suffered a downturn, with both external and internal forces threatening their hegemony. From without, anti-trust regulators began to investigate the ties between the studios and the theatres, a crucial element in ensuring a smooth income stream for the studios. From within, the talent – that is to say, the directors, writers, and actors – fought to secure more of the power and income for itself. The early 1940s saw the rise of the independent producer and also of a new breed of hyphenates – producer/directors (such as Otto Preminger) and writer/directors (such as Billy Wilder) – who were keen to establish their independence from the studios. The war years proved something of a reprieve: the government let the anti-trust legislation rest and the studios proved more than up to the task of making the patriotic war-related fare that American and British audiences wanted. But after the war was over and the wartime mentality lost its grip, the studios found their position considerably weakened once more.

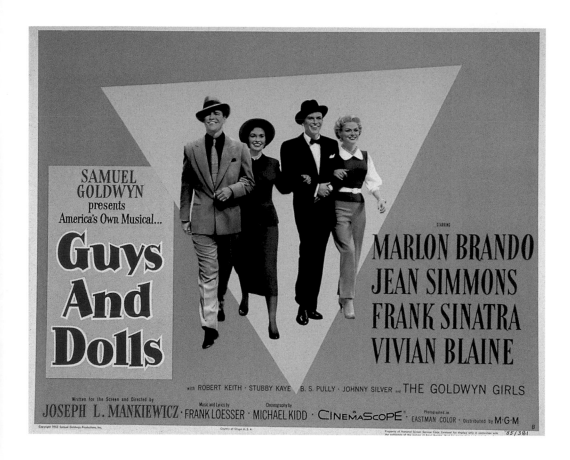

The film's leading players step out in
style, Marlon Brando leading the way.
The triangular background becomes an
emblematic path, a kind of highly
condensed yellow brick road.

LEFT *Guys and Dolls*, Joseph L.
Mankiewicz, 1955. POSTER USA
The film's leading players step out in
style, Marlon Brando leading the way.
The triangular background becomes an
emblematic path, a kind of highly
condensed yellow brick road.

RIGHT *Forbidden Planet*, Fred M. Wilcox,
1956. POSTER USA This classic science-
fiction movie is a typical chiller of the Cold
War era. Robbie, the obedient robot
represented on this image, has the
appearance of a piece of oversized
1950s domestic technology.

FAR RIGHT *Ocean's 11*, Lewis Milestone,
1960. POSTER USA Frank Sinatra leads his
Rat Pack with great style. This image was
referenced by the poster for Quentin
Tarantino's 1992 film *Reservoir Dogs*,
although the criminals in that movie lacked
the dress sense of their predecessors.

The 1948 Paramount Decision (so called because
Paramount was the first studio involved in the anti-trust
investigation) broke the link between the studios and the
theatres for good. Soon the big five were reduced to shad-
ows of their late-1930s selves and this paved the way for
maverick independent film-makers to seize control of the
making and distribution of their films. Characters such as
Preminger, Wilder, and Alfred Hitchcock began to exer-
cise more creative and executive power than ever before.
These film-makers made demands on the system and
often fell foul of rules and regulations established
decades before. Preminger and Hitchcock in particular
aroused the bodies responsible for the industry's self-
censorship with the adult, provocative nature of their
films. As well as artistic control, these film-makers

wanted more commercial control. On occasion this led
to greater involvement in the promotion of films, and
some of the most graphically adventurous film posters
emerged from this period, a large number of them
designed by Saul Bass.

Meanwhile in Europe the film industry was struggling
to recover from the devastating effects of the Second
World War. The United States was heavily involved in
rebuilding European manufacturing, but resisted, or even
opposed, the reinstatement of national film industries.
The fight for independence from Hollywood was already
long-running and in the decades after the war it was to
become more fraught than ever. The resistance to
Hollywood spawned some exciting new film genres. In
Italy a wave of neo-realist films, among the best known

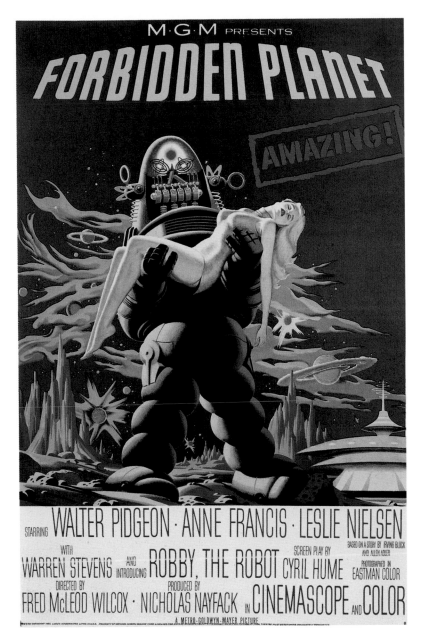

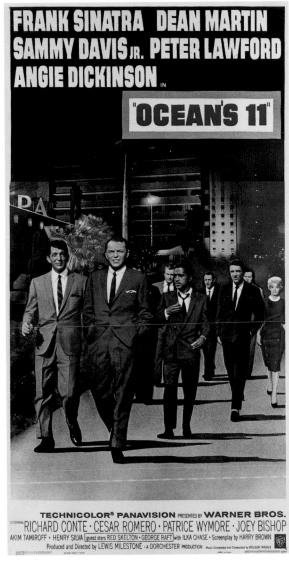

being Vittorio De Sica's *Bicycle Thieves*, pointed towards a new aesthetic and political direction for film. During the 1950s European nations began to cooperate in the production of films and this led to a situation where audiences had access to a wide range of domestic and international cinema. Only Britain was excluded from this varied diet, as ties to Hollywood remained strong. By the 1950s mainstream American and British audiences were choosing films from a shorter menu than any other Western nation. The 1950s also saw the instigation of film festivals, allowing movies to circulate around the world to small, specialist audiences and promoting the widespread conservation and archiving of film stocks.

As cinema audiences fell in the 1950s (principally owing to a migration towards the suburbs and the introduction of television) the industry invented new tricks in an attempt to lure people back to the theatres. Most of these were short-lived gimmicks – for example 3D, the biggest gimmick of them all, a technology largely reserved for horror movies. Some innovations, however, did last, chiefly wide-screen film and colour. Tinted by various means, colour movies had been around since the 1930s, but did not become widespread until the 1950s. Formerly a novelty associated with genres such as the musical, colour gradually became a standard cinematic quality. The introduction of colour changed the relationship between the movie poster and the movie itself. Where the hues on a full-colour poster had been an area for artistic licence, now they were beholden to the film itself.

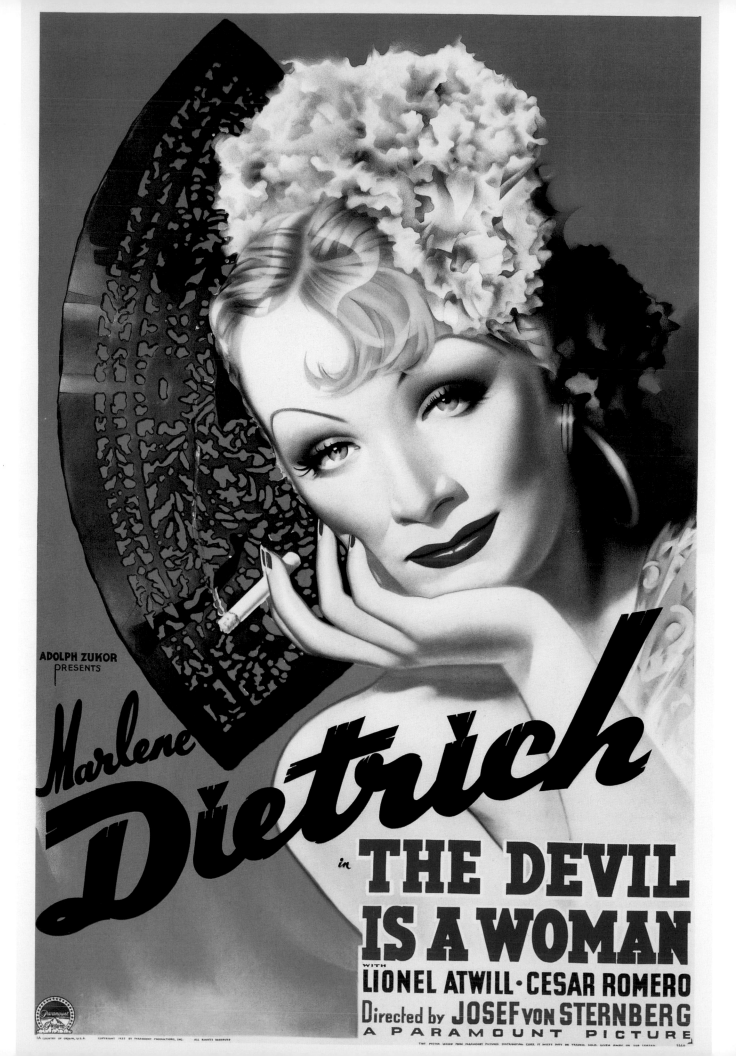

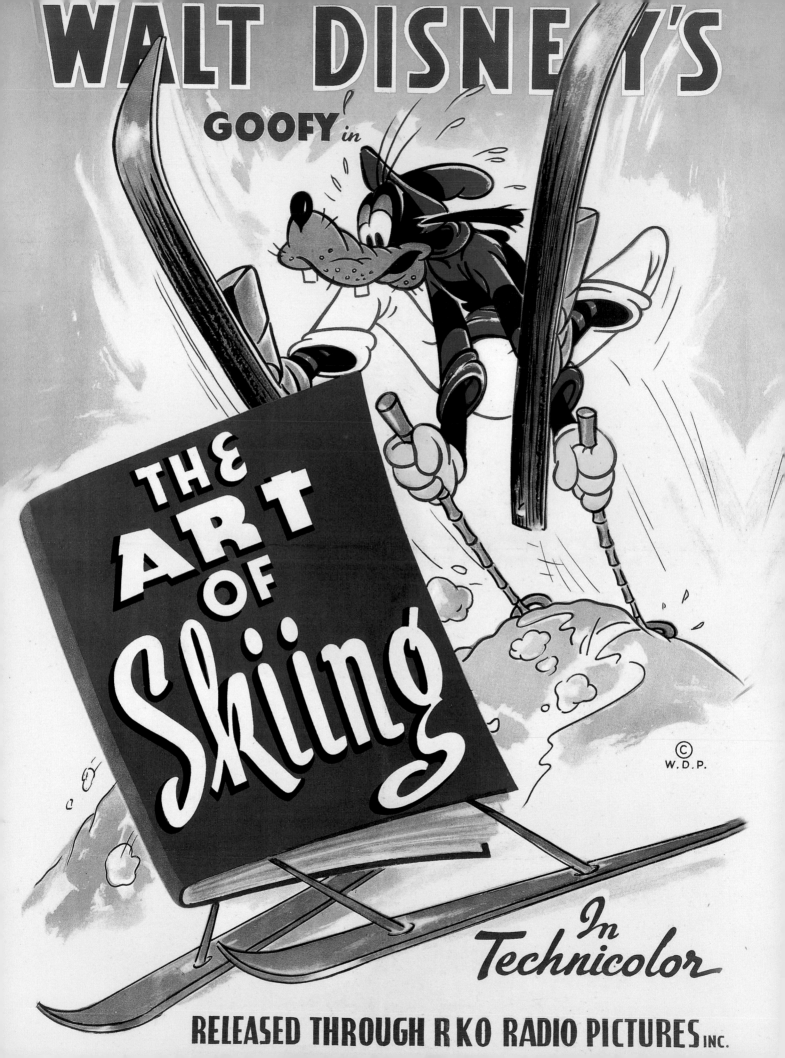

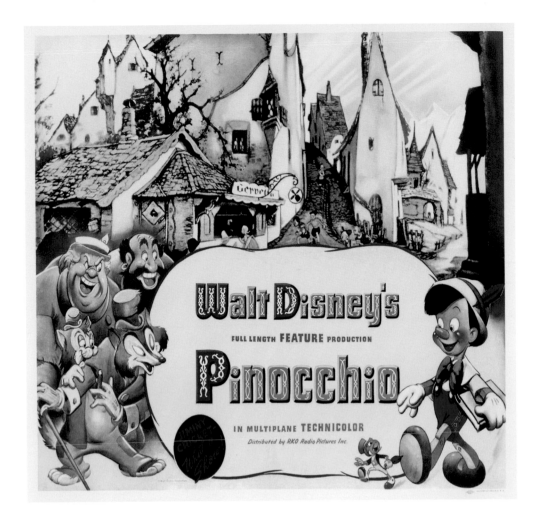

Walt Disney

The first films made by Walt Disney and his brother Roy were the *Alice Comedies*, combination live action and animated shorts made in a style quite unlike that associated with modern Disney. The Walt Disney Company made about 70 of these films between 1923 and 1927, before the advent of Mickey Mouse in 1928 changed the emphasis of output. Mickey's arrival was followed by that of Pluto, Goofy, and Donald Duck. Until Disney produced its first feature-length animation, *Snow White and the Seven Dwarfs* (1937) the company concentrated on animated shorts featuring an expanding range of characters, most of which remain active in the 21st-century Disney empire.

Snow White was a huge success and demonstrated that there was a worldwide market for animated features. Profits were invested in a lot in Burbank on which Disney constructed a modern studio for making animated films. This was also the time that the company began to produce the posters that were required for a global marketing campaign. *Pinocchio* was Disney's second feature. Based on a late 19th-century Italian tale by Carlo Collodi, *Pinocchio* was not easy to adapt. Collodi's central character is very unsympathetic and Disney's scriptwriters and animators had to modify both his physique and his attitude before he made it to the screen. Even so, Disney's *Pinocchio* retains a cruel moral tenor not in line with contemporary tastes. On its release the film was well received in the United States, but its international distribution was limited by the onset of the Second World War and it did not enjoy the success of *Snow White*.

The quality of early Disney films is legend. Entirely hand-made and drawn scene by scene, the images have a depth and resonance that is not seen in present-day animation. Disney animators first started taking technological short-cuts in the early 1960s. Xerox machines were used in the making of *One Hundred and One Dalmatians*, allowing the multiplication of a single sketch of a few dogs

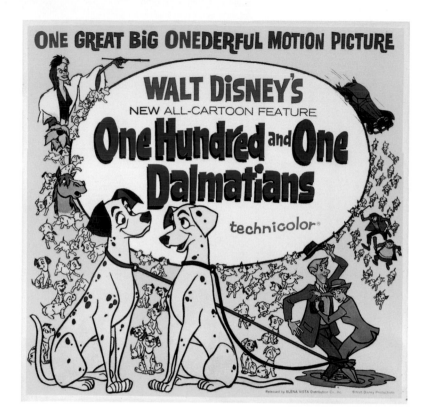

ONE GREAT BIG ONEDERFUL MOTION PICTURE

WALT DISNEY'S
NEW ALL-CARTOON FEATURE
One Hundred and One Dalmatians
technicolor

RIGHT *One Hundred and One Dalmatians* (*101 Dalmatyńczyków*), Clyde Geronimi, Hamilton Luske, 1961. POSTER Liliana Baczewska, Poland Abstracting the black and white spots to create appealing puppy-suggestive patterns, this poster speaks less of the film that is and more of an elegant (and nonexistent) alternative.

ABOVE *One Hundred and One Dalmatians*, Clyde Geronimi, Hamilton Luske, 1961. POSTER USA This film is characterized by animated slapstick, mostly at the expense of the duo of crooks Jasper and Horace Badun. This poster reflects the tenor of the film, as well as illustrating the crowd of puppies that surge through the scenes.

RIGHT *Lady and the Tramp* (*La Belle et le clochard*), Clyde Geronimi, Wilfred Jackson, 1955. POSTER France French audiences are wooed by the promise of all-singing, all-dancing dogs. This image fully reflects the sentimentality of the film, a quality that drew critical bile and public adoration in equal measure.

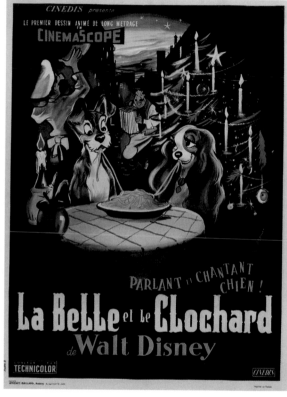

to fill a whole screen. The result is a film that, despite its bold graphic style, suffers from comparison with its forebears. The posters for Disney films tend to echo their style of animation. Those for the earlier films such as *Pinocchio* are drawn in a rich and elegant style, while later films are promoted in a much flatter fashion. Reflecting the globalization of the brand, there is little variation among the posters used to advertise Disney films internationally. The glorious Polish design for *One Hundred and One Dalmatians* shown opposite is one of the very few exceptions to this rule.

In the 1960s and 1970s Disney animated features went through a stagnant period (with some notable exceptions such as the 1967 movie *The Jungle Book*, more a musical than an artistic triumph). Things began to improve in the 1980s as new technologies facilitated animated effects that helped compensate for the loss of the handmade. In particular *The Little Mermaid* (1989) was a landmark in the revival of the animated feature.

A series of big box-office earners followed, including *Beauty and the Beast* (1991) and *The Lion King* (1994). Using sophisticated computer animation, these afforded spectacular vistas, satisfying detail, and heart-thumping action sequences, all at once. In 1995 Disney teamed up with the ground-breaking 3-D computer animation studio Pixar to make *Toy Story*, following up with other successes such as *A Bug's Life* (1998) and *Monsters, Inc.* (2002). Matching technological developments with child-friendly tales, Disney has maintained its pre-eminence in animated features for more than 60 years.

1950s Horror

The horror movies of the 1950s are often associated with Cold War chills, tales of beasts, aliens, and mutants cast as parables of the Communist threat. This theory has obvious relevance regarding the 1953 production of H.G. Wells's *The War of the Worlds*. Written in 1898, Wells's novel is now viewed by some as a colonialist fable. Adapted for radio in 1938 by Orson Welles, the broadcast derived its celebrated power (many listeners believed it to be a real report of an alien attack) from the jitteriness inspired by political instability in Europe. Committed to film 15 years later, Wells's London-based story was moved to postwar rural America

and became a tale of threat to a cherished way of life. The image advertising George Pal's 1953 production shows a tripod claw reaching to seize a healthy all-American couple. The pair take on an Adam and Eve aspect, and by implication America is cast as the Garden of Eden. The picture of wholesome America under alien threat is common to several other horror movies, such as *It Came From Outer Space* (Jack Arnold, 1953).

Applying the Cold War analogy to other 1950s horror films is less successful. *Attack of the 50 Ft. Woman* is a famously absurd tale of a woman who achieves gianthood after an encounter with an alien and takes large-scale revenge on her philandering husband. *Creature from the Black Lagoon* is a relatively sympathetic 3D tale of a monster that would rather be left alone. Those who insist on a subtext might do better referring to gender relations and early environmentalist impulses than to Cold War fears. But more than anything, these films reflected the need to attract a younger, weekend audience away from their television-watching parents and into the cinemas.

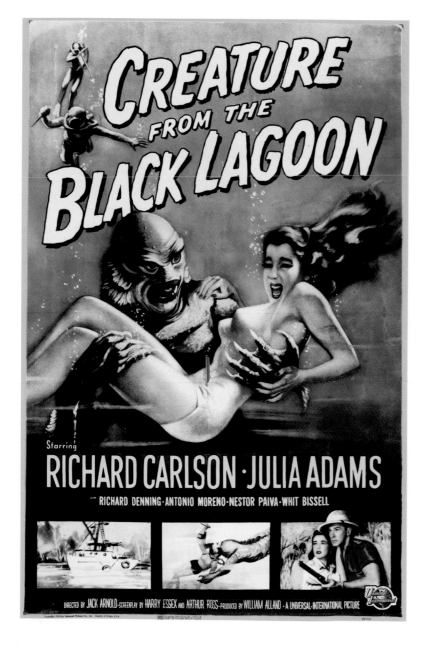

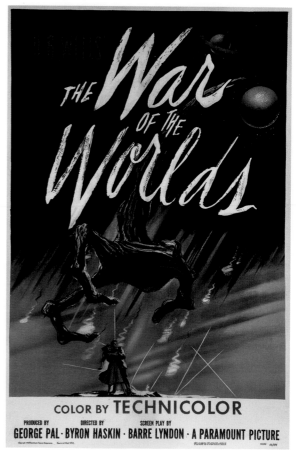

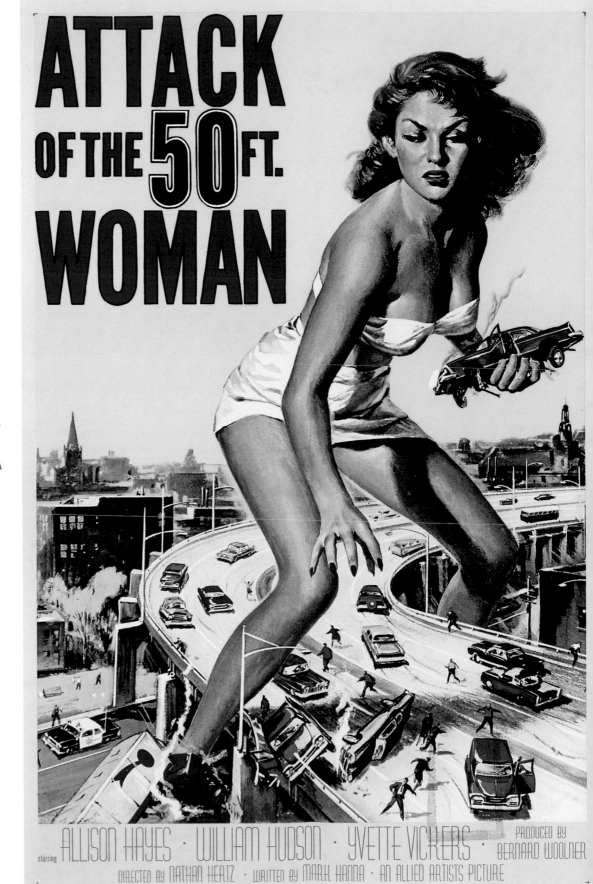

FAR LEFT *Creature from the Black Lagoon*, **Jack Arnold, 1954. POSTER Reynolds Brown, USA** This poster exemplifies Brown's ability to portray horrifying creatures. Here he shows the monster gripping the pyramid-breasted Julia Adams with surprising tenderness.

LEFT *H.G. Wells' The War of the Worlds*, **George Pal, 1953. POSTER USA** Pausing only to scrawl the title of the film in the night sky, the claw-handed alien flies from Mars to home in on the all-American couple. This image is a perfect summary of the film's plot.

RIGHT *Attack of the 50 Ft. Woman*, **Nathan Juran, 1958. POSTER Reynolds Brown, USA** The illustrator Reynolds Brown specialized in creating posters for horror movies. This image is now considerably better known than the film it advertised.

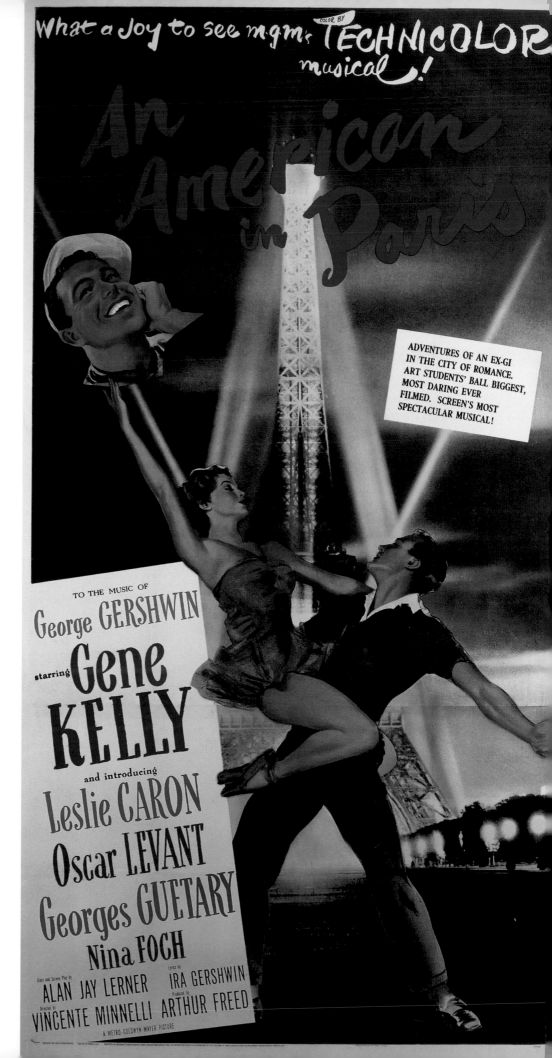

RIGHT *An American in Paris*, **Vincente Minnelli, 1951.** POSTER USA The upward V created by the pose of dancers Gene Kelly and Leslie Caron contrasts with the downward V of Paris's best-known landmark, the Eiffel Tower. As the image suggests, Kelly and Caron spend the movie cavorting across a delightfully clichéd European cityscape.

MIDDLE *Singin' in the Rain*, **Stanley Donen, Gene Kelly, 1952.** POSTER USA The best-known sequence from this film is Gene Kelly's umbrella-waving dance solo. This image is derived from that scene, pulling in pictures of the other stars to enhance publicity value.

FAR RIGHT *Gigi*, **Vincente Minnelli, 1958.** POSTER USA This poster uses Leslie Caron's head as the dot of the first "i" in the name of the movie's eponymous heroine. This very unusual logo was widely used throughout the Gigi publicity.

Musicals

The musical genre peaked in the late 1920s and early 1930s, when the studios were attempting to overcome the language barrier created by the introduction of sound. Films from this era include *42nd Street* (1933) and *Top Hat* (1935); the unchallenged king and queen of pre-war musical cinema were Fred Astaire and Ginger Rogers. The popularity of musicals waned during the war, but the genre experienced a revival in the early 1950s. Fred Astaire continued to tip-tap across screens, joined by a new generation of musical actors including Gene Kelly, Frank Sinatra, Leslie Caron, Cyd Charisse, and Debbie Reynolds.

The essence of the 1950s musical is pure escapism. In *An American in Paris*, Kelly plays an aspiring painter who dances in and out of artworks, landscapes only slightly more fantastical than the film's version of the French capital. A highly revised Paris is also the setting of *Gigi*, a film best remembered for Maurice Chevalier's rendition of "Thank Heaven for Little Girls". *Singin' in the Rain* takes a nostalgic look at the history of the musical film, building a story around the transition from silence to song in the late 1920s. As the poster suggests, this plot became a pretext for a wholesome all-American tale.

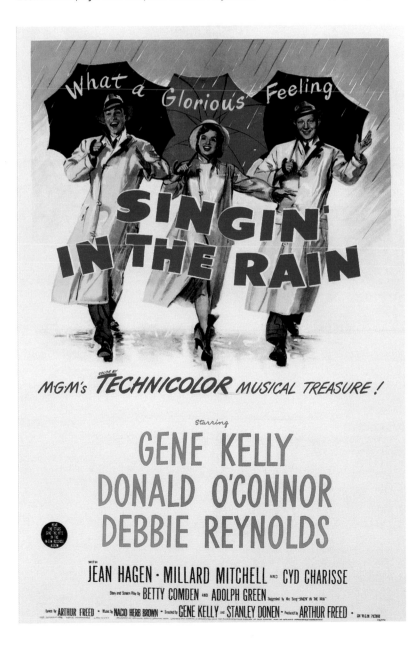

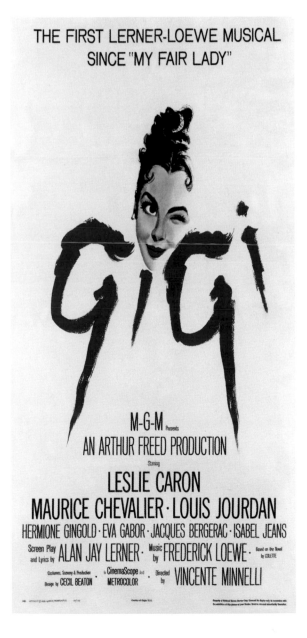

Casablanca

Casablanca is among the most celebrated romantic movies of all time. Set in Morocco during the Second World War, it was filmed on the Warner Brothers lot against a background of fake minarets and with a host of extras dressed as Arabs. The film's reference to exotic climes was a significant element of its early success.

Although located in a specific time and place, the love triangle at the heart of *Casablanca* is an essential, time-transcending tale. The Ingrid Bergman character's choice between passion and duty is one faced by stage and screen goddesses time and time again. Throughout shooting, the entire cast, including the principals, was kept ignorant as to the film's denouement. This state of affairs allowed Bergman and Bogart to act with a convincing ambiguity that has seduced audiences ever since.

According to the designer of the American campaign for *Casablanca*, Bill Gold, movie poster design was once seen as "the dregs" of advertising. Starting out in the late 1930s, Gold worked in film promotion for more than 50 years and created some of cinema's most memorable images. The poster shown here exemplifies his elevation of poster design to something approaching an art.

RIGHT *Casablanca*, Michael Curtiz, **1942.** POSTER Silvano Campeggi, Italy
Casablanca was not released in Italy until well after the war. In an interview Bergman remarked that the restrained elegance of her wardrobe prevented the film from appearing dated. This poster plays up the Arabian theme with decorative type and a background of minarets.

RIGHT *Casablanca*, **Michael Curtiz, 1942.** POSTER Bill Gold, 1941, USA
Although a famous image, this poster is now very rare, with only three copies known to exist. Although Gold concentrates on the Bogart/Bergman romance, he uses a series of portraits to create a broader sense of plot.

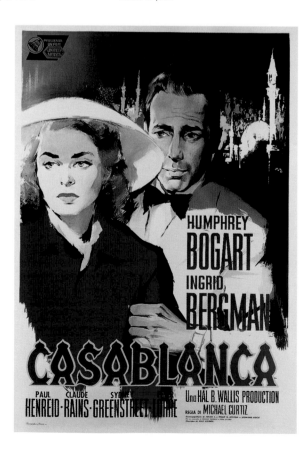

Citizen Kane

When Orson Welles made *Citizen Kane* he was a 25-year-old prodigy, imported from New York theatre by the RKO studio to attempt to revive its fading fortunes. Often cited as the greatest film ever made, *Citizen Kane* made its mark on the movie canon, but fate conspired against its becoming the popular success on which RKO had banked.

Written by Herman Mankiewicz and Welles himself, *Citizen Kane* was the thinly disguised life story of newspaper magnate William Randolph Hearst. Hearst's lawyers obtained the script during shooting and were able to all but stifle the film's distribution. Although it was well received by contemporary critics, potential audiences had grown wary of the surrounding controversy. Some posters carried the line "Everybody's talking about it", which, although true, turned out to be no advertisement.

Reissued in the 1950s, *Citizen Kane* became popular in art-house cinemas and was taken up by film theorists. French critic André Bazin regarded it as a model of narrative cinema; proponents of the *auteur* theory saw it as the epitome of authorial film. *Citizen Kane*'s appeal as a vehicle for interpretation is summed up by the debate surrounding the dying utterance of its eponymous hero. While some regard "rosebud" as the key to the whole plot, others view the word as an irrelevance.

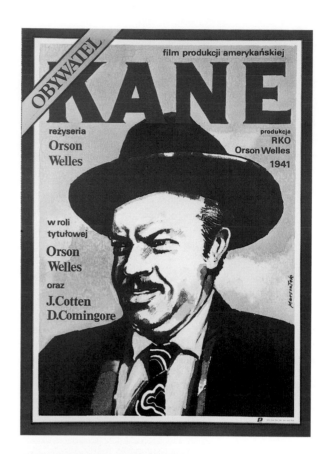

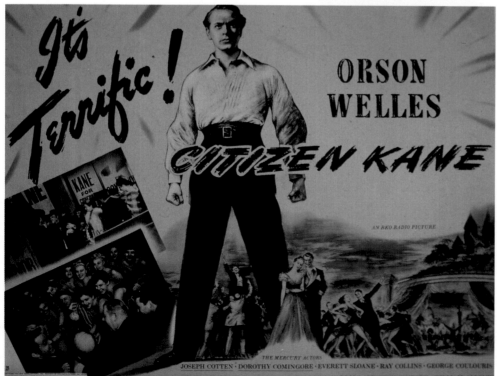

ABOVE *Citizen Kane* (*Obywatel Kane*), Orson Welles, 1941. POSTER Grzegorz Marszalek, Poland Advertising a 1980s re-release, this poster apes the cover style of the mass-market American news magazine *Time*. The image portrays a doughty middle-aged Kane, while the credits of the film pose as cover lines.

LEFT *Citizen Kane*, Orson Welles, 1941. POSTER USA The major US cinema-advertising agency was owned by an affiliate of Hearst, and RKO had difficulty in creating an advertising campaign for the film in America. Here Welles appears as the young Kane, dressed in evening clothes and squared for a fight.

RIGHT *Citizen Kane* (*Quarto Potere*), Orson Welles, 1941. POSTER Italy The Italian title means "Fourth Estate", or the press, which is traditionally regarded as the fourth power, after the aristocracy, the clergy, and the bourgeoisie. In this poster the well-dressed Kane preaches social justice to an indifferent crowd.

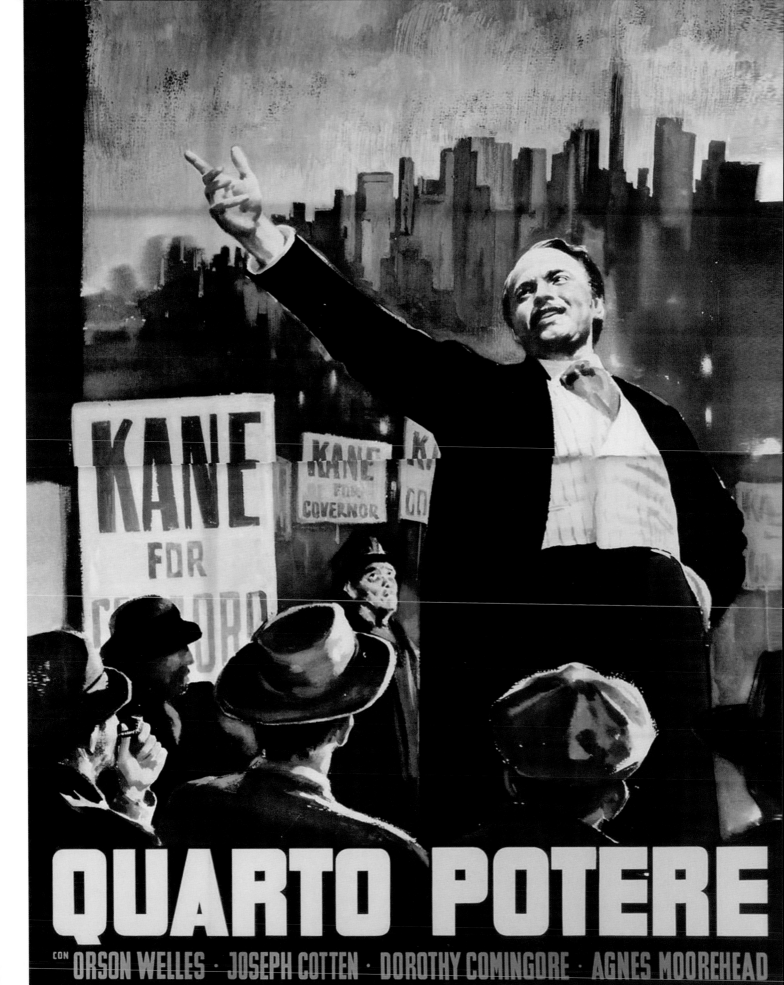

FAR RIGHT *Psycho*, **Alfred Hitchcock, 1960.**
POSTER UK Movie audiences of the 1960s
tended to be much less punctual than those
of today. Hitchcock's stern instructions were
unusual and proved an effective means of
building audience anticipation.

RIGHT *Vertigo*, **Alfred Hitchcock, 1958.**
POSTER Saul Bass, USA Saul Bass's title
sequence for *Vertigo* sets the tone of the tale
by plunging the viewer through a whirling
vortex and into the eye of the female lead.
This poster shows the hero and heroine
trapped in the same geometric device.

BELOW *Spellbound*, **Alfred Hitchcock,**
1945. POSTER USA A tale of insanity and
romance, *Spellbound* includes a memorable
dreamscape designed by Salvador Dali.
Rather than using a Dali motif, this poster
shows Ingrid Bergman clutched in a
threatening embrace.

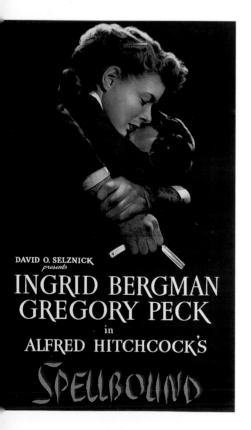

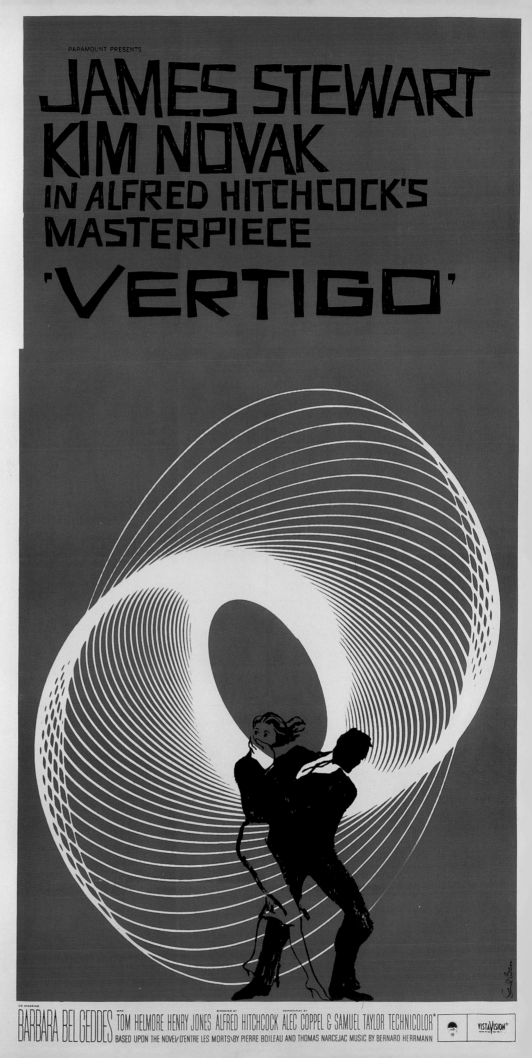

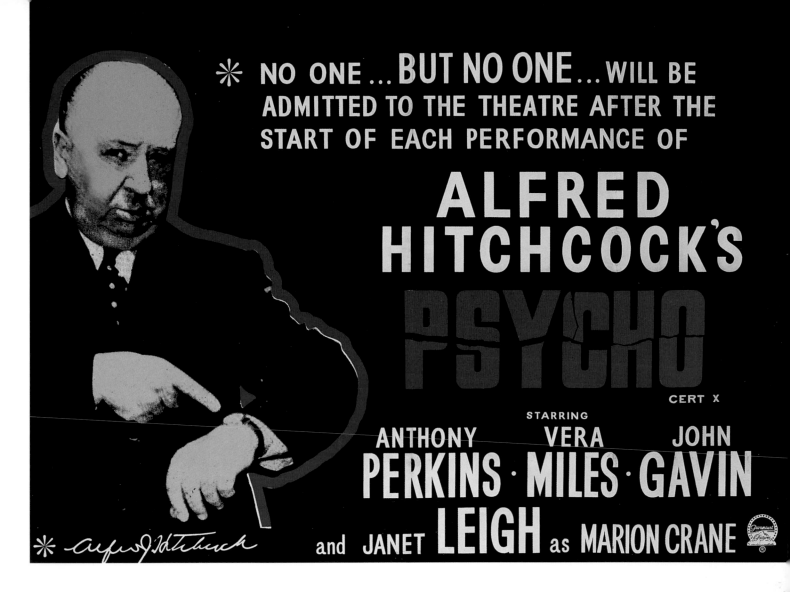

Alfred Hitchcock

Alfred Hitchcock (1899–1980) entered the movie industry as a designer of title cards, and moved swiftly to writing film scenarios and art directing. His directorial début, *The Pleasure Garden* (1925), although of little long-standing interest, won the admiration of critics and gained him a reputation as a reliable director. In the mid-1920s Hitchcock was asked to work in the United States, but he remained in Britain until the late 1930s. The best known of his movies from this time is the seminal 1935 thriller *The 39 Steps*. Hitchcock's signature style involves a combination of cinematic techniques such as harsh contrasts between light and shadow, complex camera movements, and skilled editing. He is also known for certain plot elements, including disappearance and mistaken identity.

Hitchcock's first American production was the dramatization of Daphne du Maurier's novel *Rebecca* (1940).

Made for the producer David O. Selznick, the film is effective and chilling despite being born of a power struggle between director and producer. After fulfilling his contractual obligations to Selznick, Hitchcock spent the rest of his career seeking out relationships with studios that gave him a high degree of autonomy. He bolstered this campaign for independence with his talent for self-promotion. As well as making cameo appearances in his films, he had a strong presence on his posters and marketing material. This led to a high recognition factor that later allowed him to diversify into television and publishing.

Hitchcock's origins in art direction often prompt the suggestion that he was particularly sensitive to matters of design. The theory is borne out by his films, many of which make effective use of architecture and interiors, but less so by his marketing material. Selections of Hitchcock posters

tend to be a mixed bag: some elegant and innovative (such as those by designer Saul Bass), others cheap and gimmicky. Common to all Hitchcock promotions is a direct appeal to the audience. Sometimes using images and at other times text, Hitchcock's means of addressing the viewer was always gutsy and unequivocal.

Reaching the height of popularity with *Psycho* (1960), Hitchcock's star began to fade a couple of years later. Movies from this period include *The Birds* (1963) and *Marnie* (1964); both display a lack of sympathy for their female lead (Tippi Hedren) that left audiences uneasy. Neither film did well at the box office and they prompted a slow decline in Hitchcock's career as a cinema director.

RIGHT *North by Northwest*, **Alfred Hitchcock, 1959.** POSTER USA This image exists in full colour as well as in black and red. Creating a disjunction between the characters, the poster's nesting frame device neatly reflects the complexity, and often downright obscurity, of the movie's plot.

BELOW LEFT *The 39 Steps*, **Alfred Hitchcock, 1935.** POSTER UK Of all Hitchcock's British films, *The 39 Steps* is the only one whose publicity posters have survived. The high point of this image is the glorious three-dimensional typography.

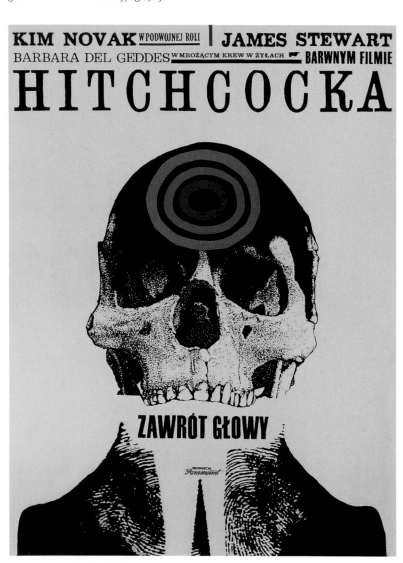

ABOVE *Vertigo (Zawrót Glowy)*, **Alfred Hitchcock, 1958.** POSTER Roman Cieslewicz, Poland Among the best known of Polish poster artists, Cieslewicz created a macabre image to advertise this film in 1963. The fingerprints around the neck refer to the theme of switched identity.

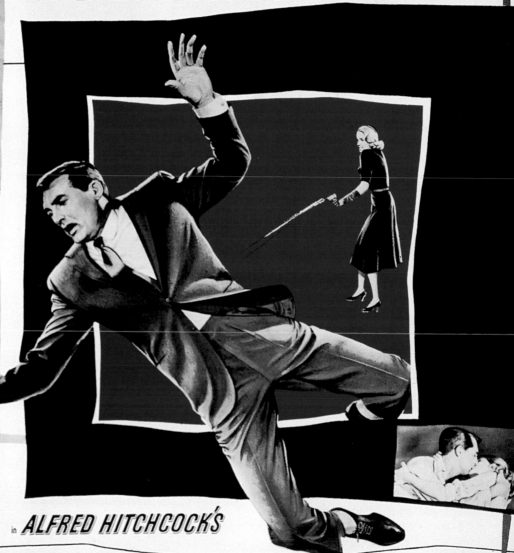

THE MASTER OF SUSPENSE WEAVES HIS GREATEST TALE!

M·G·M presents

CARY GRANT
EVA MARIE SAINT
JAMES MASON

in **ALFRED HITCHCOCK'S**

NORTH BY NORTHWEST

VISTAVISION
TECHNICOLOR®

Co-starring JESSIE ROYCE LANDIS
Written by **ERNEST LEHMAN** · Directed by **ALFRED HITCHCOCK**

AN M·G·M PICTURE

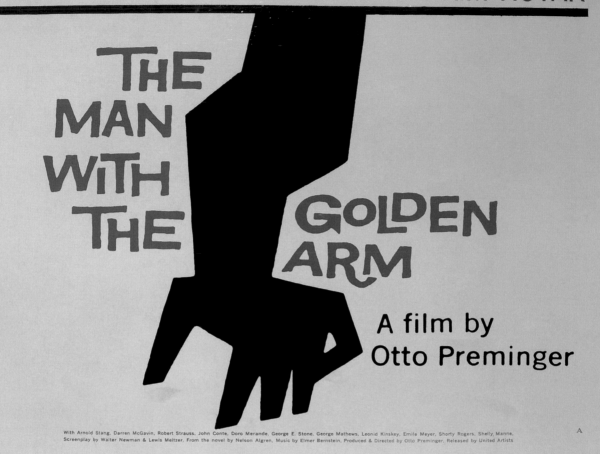

With Arnold Stang, Darren McGavin, Robert Strauss, John Conte, Doro Merande, George E. Stone, George Mathews, Leonid Kinskey, Emile Meyer, Shorty Rogers, Shelly, Manne, Screenplay by Walter Newman & Lewis Meltzer, From the novel by Nelson Algren, Music by Elmer Bernstein, Produced & Directed by Otto Preminger, Released by United Artists

Saul Bass

Saul Bass (1920–1996) attended Brooklyn College in the early 1940s, where he was taught by Gyorgy Kepes, the Hungarian-born author of the revolutionary graphic primer *The Language of Vision*. Like many Europeans, Kepes had fled to the United States during the build-up to the Second World War, and alongside other fellow émigré design visionaries such as Laszlo Moholy Nagy, he set about educating a generation of American designers using Bauhaus-related ideas and methods. Founded on clear-thinking, optimistic modernity, Kepes's teaching created a basis for Bass's work in both film and print.

Bass moved to Hollywood and began designing film publicity material. His entry to title design came through the independent producer/director Otto Preminger who, having used Bass to create posters and animated graphic identities, invited him to direct a complete animated title sequence for the film *The Man with the Golden Arm* in 1955. Bass continued to work with Preminger for several years, creating all-encompassing graphic identities for most of the director's best-known output. The posters he designed for Preminger are not free-standing images, but part of broader graphic campaigns, intended to function in a manner equivalent to that of corporate identities.

When developing identities for films, in each case Bass attempted to find a strong graphic symbol that would act as a summary of the plot. He maintained the modernist belief that it is possible to strip away layers of complexity and arrive at a single visual essence. In the case of *The Man with the Golden Arm* the twisted black arm is an expression of the central character's struggle

LEFT *The Man with the Golden Arm*, Otto Preminger, **1955.** POSTER Saul Bass, USA Bass designed a number of different posters for this film. Some of them include images of the well-known stars Frank Sinatra and Kim Novak, while others, such as this version, focus on his jagged arm symbol.

BELOW *West Side Story*, Jerome Robbins and Robert Wise, **1961.** POSTER Saul Bass, USA The film was based on a Broadway hit musical, and the poster reflects its relocation of the Romeo and Juliet story to the run-down tenement blocks of New York City.

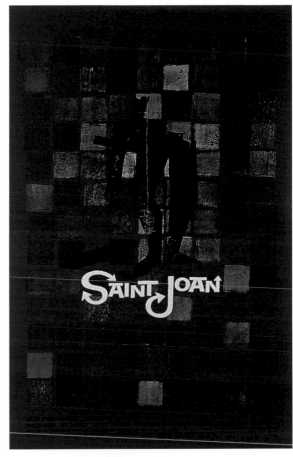

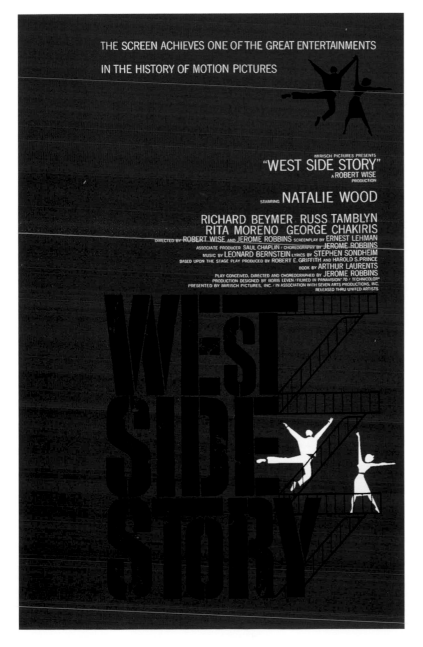

THE SCREEN ACHIEVES ONE OF THE GREAT ENTERTAINMENTS IN THE HISTORY OF MOTION PICTURES

MIRISCH PICTURES PRESENTS

"WEST SIDE STORY"
A ROBERT WISE
PRODUCTION

STARRING NATALIE WOOD

RICHARD BEYMER RUSS TAMBLYN
RITA MORENO GEORGE CHAKIRIS
DIRECTED BY ROBERT WISE AND JEROME ROBBINS SCREENPLAY BY ERNEST LEHMAN
ASSOCIATE PRODUCER SAUL CHAPLIN / CHOREOGRAPHY BY JEROME ROBBINS
MUSIC BY LEONARD BERNSTEIN LYRICS BY STEPHEN SONDHEIM
BASED UPON THE STAGE PLAY PRODUCED BY ROBERT E. GRIFFITH AND HAROLD S. PRINCE
BOOK BY ARTHUR LAURENTS
PLAY CONCEIVED, DIRECTED AND CHOREOGRAPHED BY JEROME ROBBINS
PRODUCTION DESIGNED BY BORIS LEVEN / FILMED IN PANAVISION® 70 / TECHNICOLOR®
PRESENTED BY MIRISCH PICTURES, INC. / IN ASSOCIATION WITH SEVEN ARTS PRODUCTIONS, INC.
RELEASED THRU UNITED ARTISTS.

ABOVE *Saint Joan*, Otto Preminger, **1957.** POSTER Saul Bass, USA A version of the illuminated initials that appear on medieval manuscripts, the *Saint Joan* symbol nonetheless has a distinctive late 1950s feel. The image of a torso, armoured but broken, anticipates the film's tragic end.

with drugs. In the title sequence to the film the arm juts down the screen to the rhythm of a dissonant jazz theme tune composed by Elmer Bernstein. These titles were quite unlike anything audiences had seen or heard before and Bass's arm, in both its still and its animated forms, became strongly associated with innovative film-making.

As well as working for Otto Preminger, Bass designed titles and posters for Alfred Hitchcock. Creating graphics for a number of Hitchcock's films, he developed the visual symbols most associated with the director's *oeuvre*, including the swirling geometric vortex of *Vertigo* (1958), the emphatic diagonal grid of *North by Northwest* (1959), and the cruel, jagged type of *Psycho* (1960). Bass also produced a substantial body of work for the director Billy Wilder, and it is no coincidence that Bass's major employers were three of the most outspoken producer/directors in the business. By taking Bass on board Preminger, Hitchcock and Wilder were, to use a more modern term, branding themselves and their output in a way that bolstered their position as independents. Bass's graphics encouraged cinema audiences to associate films with individual film-makers more strongly than ever before.

Near the end of his life Bass developed a new working relationship with the director Martin Scorsese. By commissioning Bass to design titles for *Cape Fear* (1991) and *The Age of Innocence* (1993), the director recognized the role that Bass's graphics played in what is now seen as a mid-century cinematic golden age.

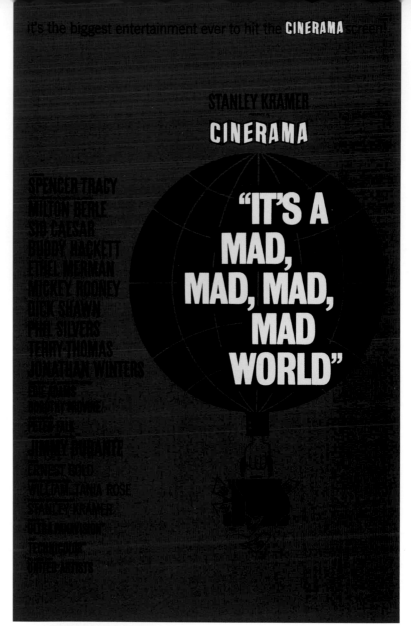

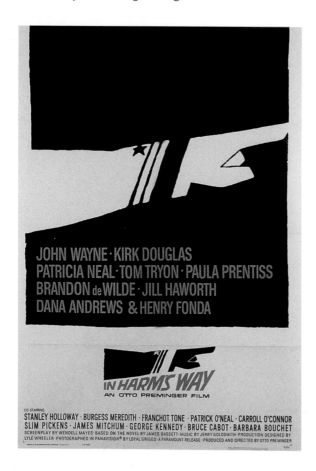

ABOVE *It's a Mad, Mad, Mad, Mad World*, **Stanley Kramer, 1963.** POSTER Saul Bass, USA Nearly three hours long and featuring a huge cast, this screwball comedy defied even Bass's ability to design a single effective motif. The balloon and bulging suitcase lack the communicative power of other Bass logos.

LEFT *In Harm's Way*, **Otto Preminger, 1965.** POSTER Saul Bass, USA The film is a Second World War naval drama: this schematic officer's arm is reminiscent of army recruitment posters from earlier in the century.

RIGHT *Anatomy of a Murder*, **Otto Preminger, 1959.** POSTER Saul Bass, USA Advertising a courtroom drama, this poster pictures a dismembered body evocative of the imprint of a corpse. During the titles of the film, the symbol appears on screen to the rhythm of a Duke Ellington jazz score.

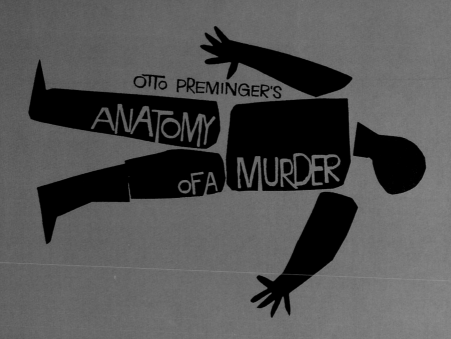

Last year's No. 1 best-seller...This year's No. 1 motion picture.

OTTO PREMINGER'S
ANATOMY
OF A MURDER

STARRING

JAMES STEWART

LEE REMICK

BEN GAZZARA

ARTHUR O'CONNELL

EVE ARDEN

KATHRYN GRANT

and JOSEPH N. WELCH as Judge Weaver

WITH GEORGE C. SCOTT/ORSON BEAN/RUSS BROWN/MURRAY HAMILTON/BROOKS WEST screenplay by WENDELL MAYES from the best-seller by ROBERT TRAVER photography by SAM LEAVITT produced & directed by OTTO PREMINGER/a Columbia release

▶ music by Duke Ellington ◀

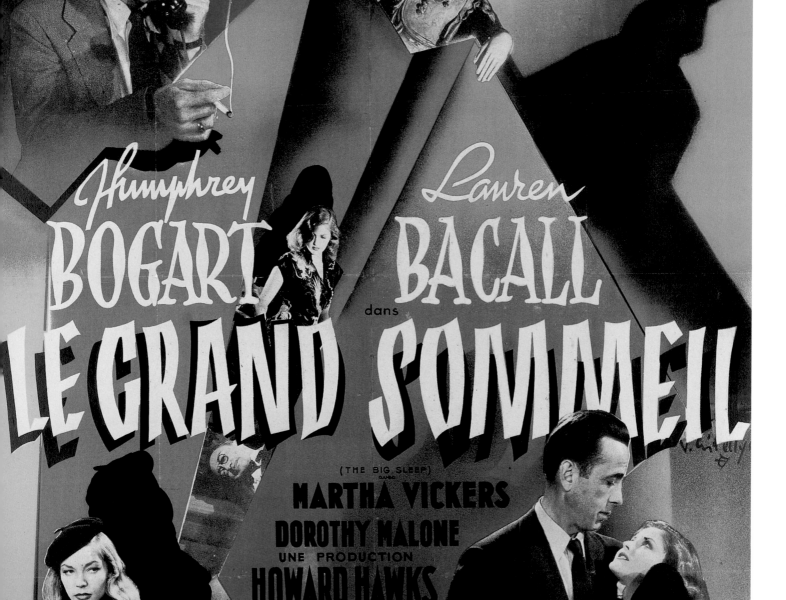

Howard Hawks

Working as a director for nearly 50 years, Howard Hawks (1896–1977) made more than 30 movies covering a variety of genres including comedy, *film noir*, and the western. Within Hollywood he was considered a skilful commercial film-maker, but in the 1950s French cine-philes took him up and recast him as an *auteur*, a director of significant independent artistic vision.

If there is one quality that sets Hawks apart from his fellow film-makers it is his concentration on the individual scene above the overall narrative framework. This is especially noticeable in *The Big Sleep*, a film that remains compelling despite being virtually incomprehensible. In posters for *The Big Sleep*, designers have largely bypassed plot to concentrate on the film's sultry atmosphere.

Another notable attribute was Hawks's ability to bring out the best in his cast. Directing many of Hollywood's greatest leading men, including Gary Cooper, Humphrey Bogart, and Cary Grant, he drew career-defining performances from each. Posters for Hawks's movies are generally character-led, reflecting his fervent populism: he was a director who wanted to make the kinds of films that studios wished to finance and audiences wanted to see.

FAR LEFT *The Big Sleep (Le Grand Sommeil)*, **Howard Hawks, 1946.** POSTER **Vincent Cristellys, France** Cristellys designed several posters for the French releases of American films. Here he addresses the tricky plot with a complex patchwork of photography and illustration.

BELOW *Gentlemen Prefer Blondes*, **Howard Hawks, 1953.** POSTER USA This high-stepping number provides a highly charged image in which long gloves emphasize bare legs and top hats exaggerate high heels.

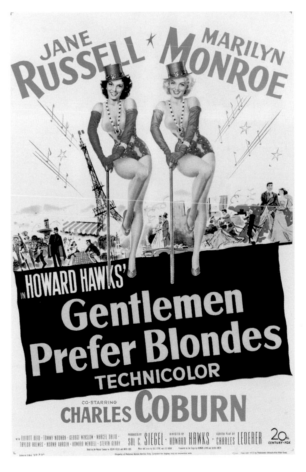

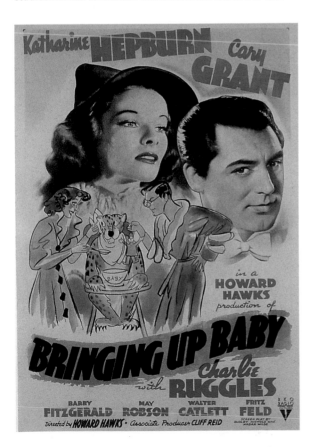

LEFT *Bringing Up Baby*, **Howard Hawks, 1948.** POSTER USA The studio RKO was known for its brash, populist posters. A compromise between the photographic and the illustrative, this design evokes both the beauty of the film's male and female leads and the screwball nature of its comedy.

Billy Wilder

Billy Wilder (1906–2002) was born in a part of the Austro-Hungarian Empire that is now Poland. He moved to Berlin and began to write for a living, first as a reporter and later as a scriptwriter for the UFA (Universum-Film Aktiengesellschaft). After his credit was removed from a film in 1933 he realized there was little future for a Jewish scriptwriter in Berlin and emigrated to Hollywood. In 1938 he teamed up with the writer Charles Brackett, with whom he scripted several significant films including *Ninotchka* (1939) and *Balls of Fire* (1941). As a writer, Wilder often resented the way in which directors treated his scripts. Once asked if it helped if a director could write, he replied, "No, but it helps if he knows how to read."

In the early 1940s Wilder was given the opportunity to direct, and among his first director/writer successes was the *film noir* classic *Double Indemnity* (1944). Until the late 1960s he produced a steady flow of movies, including comedies such as *Love in the Afternoon* (1957) and *The Apartment* (1960) and also darker fare, for example the thriller *Witness for the Prosecution* (1957). As a director his characteristic quality was his emphasis on the script. Wilder films are full of snappy dialogue.

Wilder began to amass a contemporary art and design collection which would become the basis of a substantial

FAR RIGHT *The Seven Year Itch* (*Slaměný Vdovec*), **Billy Wilder, 1955.** POSTER Czechoslovakia Whisky and cigarettes to the fore, this image reflects the seamier side of Wilder's film, an angle ignored in the mainstream publicity. The way in which Monroe's image is cropped renders her particularly vulnerable.

BELOW *The Seven Year Itch*, **Billy Wilder, 1955.** POSTER USA More than simply symbolizing the film, this pose has become the image most associated with Marilyn Monroe. But while the girl with the fluttering white skirt has become the timeless epitome of filmic sex appeal, the besuited man to her right remains an emblem of pure 1950s lechery.

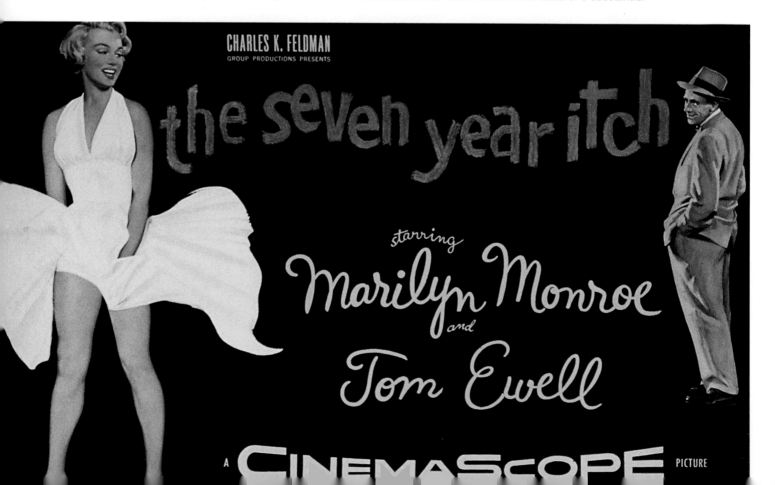

CHARLES K. FELDMAN
GROUP PRODUCTIONS PRESENTS

the seven year itch

starring

Marilyn Monroe

and

Tom Ewell

A CINEMASCOPE PICTURE

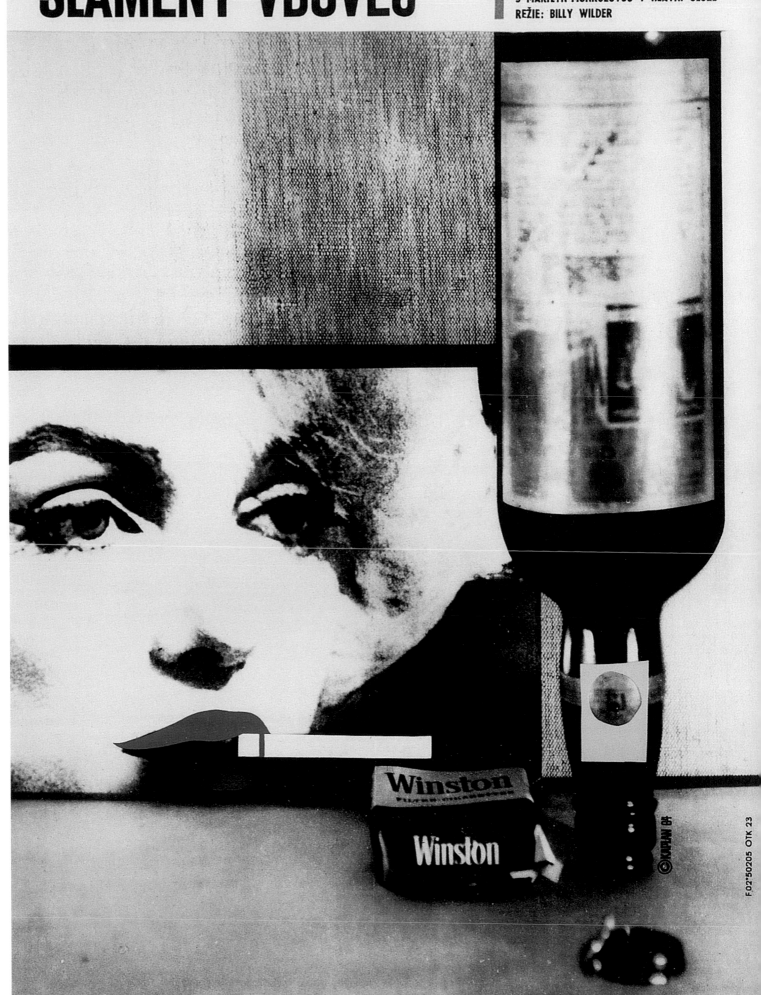

SLAMĚNÝ VDOVEC

AMERICKÁ FILMOVÁ KOMEDIE
S MARILYN MONROEOVOU V HLAVNÍ ÚLOZE
REŽIE: BILLY WILDER

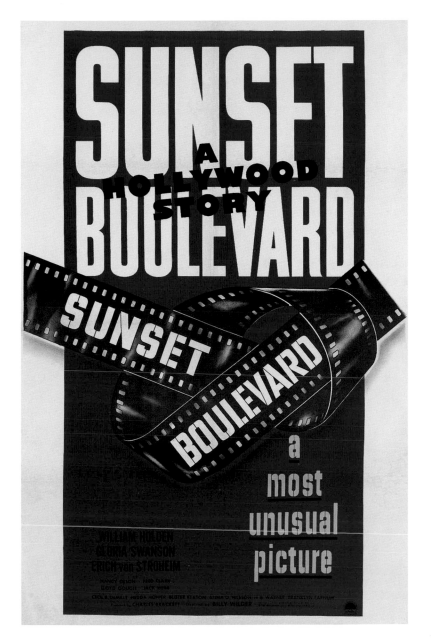

fortune. Among his wide circle of creative friends in Los Angeles was the designer duo Charles and Ray Eames, who in turn introduced him to the graphic designer Saul Bass. Quick to appreciate Bass's innovative approach to title design, Wilder engaged him to create the opening sequence to his 1955 film *The Seven Year Itch*. The result was a colourful animated patchwork that reveals the film titles in peek-a-boo fashion. Independently of these titles, the film's mainstream publicity campaign featured an illustration of the film's iconic scene: Marilyn Monroe with her full white skirt fluttering around her thighs as she luxuriates in a blast of cool air from a subway vent.

Wilder recognized the value of obvious filmic symbols such as the Monroe moment, but also expressed appreciation of the less obvious publicity devices used by Eastern European poster designers. It is likely that he would have approved of the Czech poster for *The Seven Year Itch* (p.61), in particular for the way it hints at tragedy in what is generally viewed as a purely comic movie. Possibly reflecting his own self-disgust, Wilder saw the male lead in *The Seven Year Itch* as an unappealing and exploitative character. In the Czech poster Monroe's vacant eyes and blood-red, cigarette-bearing mouth communicate a sense of abuse that is absent from the American or Western European publicity.

Wilder's sensitivity to matters of art and design left him depressed at the constraints applied to film marketing. According to Wilder, as the studio system ground to a halt in the late 1940s actors and even writers and producers began to stipulate contractually the size and order of appearance of their credit. Images too became a matter for legislation. All in all, Wilder argued, the appearance of the modern movie poster is virtually predetermined by the number of requirements placed on the design. A life-long champion of the work of Bass, he believed that there should be more room for artistic manoeuvre.

Audrey Hepburn

The musical *Funny Face* is based on the unlikely premise that the beauty of Audrey Hepburn (1929–1993) might be overlooked. Hepburn plays bookshop assistant and philosopher's groupie Jo Stockton, who requires discovery by Fred Astaire as fashion photographer Dick Avery. Hepburn's loveliness is revealed to Astaire through a process of photographic enlargement. Astaire/Avery papers his darkroom with images of her extraordinary eyes, allowing character and audience to share a moment of rapture.

Hepburn came to movie acting after training as a ballet dancer in London. She débuted in European film in the late 1940s but soon left for the United States, realizing that opportunities in postwar Europe were very limited. Playing opposite Gregory Peck in *Roman Holiday* (1953),

she won the immediate attention of American audiences. The movie concerns the adventures of a runaway princess and gave the actress the opportunity to fuse grace and naivety into an alloy of perfect charm. Hepburn spent the rest of her career playing variants on this role: all coltish charm and delicate, halting annunciation. Until her self-imposed semi-retirement in the late 1960s, her elegance and luminosity ensured that the formula never failed.

Hepburn's looks are so distinctive and seductive that the focus of almost all her film posters is a more or less schematized representation of her features. Her image is so well known that it can be represented with the fewest of sketchy lines – a quality shared only by her peer, and to some extent antithesis, Marilyn Monroe.

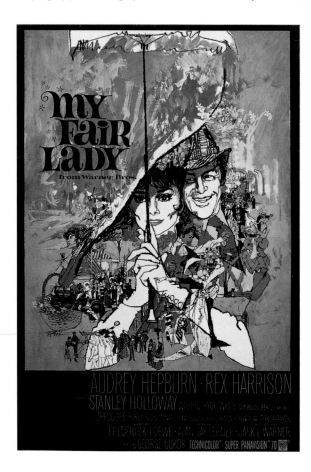

ABOVE *My Fair Lady*, George Cukor, 1964. POSTER Bob Peak, USA Typical of Peak's approach, this poster collages several scenes from the musical into a single image. While the setting of the film is supposedly late Victorian, the style of the poster is pure mid-1960s.

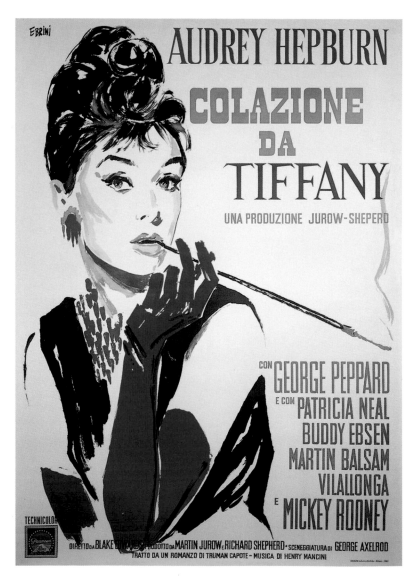

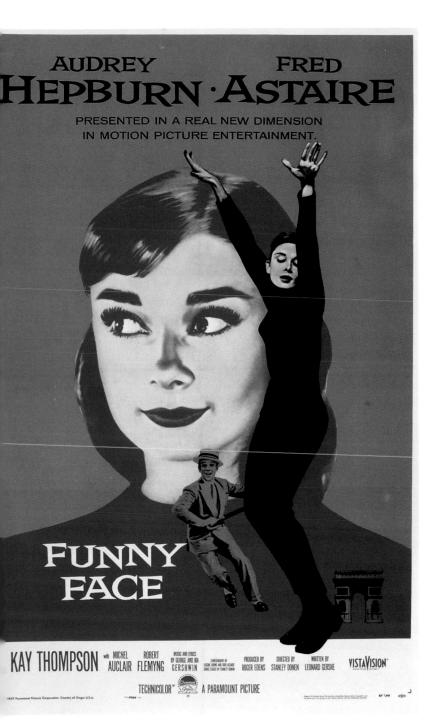

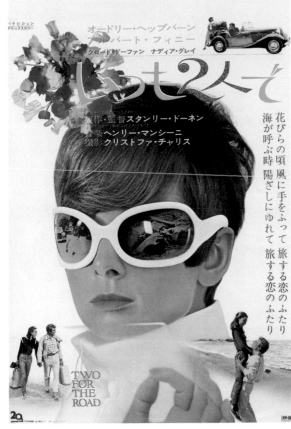

BELOW *Two For the Road*, Stanley Donen, **1967.** POSTER Japan This film uses the road trip as a metaphor for life's course and allows Hepburn to play across the years, from jaunty teen to jaded wife and mother. The main poster image offers a glimpse of Hepburn's potential as a mature actress.

LEFT *Breakfast at Tiffany's (Colazione da Tiffany)*. POSTER Ercole Brini, Italy Italian watercolour artists were well suited to the task of representing Hepburn. This poster emphasizes the contrast between the upward dash of the actress's eyeliner and the downward slope of her cigarette holder.

ABOVE *Funny Face*, Stanley Donen, **1957.** POSTER USA In this poster Hepburn's slicked-down fringe and side parting emphasize the gamine quality of her features: not so much a "funny face", but a distinct alternative to the over-blown movie godesses of the era.

James Dean

The face of James Dean (1931–1955) remains well known almost half a century after his death, a celebrity owed to the survival of his image in film posters and related material. Dean had a short but influential career. After studying acting in Los Angeles, he moved to New York where he joined the prestigious acting school The Actors' Studio. In 1954 a Warner Brothers agent offered him a screen test.

Dean's on-screen charisma was immediately clear. As Cal Trask in the adaptation of John Steinbeck's novel *East of Eden*, he created a lasting blueprint for masculine sensitivity. His next film, *Rebel Without a Cause*, was an account of middle-class rebellion. Although fairly harsh in assessing his character's shortcomings, Dean used the role of Jim Stark to create the very image of seductive disaffection. His third and last film was *Giant* (George Stevens, 1956). Co-starring Elizabeth Taylor, it allowed the actor partially to reprise his earlier parts as a troubled but good-hearted young man. Dean received Academy Award nominations for both his later performances.

On 30 September 1955, *en route* to a road race in his Porsche, James Dean was killed in a road accident. His co-star Natalie Wood paid tribute, saying: "All of us were touched by Jimmy, and he was touched by greatness."

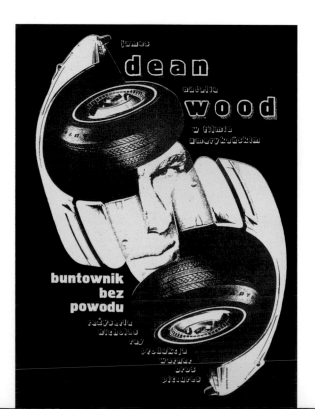

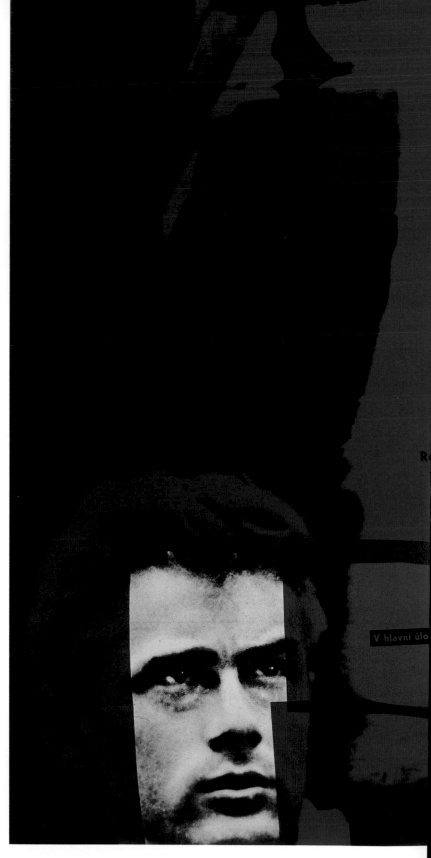

LEFT *Rebel Without a Cause* (*Buntownik Bez Powodu*), Nicholas Ray, 1955. POSTER Ryszard Kiwerski, Poland This poster was designed after Dean's death, and the strange collage of wheel and face probably refers not to the car-race scene in the film but to the actor's fatal accident.

ABOVE *East of Eden* (*Na Východ Od Ráje*), Elia Kazan, 1955. POSTER Czechoslovakia With its theme of right and wrong, this film has widespread appeal. Most Czech designs are illustrative and abstracted, but this one, from 1965, focuses on Dean's face, highlighting his knitted brows and pouting lips.

ohna Steinbecka
ovém zpracování
žiséra E. Kazana
Americký film

NA
VÝCHOD
OD
RÁJE

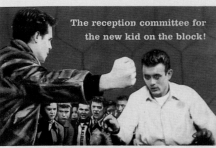

The reception committee for
the new kid on the block!

JAMES DEAN

The overnight sensation of 'East of Eden'

Warner Bros. put
all the force of
the screen
into a challenging
drama of today's
juvenile violence!

"REBEL WITHOUT A CAUSE"

IN CINEMASCOPE
AND WARNERCOLOR

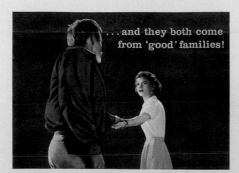

...and they both come
from 'good' families!

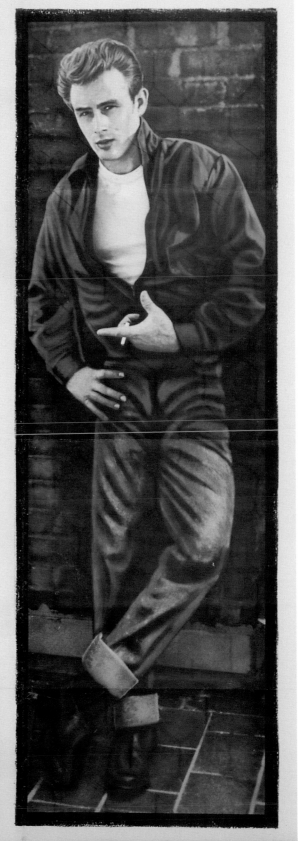

LEFT *French Cancan*, 1954. POSTER René Gruau, France Used as publicity for Renoir's story of the Moulin Rouge, Gruau's image is very close in style to the late 19th-century posters by Toulouse-Lautrec. Where Toulouse-Lautrec sold the real thing, Gruau promotes a fiction.

Jean Renoir

The son of the painter Auguste Renoir, Jean Renoir (1894–1979) worked for a short period as a ceramicist before setting up a production company in 1924. Renoir's early influences were the French and German avant-gardes and, in keeping with the mores of Expressionism, his first films were decidedly anti-naturalistic. Later Renoir became concerned with social and political issues and this encouraged him to adopt a more spontaneous mode of film-making. Commenting on the hypocrisy of contemporary life in a series of bleak films including *La Chienne* (1931) and *La Règle du jeu* (1939), by the mid-1930s he was known as the master of "poetic realism".

Renoir came to international attention in 1937 with his anti-war film *La Grande Illusion*. The film was an unflinching portrayal of the First World War's toll on human life. The image used to advertise the 1945 re-release of *La Grande Illusion* shows the dehumanized soldier: a hulking dark shadow who keeps his conscience, symbolized by the white bird of peace, prisoner inside his breast. Created by the French illustrator Bernard Lancy, this poster shows the long-standing commercial impact of the artistic experiments of Cubism and Futurism.

After spending the 1940s and early 1950s in Hollywood, Renoir returned to Paris to make *French Cancan*. The film recounts the founding of the Moulin Rouge cabaret, a true story set in Renoir's home, Montmartre, 15 years or so before his birth. *French Cancan* is gloriously colourful but not sentimental, revealing in particular the less than savoury attributes of the Moulin Rouge's impresario Danglard.

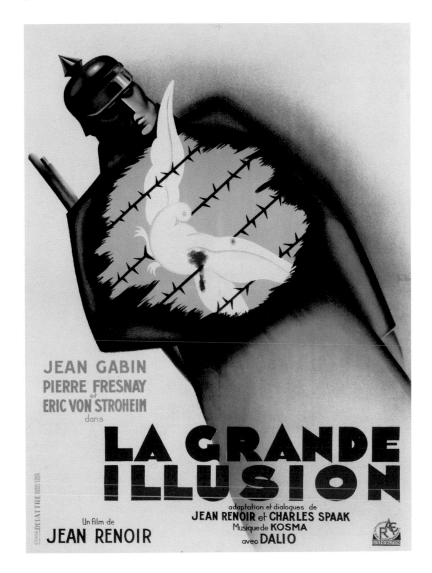

ABOVE *La Grande Illusion*, 1937. POSTER Bernard Lancy, France The French artist Lancy created posters for a number of domestic and imported films. In this advertisement for the 1945 re-release of Renoir's movie he uses an Art Deco style to create a poignant metaphor for its anti-war theme.

Ealing Comedies

Located in West London and opened in 1931, Ealing Studios boasted Britain's first purpose-built sound stage. An important centre of British film-making from the start, in 1938 it came under the auspices of producer Michael Balcon, who spent the next 17 years guiding what is now thought of as a golden period of British film. According to Balcon, the studios' productions were "comedies about ordinary people with the stray eccentrics amongst them; films about daydreamers, mild anarchists, little men who long to kick the boss in the teeth". In 1944 Balcon signed a deal with Rank, but despite commercial ties he retained artistic autonomy. Ealing's best productions, such as *Passport to Pimlico*, a tale of plucky city-dwellers, provided a lasting blueprint for indigenous British film.

RIGHT *Pink String and Sealing Wax*, **Robert Hamer, 1954.** POSTER John Minton, UK Using a collage of photograph and illustration, the poster hints at covert unpleasantness lurking behind Brighton's decorative façades. Minton is well known for his book illustrations.

BELOW *Whisky Galore!*, **Alexander Mackendrick, 1949.** POSTER Thomas Eckersley, UK In his typically gentle style, Eckersley summarizes the film's plot with a giant whisky bottle casting a huge shadow over the Outer Hebridean island of Barra.

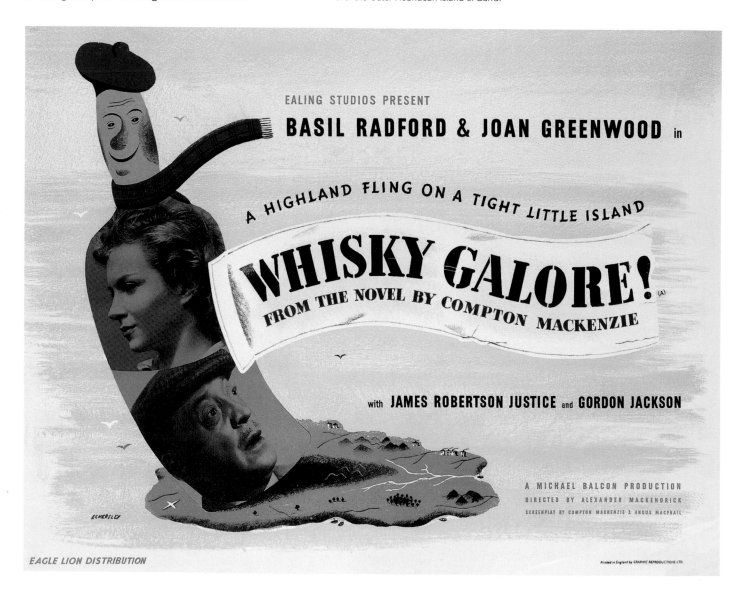

EAGLE LION DISTRIBUTION

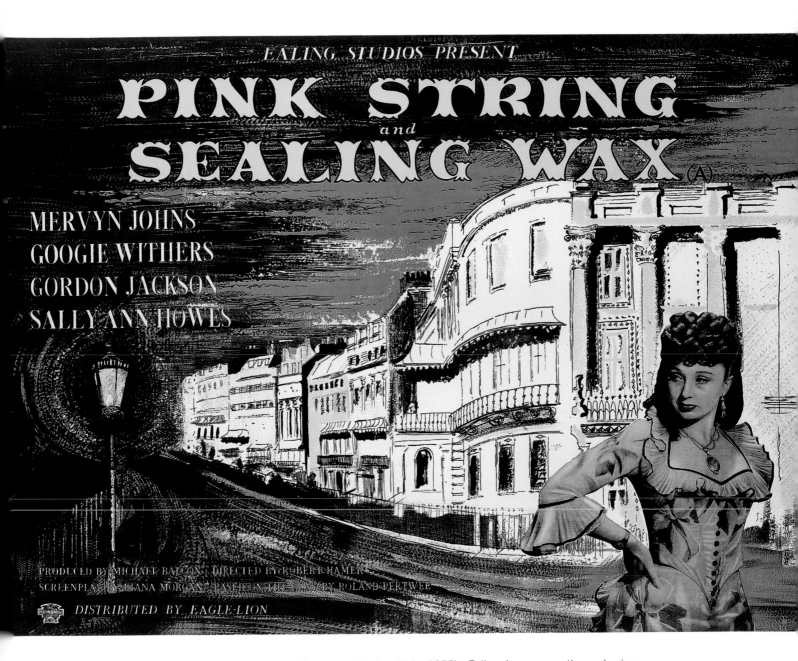

EALING STUDIOS PRESENT

PINK STRING and SEALING WAX (A)

MERVYN JOHNS
GOOGIE WITHERS
GORDON JACKSON
SALLY ANN HOWES

PRODUCED BY MICHAEL BALCON · DIRECTED BY ROBERT HAMER
SCREENPLAY BY DIANA MORGAN · BASED ON THE PLAY BY ROLAND PERTWEE

DISTRIBUTED BY EAGLE-LION

Many Ealing productions were concerned with the effects of the Second World War and its aftermath. Between 1939 and 1945 Ealing tailored its films to project a positive view of a resilient and resourceful people, but after 1945 the message became a bit more subtle and it was then that the Ealing comedies really got into their stride. Although films such as *Whisky Galore!* and *The Lavender Hill Mob* have a period charm, they are never more than a hair's breadth from the dangerous and disturbing. Other notably dark Ealing comedies include *Kind Hearts and Coronets* (Robert Hamer, 1949) and *The Ladykillers* (Alexander Mackendrick, 1955). Ealing heroes are thoroughgoing nonconformists, they flout authority in pursuit of their ends, and often they display an uncaring single-mindedness. As well as comedic realism, Ealing produced costumed escapism. Produced just after the war, *Pink String and Ceiling Wax* told a melodramatic tale of murder and adultery set in Victorian Brighton.

Ealing Studios had strong ties to Britain's broader cultural life. Balcon's casts represented the cream of British acting talent, including Alec Guinness, Peter Sellers, and Joan Greenwood, many of whom pursued

FRENCH GOINGS-ON
IN THE HEART OF
LONDON

STANLEY HOLLOWAY
HERMIONE BADDELEY
MARGARET RUTHERFORD
PAUL DUPUIS

RAYM

and

BAS

Ealing Studios present

PASSPORT
to PIML

A MICHAEL BALCON PRODUCTION DIRECTED BY HENRY CORNELIUS ORIGINAL SCREE

Printed in England by GRAPHIC REPRODUCTIONS,LTD

UNTLEY JOHN SLATER JANE HYLTON
BETTY WARREN BARBARA MURRAY

DFORD & NAUNTON WAYNE

T. E. B. CLARKE

S John Woods '49

LEFT *Passport to Pimlico*, Henry Cornelius, 1949. POSTER S. John Woods, UK
To illustrate this tale of indomitable British spirit, this poster shows a series of "national characters": the cheeky chappie, the outraged gent, the narrow-minded bureaucrat, and the soft-hearted beauty.

BELOW *The Lavender Hill Mob*, Charles Crichton, 1951. POSTER Ronald Searle, UK
Searle worked as a cartoonist from his late teens. In the background here is a range of characteristic Searle figures, including a band of unruly schoolgirls closely related to his famous St Trinian's mob.

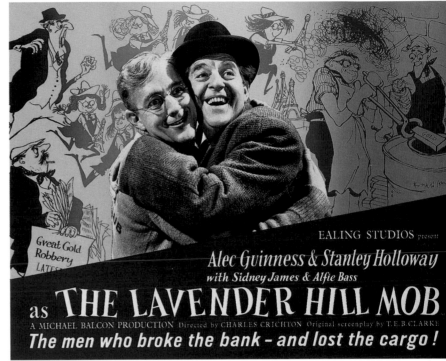

Great Gold Robbery LATE

EALING STUDIOS present
Alec Guinness & Stanley Holloway
with Sidney James & Alfie Bass
as THE LAVENDER HILL MOB
A MICHAEL BALCON PRODUCTION Directed by CHARLES CRICHTON Original screenplay by T.E.B. CLARKE
The men who broke the bank – and lost the cargo!

theatrical careers alongside their film work. Similarly the music for Ealing films was written and produced by the best contemporary composers and musicians, including Ralph Vaughan Williams and George Auric. Extending links beyond performance, Balcon also commissioned prominent artists and designers to create the publicity for his productions. The list of those involved in designing Ealing posters reads as a roll-call of significant influences on mid-20th-century British illustration and graphic design, including John Minton, Thomas Eckersley, and Ronald Searle.

There is a sense of family about Ealing productions. Actors appear in different configurations in film after film, and over time the studios developed a repertoire of recognizable characters. This on-screen continuity was reflected in the state of affairs behind the camera. Alongside Balcon, a large proportion of the backstage crew lasted the full 17 years, working to produce Ealing's five or six features a year. But all this was to come to an end in the mid-1950s. In spite of their success the studios could not withstand the twin pressures of television and Hollywood blockbusters; in 1955 Ealing's assets were sold to the BBC and an era drew to a close.

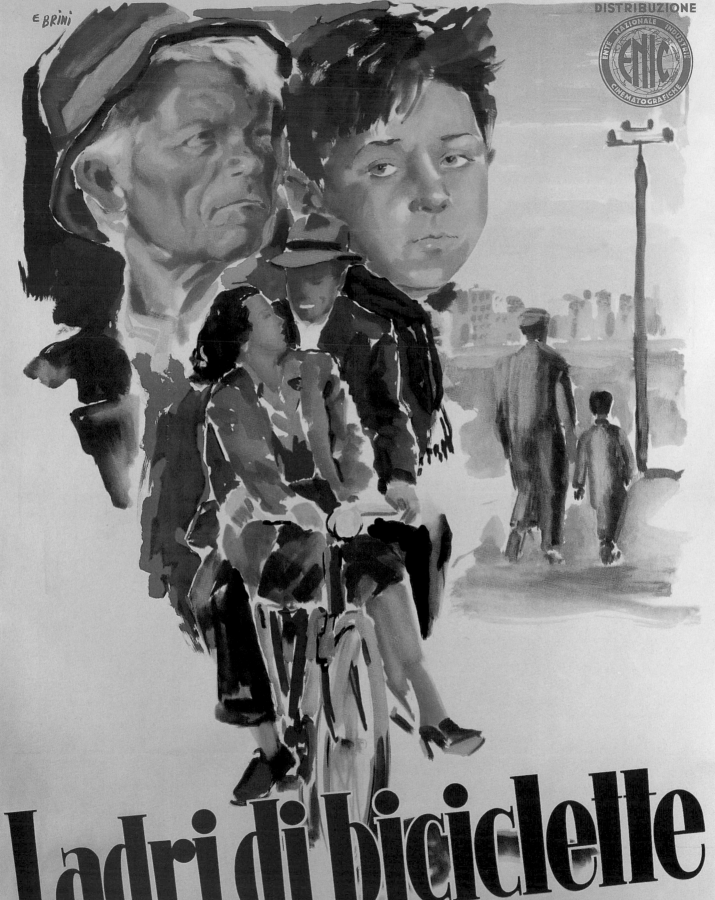

Italian Watercolour Posters

From the earliest days of cinema until the graphic revolutions of the 1960s, Italian film advertising centred on the watercolour poster. In the 1940s and 1950s domestic and imported films were promoted with elaborate paintings, of which there were often several versions for one film. The best-known poster artists are Anselmo Ballester, Ercole Brini, and Giorgio Olivetti. After the war some Italian artists moved to Hollywood and there is evidence of the Italian style being adopted in the United States.

Hitchcock's *Notorious* was released in Italy in the early 1950s, several years after its American run. Many of the Italian campaigns for the film concentrated on Ingrid Bergman, who had become popular in the country after her appearance in *Casablanca* and through the news of her affair with Italian director Roberto Rossellini. Even in a country where watercolour movie posters were the norm, Giorgio Olivetti's full-length portrait is a very unusual form of promotion. Portraying Bergman in a fitting draped silk dress and clutching a gold-chained key (a vital prop in the film), it is less a straightforward advertisement for a movie than a homage to the screen goddess.

Ercole Brini's poster for *Ladri di biciclette* (*Bicycle Thieves*) is more in keeping with the standard watercolour format. Using a characteristically loose painting style, he created a montage of characters and key scenes from the film. Brini's painting is true to the character of Vittorio De Sica's quietly tragic, realist film. He manages to portray working people with a dignity that avoids tipping into sentimentality, arriving at a balance akin to that achieved by the movie's director. To latter-day eyes Brini's *Ladri di biciclette* poster looks like an unlikely advertisement for a social-realist film. These days films about working-class life are almost exclusively advertised with gritty black-and-white photography. Also dealing with gritty

LEFT *Ladri di biciclette*, Vittorio De Sica, **1948.** POSTER Ercole Brini, Italy One of Italy's most famous poster designers, Ercole Brini usually worked in watercolours. This image is one of several fairly similar Brini paintings used to advertise the film.

RIGHT *Notorious*, Alfred Hitchcock, 1946. POSTER Giorgio Olivetti, Italy Utterly unlike the US publicity for the film, this poster ignores the male stars of the film to concentrate solely on Bergman. The appearance of the actress's name above the title was not the standard order of billing.

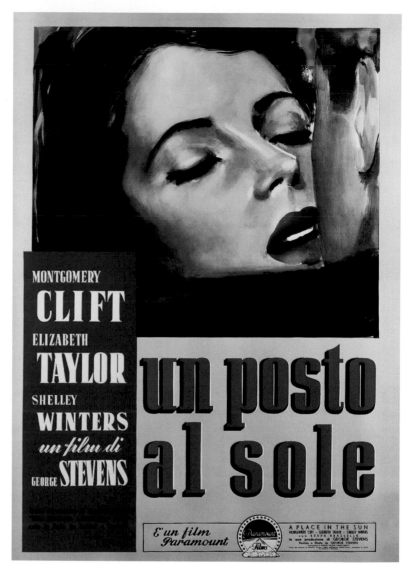

reality, though of an American rather than an Italian variety, is the movie *Tortilla Flat*. This filmed version of the John Steinbeck novel was released in Italy in the early 1950s under the title *Gente Allegra* – something akin to "Happy People". The story is about a bunch of hedonistic Mexican-Americans, and the Italian watercolour style greatly flattered the Latin good looks of lead actress Hedy Lamarr.

Watercolour poster artists can take liberties that are not available to designers who use publicity photographs as the basis of their work. Perhaps most importantly, they can invent scenes that do not exist in the movie. Anselmo Ballester's gun-toting Marlon Brando is the product of this kind of artistic licence. *On the Waterfront* has its violent moments, but at no point does a bloodstained vengeful Brando stride forth clutching a firearm. The image is pure sensationalism, designed to pull in the audience.

The potential for painterly elaboration may have been tempting, but it was not always taken up. In some cases watercolour posters are simply hand-rendered images of film stills. Ercole Brini's *Un posto al sole* (*A Place in the Sun*) is a painted version of the famous moment just before Elizabeth Taylor and Montgomery Clift's kiss. The film itself is largely remembered for the extraordinary beauty of its male and female leads, and the Taylor/Clift kiss has taken on an independent life as one of the cinema's most ravishing images of young love. Brini's skilful technique complements Taylor's dark good looks and Clift's manly shoulder.

ABOVE *A Place in the Sun* (*Un posto al sole*), George Stevens, 1951. POSTER Ercole Brini, Italy Brini's watercolour treatment emphasizes Elizabeth Taylor's glossy black hair and curtain-like eyelashes. The photograph on which it is based has become an icon of cinematic romance.

RIGHT *On the Waterfront* (*Fronte del porto*), Elia Kazan, 1954. POSTER Anselmo Ballester, Italy The Marlon Brando character on this poster is not the same as the confused, morally anguished young man that the actor plays in the film. But what Ballester loses in subtlety he makes up for with melodrama.

COLUMBIA PICTURES presenta:

MARLON BRANDO

in

FRONTE del PORTO

UNA PRODUZIONE DI
ELIA KAZAN

CON KARL MALDEN · LEE J. COBB

ROD STEIGER · PAT HENNING e EVA MARIE SAINT

COLUMBIA
CEIAD

Jane Russell and Rita Hayworth

Nineteen-forties audiences had nothing like the access to actors' private lives relished by today's public. Yet movie poster images did, to an extent, reflect stars' perceived off-screen personalities. When redheaded temptress Rita Hayworth (formerly raven-haired dancer Rita Cansino) made *Gilda* (1946) she was a twice-divorced "American love goddess". Her character in the film was overtly sexual and, to a conservative male population, excitingly contrary. *Gilda*'s smouldering poster image is about both the character and the celebrity. Six years later Hayworth reprised the role in *Affair in Trinidad*. Head still flung back in defiance, this time she earns a slap. Hayworth had been conducting an affair with Prince Aly Khan, the playboy son of a Muslim spiritual leader; the punishment she receives in this poster may be seen as a public rebuke.

Jane Russell won her part in *The Outlaw* after director Howard Hughes conducted a nationwide chest hunt. The film was completed in 1941 but, largely owing to the controversy stirred by Russell's breasts, was not released until 1950. In the interim Hughes made the most of Russell's reclining image by circulating film posters and stills as widely as possible, and like Hayworth she became the image of sexual availability. Hughes's film was very lame and it was hard for the actress ever to escape the "two good reasons" tag. By the mid-1970s Russell was advertising brassieres for Playtex.

ABOVE *Affair in Trinidad* (*Trinidad*), **Vincent Sherman, 1952. POSTER Anselmo Ballester, Italy** This giant-format Italian poster is spectacular, if somewhat nauseating. The quality of the typography and the execution of detail raise it well above the average American standard.

LEFT *The Outlaw*, **Howard Hughes, 1941. POSTER USA** This reclining image of Jane Russell is better known than the film itself. Few could recall a single scene from the movie, but the fact that Russell was contained in a specially constructed brassiere is common knowledge.

RIGHT *Gilda*, **Charles Vidor, 1946. POSTER USA** In *Gilda*'s most famous scene Hayworth performs a modest striptease, removing her long gloves and flashing an underarm. This image refers to the moment immediately after that scene, the cigarette indicative of a completed act.

There NEVER was a woman like *Gilda*!

COLUMBIA PICTURES presents

Rita **HAYWORTH**

as

Gilda

with

Glenn **FORD**

GEORGE MACREADY · JOSEPH CALLEIA

SCREENPLAY BY MARION PARSONNET

Produced by
VIRGINIA VAN UPP

Directed by
CHARLES VIDOR

03 New Wave and Blockbusters

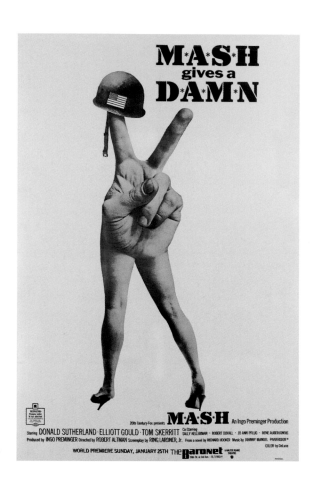

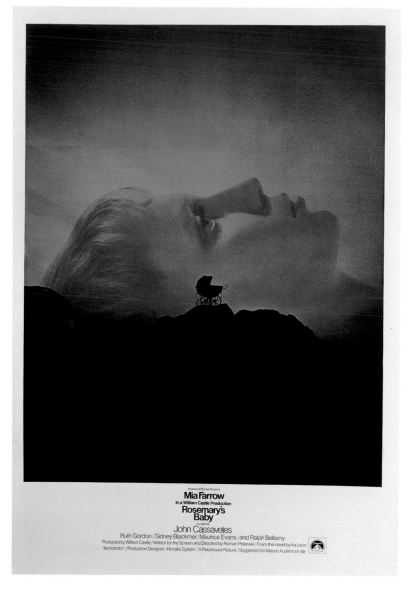

WITH THE RAPID EXPANSION of television after the Second World War, cinema needed to adapt. In the United States film production companies diversified into television right from the outset and this pattern was repeated in Europe once the state monopolies lost their hold on television broadcasting. Perhaps the most significant direct effect of the rise of television in the US was the fall of the B film. During the 1950s, B-film resources were redirected into television production while movies destined for the cinema were made on an increasingly large scale. By the turn of the decade the blockbuster phenomenon was in full swing. The Hollywood philosophy was "Make them Big; Show them Big; and Sell them Big", and each film competed to be the season's only must-see, the single movie worthy of

luring audiences away from their televisions. The result was a number of bloated epics: big, clumsy pictures such as Stanley Kubrick's, or perhaps more accurately Kirk Douglas's, *Spartacus* (1960).

Away from Hollywood, cinema readjusted to the ubiquity of television in a different fashion. In France the existence of state subsidies for film-making alongside an intellectualized film culture promoted the birth of a new school of experimental cinema. Collectively known as the French New Wave, a group of directors in the late 1950s, including François Truffaut, Jean-Luc Godard, and Alain Resnais, began making movies that were revolutionary in both form and content. The films grouped together under the New Wave banner are extremely various. Some, for example Godard's *Week-End* (1968), tamper with the

niesamowity film
ALFREDA HITCHCOCKA
wykonawcy: Rod Taylor
„Tippi"Hedren, JessicaTandy
Suzanne Pleshette
produkcja: Hitchcock-Universal

FAR LEFT *MASH*, Robert Altman, 1970. POSTER Murray Duitz, USA This movie poster still survives on bedroom walls decades after the film's release. Its ongoing currency is the product of Duitz's irreverent anti-military take and the long-term popularity of the spin-off television series.

LEFT *Rosemary's Baby*, Roman Polanski, 1968. POSTER Steve Franfurt, USA Mia Farrow's profile looms over the horizon as if it were the setting sun, in contrast to which the silhouetted pram looks insubstantial and vulnerable. The poster does not communicate much about the film, but is a powerful free-standing image

RIGHT *The Birds*, Alfred Hitchcock, 1963. POSTER Bronislaw Zelek, Poland By taking the Polish word for bird, *ptaki*, and repeating it again and again, Zelek creates a sinister typographic composition that is the equivalent of the film's most chilling scene, that of the chattering flock.

heart of narrative tradition, while others, such as Truffaut's *Jules et Jim* (1961), adopt a more classical mode. They also come from diverse political standpoints. The directors associated with Truffaut's film journal *Cahiers du Cinema* were avowedly apolitical, but in fact were informed by a centre-right stance – Godard particularly attracted controversy for his position on terrorist activity in Algeria; meanwhile those allied to *Cahiers* arch-rival *Positif*, including Resnais and Agnès Varda, were actively left-wing. These differences aside, common to all the films to emerge from the New Wave is an intelligently free hand with filmic convention.

The French New Wave was the outcome of purely cinematic impulses, a combative admiration for Hollywood film on the part of young French directors.

In stark contrast, British film-makers of the same period were looking to theatre for inspiration. A number of interesting movies emerged from early 1960s Britain, but those directing and writing these films, such as Tony Richardson and John Osborne, were steeped in the traditions of the stage. Sometimes called the British New Wave, these films portrayed indigenous working-class culture; for the first time Britain's urban population saw its own experience on screen. The phenomenon was short-lived. The frenzied excitement surrounding "swinging London" led to black-and-white realism being shunted off the screens in favour of the Technicolor fantasies of James Bond. The Bond series was made in Britain with American money and in the wake of its success a number of US companies invested in UK cinema. Unsurprisingly the

RIGHT *Etiopia, Diario de una Victoria*, **Miguel Fleitas, 1979.** POSTER **Eduardo Muñoz Bachs, Cuba** Bachs transforms the upturned crown of deposed Emperor Haile Selassie into a flowerpot, nurturing new life. In retrospect it is safe to say that the Cuban assessment of the outcome of the Ethiopian revolution was somewhat optimistic.

MIDDLE *Saturday Night Fever*, **John Badham, 1977.** POSTER **USA** The flared white pants, the wide lapels, the underlit floor, and the thunderbolt type all add up to an iconic 1970s image. Shown here in the classic disco pose, John Travolta influenced the body language of a generation.

FAR RIGHT *Grease*, **Randal Kleiser, 1978.** POSTER **USA** This film brought Travolta, fresh from his success in *Saturday Night Fever*, to an even wider audience. Parents bought the 1950s nostalgia, while kids sang along to the upbeat tunes and swooned at the stars.

American investors favoured high jinks and historical epics over kitchen-sink drama. By 1969, 90 per cent of the investment in British films came from the US, the majority of it directed towards a new wave of increasingly flaccid would-be blockbusters.

A much longer-lived indigenous cinema was that of Italy. In 1960 home-made films attracted 50 per cent of Italian box-office takings, substantially more than Hollywood film, and Italian cinema enjoyed critical and popular acclaim well into the 1970s. The directors who emerged during this period, such as Michelangelo Antonioni, Luchino Visconti, and Bernardo Bertolucci, achieved significant artistic and political freedoms and at the same time enjoyed substantial commercial success. Federico Fellini can also be included with this group.

Although strictly of the neo-realist generation, his films were much more in tune with the free-wheeling, filmic experiment of the 1960s. In spite of its apparent momentum, at the very end of the 1970s the Italian film industry all but collapsed. Neglected by a government whose interests were closely tied to television broadcasting, domestic film-making was reduced to a shadow of its former self and during the 1980s Hollywood re-established its grip on the Italian box office.

Of course it is wrong to view Hollywood as the perpetual bad guy. Far from being the enemy of creativity, the hub of the world's film industry has spawned both the filmic conventions and the filmic rebellions that fuel much of the rest of world cinema. In the late 1960s Hollywood film went through a period of heightened

experimentation as investors strove to attract the hippie generation into the cinemas. The palpable existence of an American counter-culture drew funds to Stanley Kubrick's *2001: A Space Odyssey* (1968), a film that would have been unthinkable only a few years before. Equally, Dennis Hopper's low-budget *Easy Rider* (1969) was a huge success and prompted a number of imitations of varying merit. In the early 1970s the US film industry fell into the commercial doldrums. It suffered badly from the twin shocks of financial turmoil caused by the oil crises and cultural turmoil arising in the wake of the Vietnam War. Unlikely as it may seem, this flailing industry gave birth to some of Hollywood's finest productions. Directors such as Robert Altman, Francis Ford Coppola, and Martin Scorsese tapped into the full

sweep of cinematic history and the contemporary American psyche to produce movies of lasting power.

Hollywood film-making went through a significant shift in the mid-1970s. In 1975 the extraordinary success of Steven Speilberg's *Jaws* prompted a rethink of film production and a return to notions of formula and genre that had guided Hollywood in its earlier days. The most characteristic films of the late 1970s – *Star Wars* (1977), *Superman* (1978), *Star Trek* (1979) – were each the first in a series of movies that stretched through the 1980s and into the 1990s and, in the case of *Star Wars*, into the third millennium. Their posters are as formulaic as the productions. Many designed by Bob Peak, they tend to show a triangular slice of action containing girls, guns, pectorals, and fantastical technology.

Cuban Film Posters

Before the revolution in 1959 most films and film posters came to Cuba from abroad. Cubans were quick to embrace cinema and the country proved a profitable market, first for European silent films and later for the full-blown productions of Hollywood. Hoping to capitalize on the popularity of film, the Revolutionary Government established the Instituto Cubano de las Artes e Industrias Cinemátograficas (ICAIC) in its first cultural decree in 1959. Early ICAIC-sponsored films were strongly influenced by Italian realism, but Cuban directors were also sympathetic to the idea of Free Cinema (translated into Spanish as *cine espontáneo*), the international movement inspired by the French New Wave. The richest years of Cuban feature-film production were between 1966 and 1979. During this period filmmakers remained relatively free from political interference and their work was characterized by a plurality of approaches and a productive exploration of national and international traditions.

The ICAIC was responsible for both domestic film production and the distribution of foreign films in Cuba. By founding a silk-screen workshop to create posters for all films shown in Cuba it created an aesthetic unity between these two branches of activity. The characteristic look of the Cuban film poster helped fuse national and international productions into a single cinematic culture. The posters produced by the workshop were all of identical size, designed to fit in standardized kiosks throughout

now!

Documental del ICAIC
Con la voz de LENA HORNE
Realización
SANTIAGO ALVAREZ

BESOS ROBADOS

FILM FRANCES EN COLORES DIRECCION: FRANCOIS TRUFFAUT CON: JEAN-PIERRE LEAUD

LEFT *Now!*, Santiago Alvarez, 1965. POSTER
Alfrédo J. Gonzalez Rostgaard, Cuba In the
years following the launch of the ICAIC the
feature-length documentary became an
increasingly popular form. This film about
Lena Horne was one of 40 such documen-
taries made in Cuba in 1965.

ABOVE *Baisers volés (Besos Robados)*,
François Truffaut, 1968. POSTER Cardenas
René Azcuy, Cuba This image is simple but
effective, suggestive of the film's mix of low-
key cinematography and rich romantic sub-
ject-matter. The fusion of photography with
illustration is typical of the Cuban style.

film japonés en cinemascope dirección: koreyoshi kurah
con: sayuri yoshinaga / tetsuya watari
LOS AMANTES DE HIROSHIM

BELOW *Karate Campeon*, Miyoshi Saeki, date unknown. POSTER Eduardo Muñoz Bachs, Cuba, 1969 Representing Japanese subject-matter in a Cuban style, Bachs achieves an elegant mix of the two cultures. His use of red, an emotive colour in both countries, is sparing and effective.

KARATE CAMPEON
DIRECCION: MIYOSHI SAEKI
CON: SHINICHI CHIBA
RYOHEI UCHIDA
FILM JAPONES
EN CINEMASCOPE

bachs 69

bac

Havana and other cities. These images also travelled beyond urban centres, accompanying the mobile projection crews that made film accessible to Cuba's large rural population. As with Polish posters, Cuban designs were used not so much for promotional purposes – cinema was consistently popular and most films showed to a full house – but more as a form of cultural education, presenting a distinctively Cuban slant on the film's subject.

The Cuban graphic aesthetic was born several years before the revolution, in the early 1940s, when graphic artists such as Eladio Rivadulla Martínez began to create silk-screen movie posters specifically for the local market. The ICAIC, in promoting this burgeoning graphic tradition, was the prime force in the post-revolutionary emergence of a uniquely Cuban style of poster art. An employee of the ICAIC from the outset, the visionary publicist Saúl Yelin was instrumental in turning the new film institute into an international cultural presence. In keeping with the spirit of the times, the contribution of individual artists was seen as less important than the poster's content, and dozens of idealistic talents applied themselves to the enterprise. That said, several prominent artists did emerge from the workshop, the best known of whom is the Spanish-born illustrator Eduardo Muñoz Bachs. The ICAIC is rare among film agencies for having actively marketed its posters as a commercial product. It maintained a small retail store in Havana and sold many posters on the local and international markets. Good examples of these posters are now quite rare and are very collectible. Many are lodged in museum collections.

LEFT *Los Amantes de Hiroshima*, **Koreyoshi Kurahara, 1967.** POSTER **Eduardo Muñoz Bachs, Cuba** In English this film is known as *The Heart of Hiroshima*. In contrast to the pitch black surrounding the body, the poster (dating from 1969) represents the internal condition as a series of colourful swirls.

BELOW *Moby Dick*, **John Huston, 1956.** POSTER **Antonio Fernández Reboiro, Cuba** The popularity of graphic psychedelia was short-lived but widespread. In this poster dating from 1968 Reboiro uses an unmistakably late-1960s style to promote a film made more than a decade earlier.

ABOVE *Una Mujer, un Hombre, una Ciudad*, **Manuel Octavio Gómez, 1978.** POSTER **Antonio Fernández Reboiro, Cuba** This poster represents the woman and the industrial framework of the city with flat planes of colour. The palette of the poster mixes the sombre and the optimistic, and the woman's face appears uncompromising but beautiful.

Polish Film Posters

Film Polski was founded immediately after the Second World War in the small town of Lodz. The institution was intended to deal with Poland's newly nationalized film industry and one of its aims was to create a new graphic language for the promotion of film, an alternative to the United States' ideologically unacceptable "women and guns" convention. In 1946 the established graphic artists Eryk Lipinski and Henryk Tomaszewski were asked to design a series of film posters and, out of this initial approach, an entire tradition was born. In the 1950s Film Polski handed over responsibility for the distribution of films to the Warsaw-based Film Rental Agency (CWF), but this move did not stem the development of the "artistic poster". Competition among the poster designers became ever keener, often with several of them attending a single screening and presenting their poster proposals to a jury. For these artists film posters were not a sideline but a major creative outlet.

As the Communist government began to exert tighter control on the country's culture, poster design became even more important owing to the relative artistic freedom that it allowed. Among the most significant artists to

LEFT *Black Narcissus (Czarny Narcyz)*, **Michael Powell and Emeric Pressburger, 1947.** POSTER Henryk Tomaszewski, Poland The story of a group of nuns establishing a school and hospital in a former bordello in the Himalayas, this film won an Oscar for best cinematography. Tomaszewski's decorative illustration reflects the sumptuousness of the film itself.

RIGHT *Noz w Wodzie (Knife in the Water)*, **Roman Polanski, 1962.** POSTER Jan Lenica, **Poland** As well as being Polanski's début, *Knife in the Water* was the first movie made in postwar Poland not to deal with a military theme. Lenica's three fish represent the film's main characters.

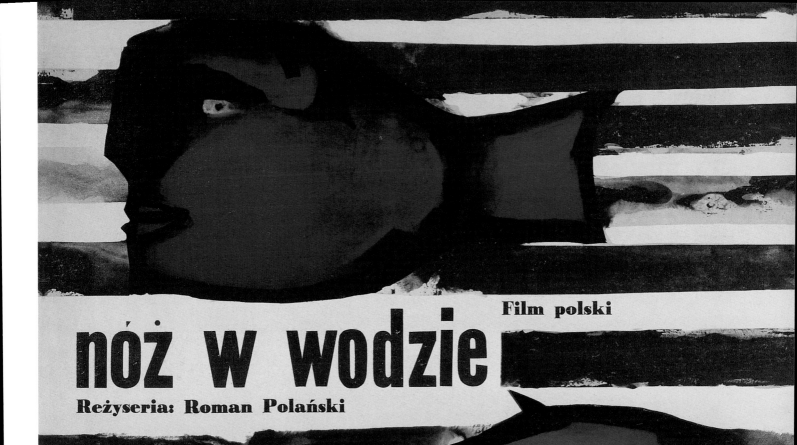

Film polski

nóż w wodzie

Reżyseria: Roman Polański

Produkcja: ZRF „Kamera"

Zdjęcia: Jerzy Lipman

W rolach głównych: Jolanta Umecka Leon Niemczyk Zygmunt Malanowicz

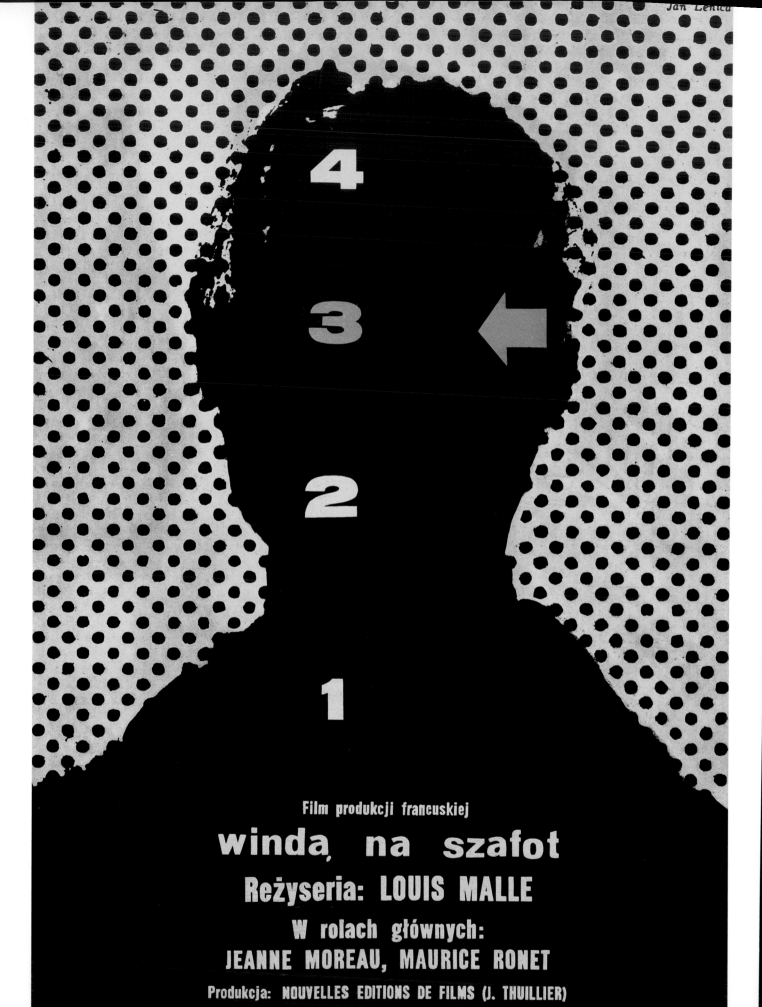

emerge from the Polish poster tradition are Tomaszewski, Waldemar Swierzy, Jan Lenica, and Roman Cieslewicz.

Polish film posters were never required to attract an audience. In the postwar decades new films were scarce in Poland and most screenings were full. Instead of promotional pieces, these posters were viewed as a kind of education for the masses, art primers that reached beyond the towns and cities and into the villages. Although many such posters were not well received by local cinema managers, by the mid-1950s the Polish art establishment was already viewing the collection as a national treasure.

The best period for Polish poster design was between the mid-1950s and the early 1970s. After that the increasing influence of the West detracted from the indigenous tradition and Polish posters adopted a more generic European style. Also, as the 1970s and 1980s progressed, fewer posters were designed for the Polish market. Distributors of mainstream movies preferred to use more audience-friendly adaptations of American or European posters and the custom-designed poster became almost wholly the province of the art house or film festival.

Although chances to work decreased, the 1970s and 1980s saw the emergence of a number of exciting poster artists, including Andrzej Klimowski, Andrzej Pagowski, and Grzegorz Marszalek. With fewer chances to create film posters, these artists also turned their talents to other kinds of design work, including book-cover illustration and theatre design. Like important Polish film directors such as Roman Polanksi and Krzysztof Kieslowski, many of this younger generation have chosen to live and work abroad.

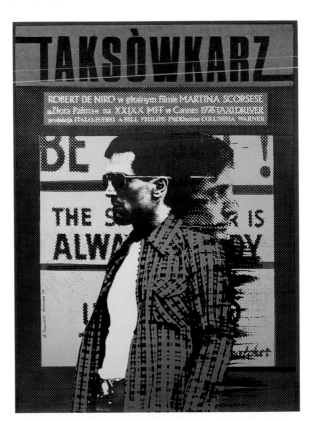

FAR LEFT *Ascenseur pour l'échafaud* (*Winda, Na Szafot*), Louis Malle, 1958. POSTER Jan Lenica, Poland A murderer gets stuck in an elevator while attempting to cover his tracks. Lenica's poster illustrates the literal and pyschological entrapment of the film's male lead.

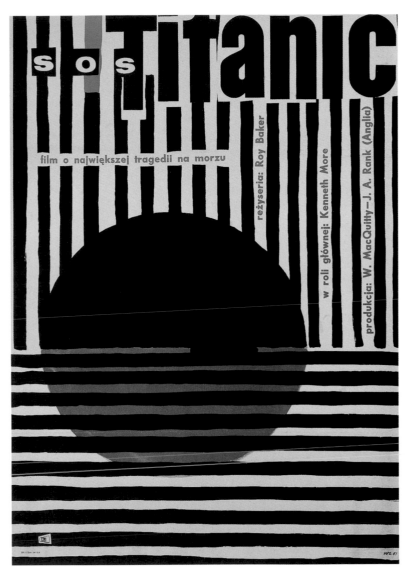

ABOVE *SOS Titanic* (*A Night to Remember*), Roy Ward Baker, 1958. POSTER Wojciech Zamecznik, Poland This film is a documentary-style account of the sinking of the *Titanic*. Zamecznik's poster reflects the dignity and reserve of the film's story-telling style.

LEFT *Taxi Driver* (*Taksòwkarz*), Martin Scorsese, 1978. POSTER Andrzej Klimowski, Poland Klimowski's interpretation of Scorsese's film suggests some kind of identification between the protagonist Travis Bickle and the director himself, a portrait of the latter emerging from an inky mess at the back of the former.

Czech Film Posters

Czech film posters experienced a golden age in the 1960s. Influenced by the posters produced in Poland, in the late 1950s Czech artists began to throw off the yoke of Soviet-style social realism. Instead of depicting rosy-cheeked farm workers, these artists began to explore more expressive, experimental visual trends. Around the same time the Czech Union of Visual Artists relaxed its centralist policies, allowing graphic designers a greater degree of freedom. As in Poland, Czech film distribution was under government control and posters had to be submitted to the Central Film Distribution Centre for approval. This requirement ceased to be repressive as the Distribution Centre allowed young artists from across the disciplinary spectrum into their film promotion team. Instead of suffocating creativity, the government institutions became relatively ideology-free centres for artistic discussion.

Important artists to emerge from this period include Karel Vaca, Zdenek Ziegler, and Karel Teissig. In the mid-1960s these artists were joined by a younger generation including Jan Vyletal and Olga Vyletalova. The work produced by Czech poster artists is varied in technique and style, but common to all is a highly individual approach to the subject-matter, a tendency towards idiosyncratic interpretation rather than the straightforward communication of plot. The role of the posters went beyond that of movie promotion. Exhibited as works of art, they were embraced by the public, to an extent providing a relief from grim political realities. Artist Karel Teissig suggested that the beauty and artistic freedom of the posters "put a certain sense into the absurdity of the times".

ABOVE *The Birds* (*Vtaci*), **Alfred Hitchcock, 1963.** POSTER Jan Vyletal, Czechoslovakia Using Hitchcock's ornithological theme as a starting point, this symbolist image takes off in a direction all of its own. The landscape is suggestive of the film's American setting, but the creatures are entirely imaginary.

BELOW *Blow-Up* (*Zvětšenina*), **Michelangelo Antonioni, 1966.** POSTER Milan Grygar, Czechoslovakia This poster focuses on the performative aspect of Antonioni's film. The theatre plan in combination with the repeated film still suggests a degree of distance between audience and imagery.

RIGHT *The Boston Strangler* (*Bostonsky Případ*), **Richard Fleischer, 1968.** POSTER Zdenek Ziegler, Czechoslovakia Tony Curtis plays a serial killer with multiple personality disorder. In this poster his psychological state is represented by skin as thick as elephant hide and an oddly striped eyeball.

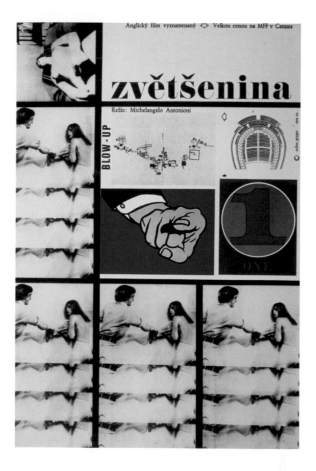

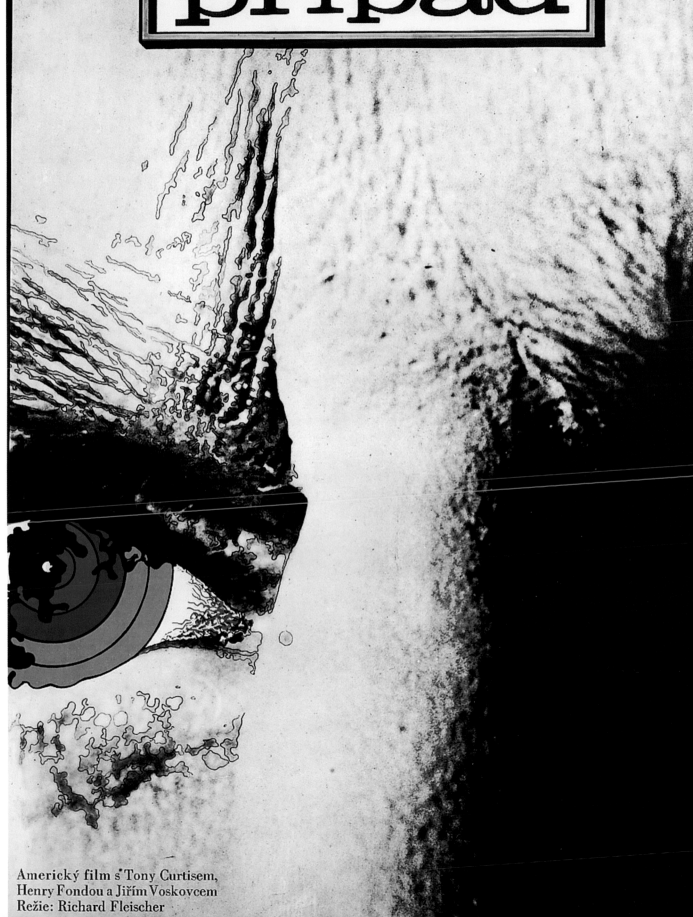

BOSTONSKÝ
případ

Americký film s Tony Curtisem,
Henry Fondou a Jiřím Voskovcem
Režie: Richard Fleischer

French New Wave

The films grouped together under the French New Wave banner are extremely various. Likewise, the images used in their promotion have adopted a wide range of styles and formats. From illustrative to photographic, from elaborate to pared down, taken as a whole these posters amount to a worthy reflection of one of cinema's most experimental episodes. The directors most associated with the New Wave are François Truffaut, Jean-Luc Godard, Alain Resnais, and Claude Chabrol.

Although the term first appeared in 1958, the New Wave took the national industry by storm a year later with several films including *Pickpocket* by Robert Bresson and Truffaut's *Les 400 Coups*. Sharing the theme of petty crime, these films were also united by their inventiveness and fresh vision. Truffaut's semi-autobiographical movie about a neglected and mildly delinquent teenage boy still stands as one of the great films made on the subject of disaffected youth. The black-and-white photographic posters for the two films are in keeping with their respective story-telling styles. The harsh tones of the *Pickpocket* image can be read as a metaphor for its unforgiving moral tenor, while the softer shades of the *Les 400 Coups* photograph reflect its more liberal approach.

Made a couple of years after *Les 400 Coups*, Truffaut's *Jules et Jim* is a more classic cinematic adventure. Set just before the First World War, it tells a tale of friendship and doomed love. The tragic outcome of the infatuation of Austrian Jules and Frenchman Jim with the magical,

BELOW *Zazie dans le Métro*, Louis Malle, 1960. POSTER France Malle's *Zazie* relates the madcap adventures of an undersized anarchist hell-bent on revealing the hypocrisies of the adult world. With her toothy grin and dimpled cheeks, Zazie is the appealing voice of childlike reason.

RIGHT *L'Année dernière à Marienbad* (*Letztes Jahr in Marienbad*), Alain Resnais, 1961. POSTER Hans Hillman, Germany The film's narrative is strange and disjointed; here, the repetition of the image renders the woman eerily static, doomed to replay the same incidents over and over again.

ABOVE *Pickpocket*, Robert Bresson, 1959. POSTER Jacques Fourastié, France Jacques Fourastié is the name of a studio of artists who designed a large number of French movie posters from the 1940s onward. This strangely twisted probing hand acts as a metaphor for the moral dilemma that is at the heart of the film.

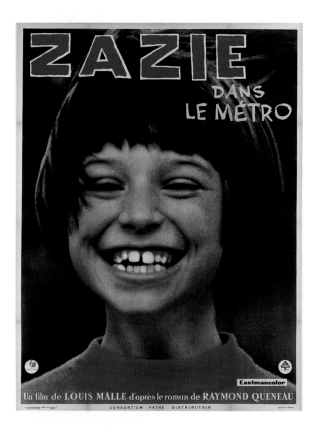

LETZTES JAHR IN MARIEN-BAD

(L'année dernière à Marienbad)

Regie:
ALAIN RESNAIS

Buch:
A. ROBBE-GRILLET

MIT DELPHINE SEYRIG, GIORGIO ALBERTAZZI, SACHA PITOEFF

NEUE
FILMKUNST
WALTER
KIRCHNER

slightly frightening Catherine is predictable, but the route towards murder and suicide is engaging and cinematically beautiful. Christian Broutin's poster focuses on Jeanne Moreau's Catherine character. The combination of illustration and photography creates an extraordinary aura around Moreau's image, emphasizing her beauty but also allowing a glimpse of her dangerous qualities. Like Catherine, Zazie from *Zazie dans le Métro* by Louis Malle appears on her poster in a tinted halo. The foul-mouthed prepubescent and the selfish romantic heroine could not be more different, but both deserve their Technicolor glow.

French New Wave films were often released abroad several years after their original outings. Foreign re-release usually involved a new campaign, some of which outshone the original. The German designer Hans Hillman created extremely intelligent images that promoted experimental French film in a manner appropriate to its style and substance. Among Hillman's finest work is his poster for the 1961 Alain Resnais film *L'Année dernière à Marienbad*. Resnais is known for tampering with conventional notions of time and Hillman's fragmented image addresses that theme. In *Marienbad* the events of last year are enacted according to the subjective view of a character known as X; episodes are replayed in an uncertain sequence rather than a chronological flow. Showing the same scene four times with its dimensions reduced by half each repeat, Hillman gives the impression of a fleeting memory, a recollection of events that becomes less and less distinct.

The New Wave is widely considered to have ended with the political unrest of May 1968. Of the films that addressed those events, Jean-Luc Godard and Jean-Pierre Gorin's *Tout va bien* (1971) is the best known. French films of the late 1960s and early 1970s also tapped into the changes in social attitudes and the greater levels of freedom that emerged from the upheaval. Even today French film-makers enjoy a more liberal film-making environment than their British or American counterparts.

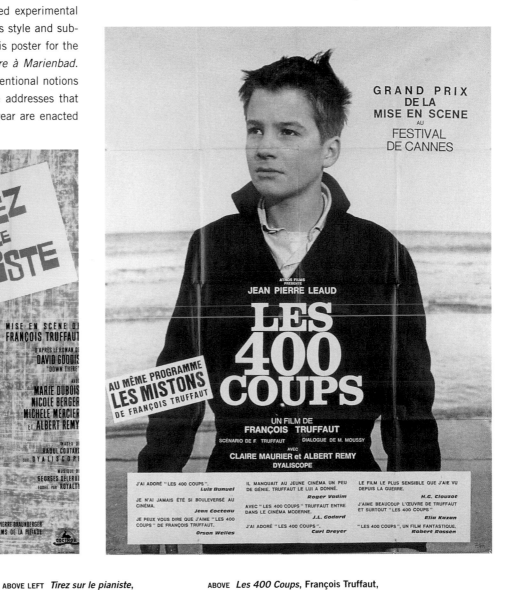

LEFT *Jules et Jim*, François Truffaut, **1961.** POSTER Christian Broutin, France This poster is all about the charisma brought to the potentially dislikeable role of Catherine by Jeanne Moreau, who created a seductive energy that renders believable the affections of Jules and Jim.

ABOVE LEFT *Tirez sur le pianiste*, **François Truffaut, 1960.** POSTER France Like much of François Truffaut's work, this film is partly autobiographical. Depicted in isolation, even from his own instrument, the pianist is portrayed as the archetypal artistic loner.

ABOVE *Les 400 Coups*, **François Truffaut, 1959.** POSTER France Several images were used to promote this film in France, among them an illustration of the scene shown here. This simple photographic poster is particularly effective in drumming up sympathy for the film's tousle-haired hero.

Jean-Luc Godard

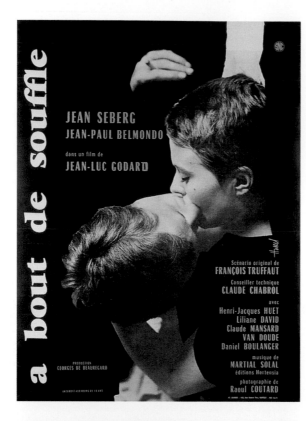

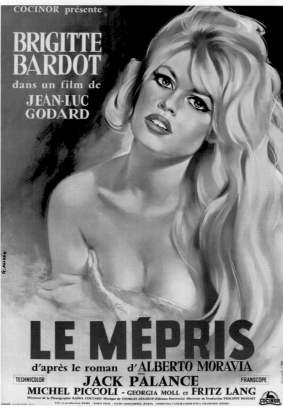

Jean-Luc Godard (b. 1930) developed his passion for film as a member of the audience. He was a particular fan of 1940s Hollywood cinema, much of which arrived in Paris only in the early 1950s. While still a student he wrote for French cinema journals, including *Cahiers du cinéma*, and in his early twenties began to produce short films and to write screenplays. *A bout de souffle* (*Breathless*) was one of his earliest feature films. In the decades since it was made it has come to be regarded not only as a key work of the French New Wave, but also as one of the most important moments in experimental cinema. Still making films today, Godard has explored a range of cinematic themes and genres, but throughout his career he has remained faithful to the pioneering tenets of European Modernism.

Clément Hurel's poster for the French release of *A bout de souffle* adopts an ordinary image, that of a kissing couple, and renders it unfamiliar. Using a photograph taken at an odd angle and cropping to confuse further the relationship between hands, arms, hair and lips, Hurel makes the romantic encounter look like a fight for survival. The poster for the later film *Le Mépris* (*Contempt*) is much more conventional. An illustration of the celebrated sex symbol Brigitte Bardot, it appeals in a direct fashion: *Le Mépris* is a complex, difficult film, but it is sold to the audience using eyes, lips, hair, and breasts.

Week-End is a surreal, savage take on modern society. Portraying violence in a deadpan manner, it expresses Godard's belief that horrors lurk only just below the surface of late 20th-century society. Hans Hillman's poster for the German release of the film in the 1970s avoids illustrating its gory moments and instead sums up the plot with a single typographic metaphor.

ABOVE LEFT **A bout de souffle**, Jean-Luc Godard, 1959. POSTER **Clément Hurel, France** Hurel often used photomontage in his poster designs. This is the image most associated with Godard's early film and it has come to be regarded as among the most romantic movie posters of all time.

LEFT **Le Mépris**, Jean-Luc Godard, 1963. POSTER **France** Godard swung between casting well-known stars and unknowns. Brigitte Bardot had come to worldwide attention in 1956 and this poster makes the most of her well-established celebrity.

RIGHT **Week-End**, Jean-Luc Godard, 1967. POSTER **Hans Hillman, Germany** *Week-End* juxtaposes the everyday with the surreal and extraordinary. Hillman's ingenious typographic poster communicates the idea of surface normality disguising underlying weirdness.

Mit Mireille Darc,
Jean Yanne,
Daniel Pommereulle,
Jean-Pierre Lèaud,
Jean-Pierre Kalfon

Nach der Mao-roten „Chinoise"
eine hämoglobingetränkte
Geschichte von Rittern der Land-
straße, Normalverbrauchern
und Kannibalen.

Kamera: Raoul Coutard
Prädikat: Besonders wertvoll
Regie und Buch:

Jean-Luc Godard

Neue
Filmkunst
Walter
Kirchner

HANS HILLMANN Reproduktion u. Druck P. R. Wilk, Seciberg/Taunus

Joseph Mankiewicz

Although Joseph Mankiewicz (1909–1993) was born in Pennsylvania, his earliest job in movies was in Berlin translating titles for German silent films to be exported to the United States. Coming from a family of writers (his older brother Herman was the author of *Citizen Kane*), Mankiewicz spent two decades in Hollywood penning scripts and producing before being allowed to take the director's chair on the movie *Dragonwyck* in 1946. Some argue that Mankiewicz films are all talk and no action, but others insist that this assessment is unfair. The writerly origins of films such as *No Way Out*, *All About Eve*, and *The Quiet American* (1958) are apparent, but Mankiewicz's 1955 musical *Guys and Dolls* is a piece of pure cinema. Whatever the final assessment, Mankiewicz usually took a writer/director credit, and was unwilling to squander a fragment of his own incisive dialogue. Posters for Mankiewicz films reflect this approach to film-making. More like book jackets, they are about plot rather than the single cinematic image.

Made a decade before the US civil rights movement, *No Way Out* was a prescient drama of race relations. Featuring the début performance of Sidney Poitier, it concerns a group of gangsters who take revenge on the black community after a young black doctor fails to save the life of one of the gang members. Graphic designer Paul Rand's poster speaks of violent movement (the red arrow thrusting from left to right) and nihilistic standstill (the broken black stripe containing the image of a handcuff clamped to a hospital bed). The eyes caught in the centre of the graphic device represent the deadlock experienced both by the characters in the film and by members of the audience. On a lighter note, the diagrammatic poster by Erik Nitsche for *All About Eve* describes a circular romance: she loves him, who loves her, who loves him, and so on.

BELOW *No Way Out*, Joseph Mankiewicz, **1950.** POSTER **Paul Rand, USA** An experienced book-jacket designer, Rand brings an unusual and extremely intelligent design sensibility to this poster. The use of graphic motifs and fragmentary images conveys a feeling of tension and suspense.

RIGHT *All About Eve*, Joseph Mankiewicz, **1950.** POSTER **Erik Nitsche, USA** The facial fragment at the bottom left corner of this poster is that of Marilyn Monroe, who played a small, but scene-stealing role. Monroe makes a very believable catalyst for an image about misplaced affections.

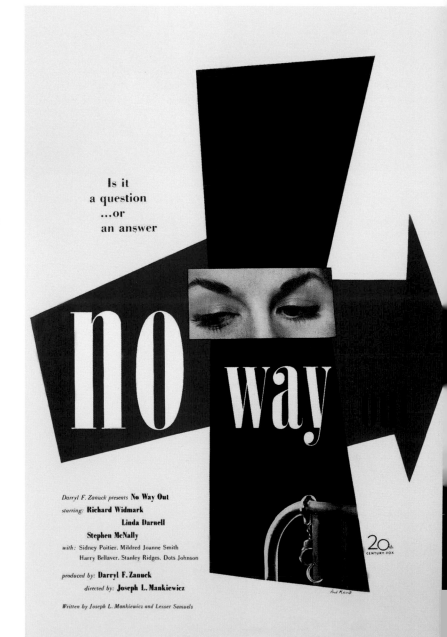

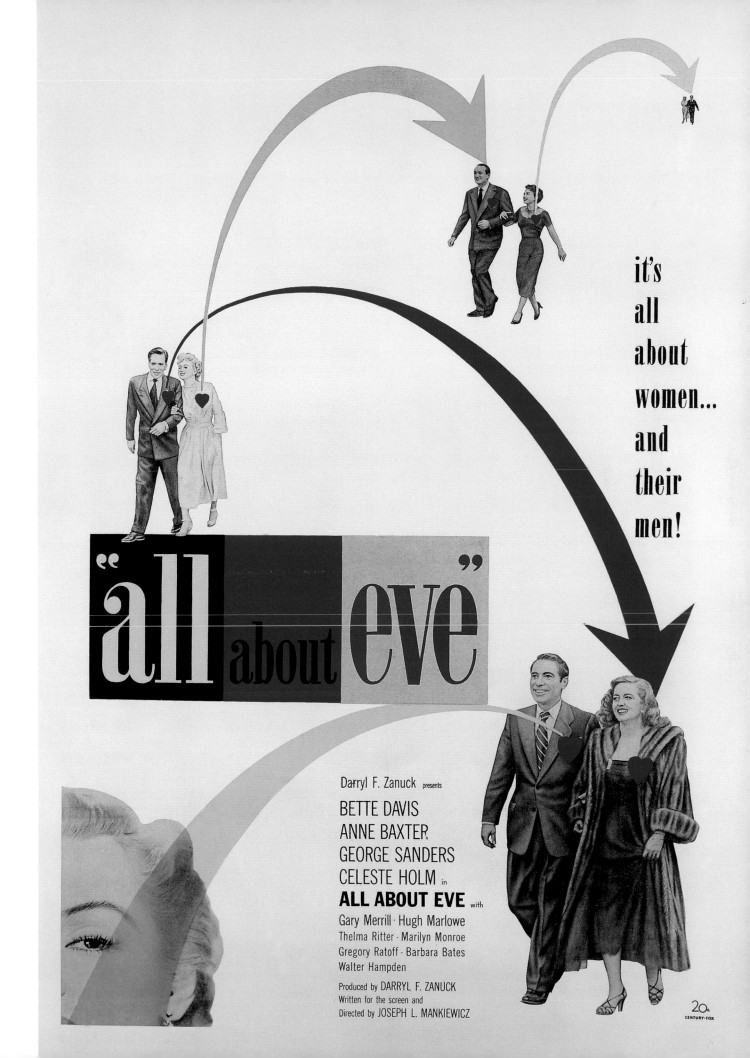

it's all about women... and their men!

"all about eve"

Darryl F. Zanuck presents

BETTE DAVIS
ANNE BAXTER
GEORGE SANDERS
CELESTE HOLM in

ALL ABOUT EVE with

Gary Merrill · Hugh Marlowe
Thelma Ritter · Marilyn Monroe
Gregory Ratoff · Barbara Bates
Walter Hampden

Produced by DARRYL F. ZANUCK
Written for the screen and
Directed by JOSEPH L. MANKIEWICZ

20th
CENTURY-FOX

British Films of the 1960s

British cinema has an uneven history, and although recent decades have witnessed the odd cluster of worthwhile British movies, the early 1960s was possibly the last time that Britain sustained a notable independent cinema for any length of time. Born of a mix of theatrical, literary, and documentary traditions, film-makers such as Lindsay Anderson, Karel Reisz, and Tony Richardson took on a moribund late 1950s industry and transformed it into the beating heart of British culture.

These directors were concerned that film should reflect the reality of British existence, especially that of the working class, an aim shared by a number of British novelists. Many early 1960s films were literary adaptations. Alan Sillitoe provided screenplays based on his novels for Reisz's *Saturday Night and Sunday Morning* and Richardson's *The*

Loneliness of the Long Distance Runner (1962). The harsh, realist subject-matter gave birth to a new breed of British actor. Performers such as Albert Finney and Rita Tushingham acted with a grit and authenticity closer to the style of American stars such as James Dean and Marlon Brando than to the actorly virtues of the British tradition best represented by Laurence Olivier.

To an extent, early 1960s British cinema was a victim of its own success. An important element in a revitalized cultural scene, it encouraged an emphasis on glitz and glamour that eclipsed its own more downbeat concerns. Anderson's 1968 movie *If...* was made during the decline of the swinging scene. Although the film returns to the issues of social inequality that had gripped directors five years earlier, Anderson's take is here distinctly jaded.

"Do you know what the most FRIGHTENING thing in the world is...?"

PEEPING TOM

CERTIFICATE
X
ADULTS ONLY

CARL BOEHM
MOIRA SHEARER
ANNA MASSEY
MAXINE AUDLEY

IN EASTMAN COLOUR

Original Story and Screenplay by LEO MARKS

Produced and Directed by MICHAEL POWELL

Distribution by ANGLO AMALGAMATED FILM DISTRIBUTORS LIMITED

ABOVE *Peeping Tom*, Michael Powell, 1960. POSTER UK Although the ragged, uneven typography of this poster's tagline suggests conventional horror, the film is less a slasher than a tale of extreme psychological disorder.

LEFT *If...*, Lindsay Anderson, 1968. POSTER UK Anderson's movie takes a sensationalist stance on the issue of social inequality. Appropriately, the style of the poster apes that of Britain's *Nova* magazine, a publication renowned for mixing politics with fashion.

RIGHT *Saturday Night and Sunday Morning*, Karel Reisz, 1960. POSTER UK Sandwiched between Saturday night and Sunday morning, Albert Finney's working-class hero adopts a defensive stance. This charismatic 1960 performance launched Finney's five-decade career.

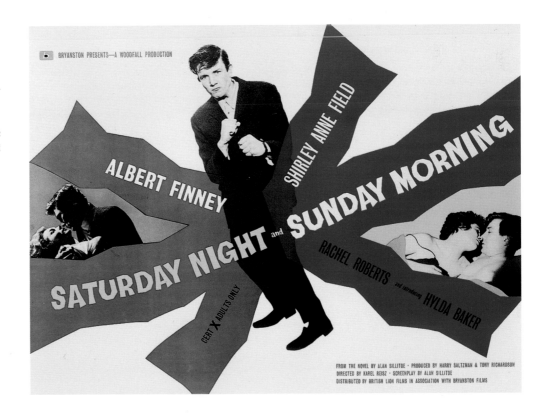

BRYANSTON PRESENTS—A WOODFALL PRODUCTION

ALBERT FINNEY

SHIRLEY ANNE FIELD

SATURDAY NIGHT and SUNDAY MORNING

RACHEL ROBERTS *and introducing* HYLDA BAKER

CERT X ADULTS ONLY

FROM THE NOVEL BY ALAN SILLITOE · PRODUCED BY HARRY SALTZMAN & TONY RICHARDSON
DIRECTED BY KAREL REISZ · SCREENPLAY BY ALAN SILLITOE
DISTRIBUTED BY BRITISH LION FILMS IN ASSOCIATION WITH BRYANSTON FILMS

ACADEMY CINEMA
TWO
Oxford Street · 437 5129

First British Screen Presentation

THE COMPLETE VERSION
of the epic Japanese masterpiece

AKIRA KUROSAWA'S

SEVEN SAMURAI (X)

starring

TOSHIRO MIFUNE
TAKASHI SHIMURA

ABOVE *The Seven Samurai*, Akira Kurosawa, 1954. POSTER Peter Strausfeld, UK Contrasting the bold face of the warrior in the foreground with the seven silhouetted samurai in the distance, Strausfeld reflects the director Kurosawa's successful combination of the intimate and the epic.

RIGHT *Giulietta degli spiriti* (*Juliet of the Spirits*), Federico Fellini, 1965. POSTER Peter Strausfeld, UK The bold black-and-white woman in the foreground is Juliet, while the colourful figures in the background represent the spirits that appear to her. Strausfeld uses print technique to convey the substance of the film's plot.

Peter Strausfeld

BELOW *Murder in the Cathedral*, George Hoellering, 1951. POSTER Peter Strausfeld, UK An adaptation of a work by T.S. Eliot, the film addresses the assassination of the Archbishop of Canterbury Thomas Becket at the behest of King Henry II. The poster mimics the style of a stained-glass window.

As a young man, Peter Strausfeld (1910–1980) emigrated from Cologne to Britain. During the years of the Second World War he was held in an internment camp where he met the film director George Hoellering, a fellow German émigré. On their release at the end of the war years, Hoellering asked Strausfeld to design a poster for a showing of one of his films at the Academy Cinema on Oxford Street in London. Strausfeld undertook the commission, and continued to design posters for the cinema until his death three decades later.

Strausfeld's posters, always executed using distinctive woodblock or linocut methods, became something of a London landmark. The artist's confident drawing style and bold use of colour won him a local following. Strausfeld's work shows the influence of the German Expressionist print-makers of the interwar years, in particular that of artist Käthe Kollwitz. Alongside the designs of the Sternberg brothers or those of Saul Bass, Strausfeld's posters are a rare instance of the experiments of fine art being brought to the business of movie promotion.

The Academy Cinema had opened on Oxford Street in 1913. In 1928 property developers threatened to turn it into a shopping arcade, whereupon it was saved by a leading member of Britain's Film Society, Elsie Cohen. On her success, Cohen proceeded to run the cinema as an art house and it remained in much the same form until its closure in 1986. Strausfeld's posters were dedicated to the Academy and as such were rarely distributed outside London. Printed in small runs of between 300 and 500, the earlier posters were produced by the prestigious Westminster Press and the later by Ward and Foxlow.

THE ACADEMY CINEMA
165 OXFORD STREET, LONDON, W.1 · GERrard 2981

T.S. ELIOT'S
Murder in the Cathedral
A GEORGE HOELLERING FILM

Ingmar Bergman

Ingmar Bergman (b. 1918) first worked as a stage director and he directed for theatre throughout his film career, an activity that strongly inflected his cinematic work. Bergman takes both the writer and the director credit on all his best-known movies. He failed to make an impact in the international film industry, but his work is the foundation of Sweden's national cinematic tradition.

The Seventh Seal (*Det Sjunde Inseglet*) is Bergman's best-known film, largely owing to the iconic scenes in which a Knight tries to stave off Death through a game of chess. Designed by the prolific poster designer Gosta Aberg, this image refers to the contest. The Knight and the Squire are cast as chess pieces with other characters from the film. Death transcends the game, appearing in profile against a red triangle. This arrangement reflects the outcome of the film and the inevitable triumph of Death. The use of small photographic elements in a complex composition is typical of Swedish posters of the time. In the late 1930s Swedish poster designers moved from an illustrative to a more photographic style, retaining a sense of handcraft through collage and expressive typography.

Persona is a black-and-white drama dealing with questions of identity. The movie focuses on the relationship between an elective mute actress (Liv Ullman) and her nurse (Bibi Andersson). The actress gradually absorbs the personality of her carer. The Swedish poster for this film, designed by Aberg's colleague Ranke Sandgren, is a low-key black-and-white photographic collage that foregrounds the image of the two female leads. The Japanese poster uses a similar photograph to very different effect. Saturating it with colour and juxtaposing it with other scenes from the film, it no longer conveys the minimalism of Bergman's story but instead titillates with the prospect of all-female love scenes.

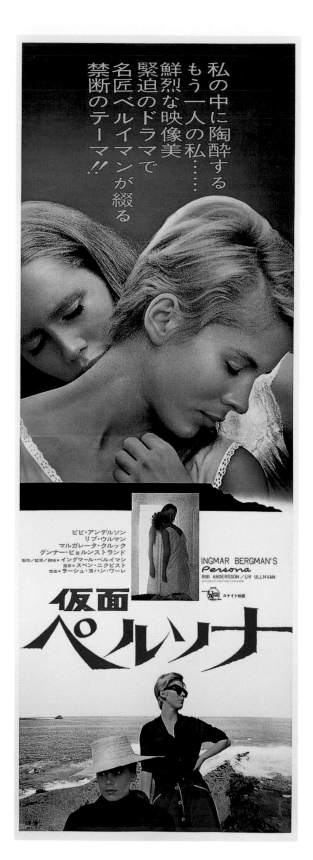

RIGHT *Persona*, Ingmar Bergman, 1966. POSTER Japan The vertical format of this poster is characteristic of Japanese film advertising. As with Japanese script, the image ought to be read from top to bottom.

FAR RIGHT *Det Sjunde Inseglet*, Ingmar Bergman, 1957. POSTER Gosta Aberg, Sweden Aberg was the pupil of the well-known Swedish poster designer Eric Rohman. Where Rohman was renowned for his illustrative work, Aberg used a distinctive style of photographic collage.

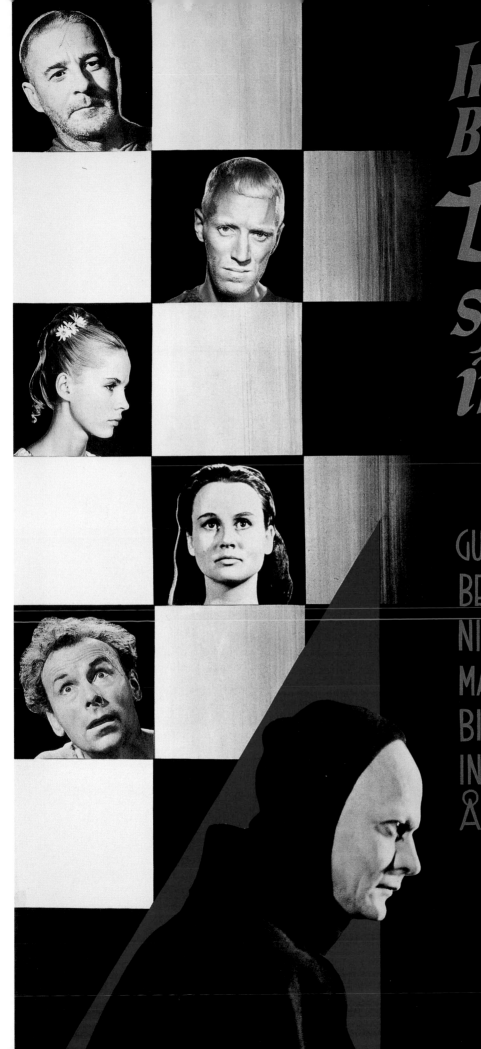

Ingmar Bergmans Det sjunde inseglet

GUNNAR BJÖRNSTRAND
BENGT EKEROT
NILS POPPE
MAX VON SYDOW
BIBI ANDERSSON
INGA LANDGRÉ
ÅKE FRIDELL

ROBERT et RAYMOND HAKIM présentent

CATHERINE DENEUVE
JEAN SOREL
MICHEL PICCOLI

dans

un film de

Luis Buñuel

BELLE DE JOUR

d'après le roman de

JOSEPH KESSEL
de l'Académie Française

avec

GENEVIÈVE PAGE
PIERRE CLÉMENTI
FRANCISCO RABAL
FRANÇOISE FABIAN
MACHA MERIL
MARIA LATOUR • MUNI
et
GEORGES MARCHAL
avec la participation de
FRANCIS BLANCHE
Adaptation et dialogue LUIS BUÑUEL et JEAN-CLAUDE CARRIÈRE
Directeur de la production HENRI BAUM

EASTMANCOLOR
Distribution VALORIA FILMS

PUBLICITÉ Grebaisson S.A. INTERDIT AUX MOINS DE 18 ANS

Belle de Jour
Éditions Gallimard

Luis Buñuel

The Spanish director Luis Buñuel (1900–1983) embarked on his cinematic career with a pair of extraordinary films, *Un chien andalou* (1929) and *L'Age d'or* (1930), both of which were co-written with Salvador Dali. The former will forever be remembered for the scene in which a woman's eye, enlarged to fill the screen, is split open with the blade of a scalpel. Around that image are a series of other peculiar and striking sequences, such as a man dragging two grand pianos filled with dead donkeys and live priests. The overall impression is of something hovering between profundity and meaninglessness. Buñuel and Dali's second co-production had more pretence of a plot, but was equally surreal.

Buñuel fled Spain when General Franco came to power in the mid-1930s and, after a few years in the United States, settled in Mexico, where he lived for the rest of his life. Around 40 years after his film début, the director enjoyed a late flowering with a series of movies made in Europe. The best known are *Belle de Jour* (1967), *Le Charme discret de la bourgeoisie* (1972), and *Cet obscur objet du désir* (1977). Buñuel remained committed to the central tenets of Surrealism throughout his 50-year career.

The posters for the first, French releases of Buñuel's later films were designed by René Ferracci. Ferracci had worked in cinema distribution since the mid-1950s and by the time he began to design for Buñuel he was France's leading expert in poster design. Ferracci's work is not distinguished by a single style or technique; instead the designer used whatever means appropriate, be it illustration, typography, or photographic collage, to best communicate the themes of the film. During his 25-year career Ferracci designed more than 3000 film posters.

LEFT *Belle de Jour*, Luis Buñuel, 1967. POSTER René Ferracci, France This film cast the classically beautiful Catherine Deneuve as a woman who, failing to find sexual satisfaction in her marriage, takes up work as a part-time prostitute. On the poster Deneuve looks demurely over her shoulder.

BELOW *Le Charme discret de la bourgeoisie*, Luis Buñuel, 1972. POSTER René Ferracci, France The centrepiece of this film is a constantly interrupted, unfinishable dinner party. Ferracci's illustration is a surreal juxtaposition of traditional middle-class emblems.

BELOW *Cet obscur objet du désir*, Luis Buñuel, 1977. POSTER René Ferracci, France The central conceit is that the object of desire is played by two actresses. The lips on this poster recall those on Ferracci's previous image for this film. Now sewn shut, they create an oddly unyielding metaphor.

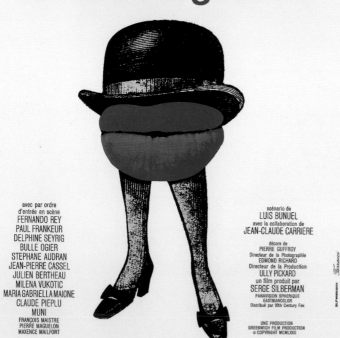

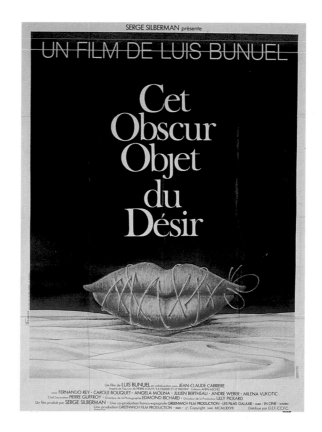

Federico Fellini

The single image most associated with the *oeuvre* of Federico Fellini (1920–1993) is that of the majestic Anita Ekberg frolicking in the Trevi fountain in *La dolce vita*. Stills from this scene are much used in publicity for the film, but were not part of the first-run campaign. In the watercolour posters advertising the Italian release, Ekberg is sometimes barefoot, but remains resolutely dry.

Embarking on his career during Italian cinema's neo-realist period, Fellini did not embrace the concerns of his peers. Although a social conscience is evident in his work, the style of delivery tends more towards the personal and emotional than the detached and political. Fellini was raised in Rimini, on the Adriatic coast. As a young man he was strongly attracted to the circus and vaudeville. His directorial début, *Luci del varietà* (1950), deals with the circus environment; his next film, *I vitelloni* (1953), tells the tale of a group of young men who feel trapped by small-town life. Fellini's subsequent films are equally inward-looking, *La dolce vita* reflecting the director's short early career on the fringes of journalism and *8½* dealing with his mid-life crises (the title referring to his tally of films in 1963, the year the film was made).

Fellini's autobiographical bias has won him equal measures of praise and censure. Whatever the final assessment, his lavish, fantastical films provided wonderful subject-matter for poster designers in Italy and beyond.

BELOW *La dolce vita*, Federico Fellini, 1959. POSTER USA This poster tempts audiences with a combination of stills focusing on a befurred Anita Ekberg holding a small furry friend. The wilfully illiterate tagline serves only to spoil the mood.

RIGHT *8½*, Federico Fellini, 1963. POSTER Italy Although combining unlikely elements, this poster achieves an effective overall look. The harsh geometry created by the film-set scaffold provides an elegant frame for the photographs, topped with the decorative flourish of the 19th-century-style numerals.

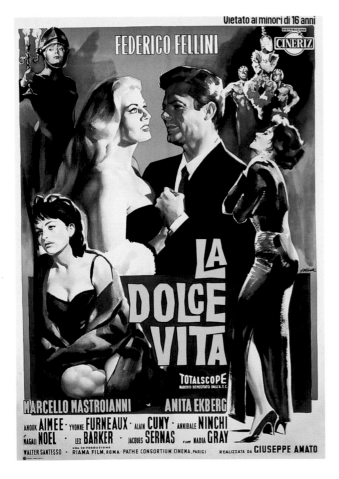

ABOVE *La dolce vita*, Federico Fellini, 1959. POSTER Giorgio Olivetti, Italy Olivetti's painting technique is a perfect match for the charms of Anita Ekberg. Hair has never appeared more lustrous, flesh never fleshier. The result is an over-whelming image of abundance.

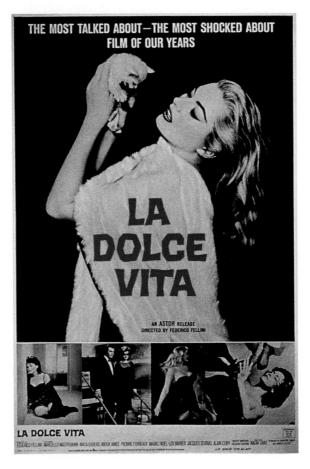

ANGELO RIZZOLI presenta

FEDERICO FELLINI

8 ½

con

MARCELLO MASTROIANNI
CLAUDIA CARDINALE
ANOUK AIMEE
SANDRA MILO

ROSSELLA FALK · BARBARA STEELE · GUIDO ALBERTI
MADELEINE LEBEAU · JEAN ROUGEUL · CATERINA BORATTO
E CON ANNIBALE NINCHI · GIUDITTA RISSONE

PRODUZIONE
CINERIZ
DISTRIBUZIONE
S.p.A.

LITO-P. RAGIONI Roma Via Prenestina 738

James Bond

The rise of James Bond during the 1960s echoed the absorption into the mainstream of soft-porn magazines such as *Playboy* and increasingly open discussions about sex in the British and American media. Bond has always been tinged with parody, but during his first cinematic decade he was a figure of some cultural significance. This changed in the early 1970s, when the role played by Sean Connery was relinquished first to George Lazenby and then to Roger Moore. No longer edgy and titillating, the secret agent began to seem anachronistic and faintly absurd. On the poster for *From Russia With Love* the gun-toting Connery appears super-confident and virile, whereas in the image for *The Spy Who Loved Me* Roger Moore flicks his revolver in a manner that verges on the camp.

The imagery on Bond posters often draws from their title sequences. Designed mainly by Maurice Binder, these three-minute films-within-a-film bring together girls, guns, and explosives to create pure essence of Bond. Created by American graphic designer Robert Brownjohn, the title sequences for the second and third films, *From Russia With Love* and *Goldfinger*, are more minimal than Binder's extravaganzas. The advertising campaign for *Goldfinger*

was faithful to the motif of the titles, in which scenes from the film are screened on a gold-painted nude, and is strikingly more restrained than most Bond imagery.

Bond films were made in Britain using American money raised by the expatriate American producers Harry Saltzman and Albert "Cubby" Broccoli. A US/UK hybrid, they offer a view of British manners and culture that the British find flattering and the Americans amusing.

BELOW *You Only Live Twice (Si vive solo due volte)*, **Lewis Gilbert, 1967.** POSTER Italy
The last of Connery's run as Bond, *You Only Live Twice* sold itself on the familiar formula of gadgets, guns, and sharp suits. Here the type of the title peels apart, a visual analogy for the possibility of a double life.

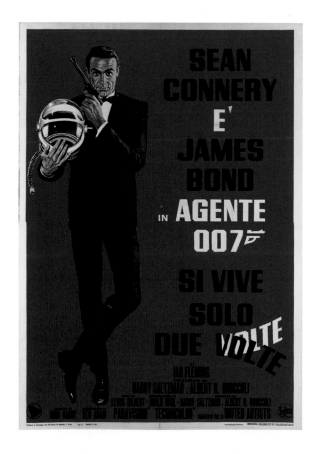

LEFT *The Spy Who Loved Me*, **Lewis Gilbert, 1977.** POSTER Japan
This combination of female flesh, high-speed vehicles, and explosives is very similar to that of the film's title sequence. By 1977 Bond was a formula that could be relied on to attract an audience.

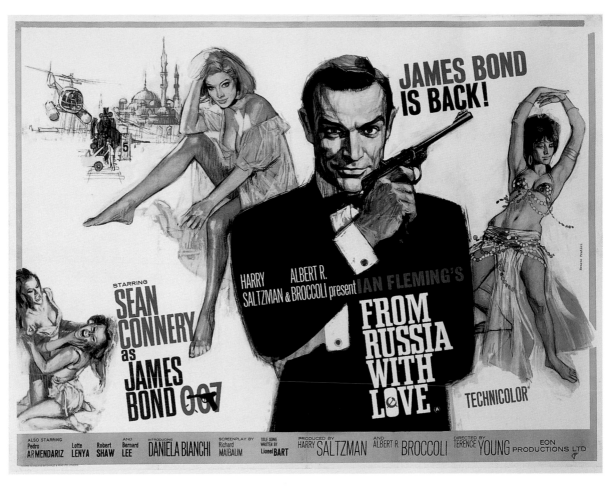

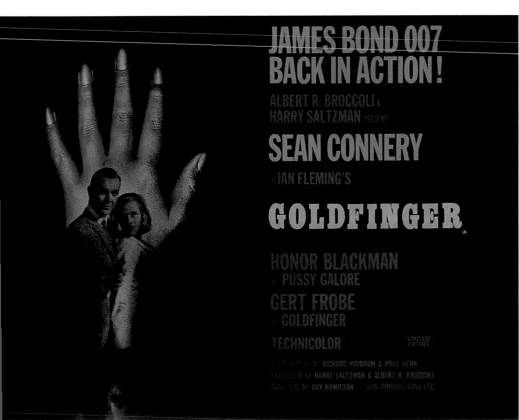

ABOVE *From Russia With Love*, Terence Young, 1963. POSTER Renato Fratini, UK This image was among the first to show Bond in his characteristic arms-across-chest-and-gun-at-shoulder pose. As such it has become the closest there is to a definitive Bond illustration.

LEFT *Goldfinger*, Guy Hamilton, 1964. POSTER UK This image of the outstretched golden hand is the film's B-style poster. The better-known A-style shows more extended scenes from the film projected across the gilded woman's flank.

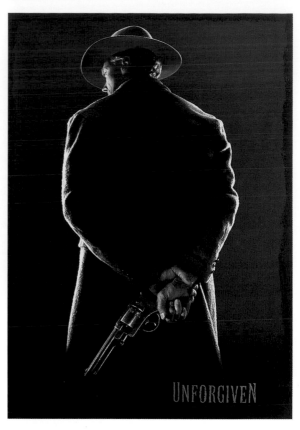

Clint Eastwood

Seeking an actor to star in a western remake of Akira Kurosawa's *Yojimbo*, Italian director Sergio Leone spotted Clint Eastwood (b. 1930) in the television series *Rawhide*, and promptly flew him to Spain to head the cast of *A Fistful of Dollars*. The film was a hit and Eastwood's acting style, characterized by passages of languidness interspersed with bursts of firepower, proved compelling. A year later Leone directed Eastwood in a sequel, *For a Few Dollars More*; the third film in the series was *The Good, the Bad and the Ugly*. After completing the trilogy, Eastwood returned to the United States. In his later movies he continued to work on variations of the ruthless yet honourable character he had developed during his Italian adventure.

In 1971 Eastwood entered into a collaboration with the designer Bill Gold. Initially creating posters for the *Dirty Harry* series, Gold belied his 30-year experience and came up with a collection of pared-down images that still look strikingly modern. Once in the director's chair, Eastwood commissioned Gold to create the campaigns for most of his movies. He débuted as a director with the stylish thriller *Play Misty for Me* (1971) and has since created a steady stream of movies. The height of his acting and directorial achievement so far is the neo-western masterpiece *Unforgiven*. Designing a teaser campaign for this powerful film, Gold created one of the most memorable images of his career. Eastwood stands with his back to the viewer, blocking a light source that illuminates his half-turned face and the bulky outline of his coat. The gun that the actor clutches behind his back has been his constant on-screen companion for nearly 50 years.

LEFT *Unforgiven*, Clint Eastwood, 1992. **POSTER** Bill Gold, USA The teaser campaign for this neo-western masterpiece relies on our familiarity with Eastwood's image. It is as if the young man in the poster on the far left had aged several years and turned his back to us.

BELOW *A Fistful of Dollars (Per un pugno di dollari)*, Sergio Leone, 1964. **POSTER** Sandro Simeoni, Italy Advertising the first Eastwood/Leone film, this emphasizes action over leading players. Eastwood takes a clockwise dive in a wonderful graphic expression of a shootout.

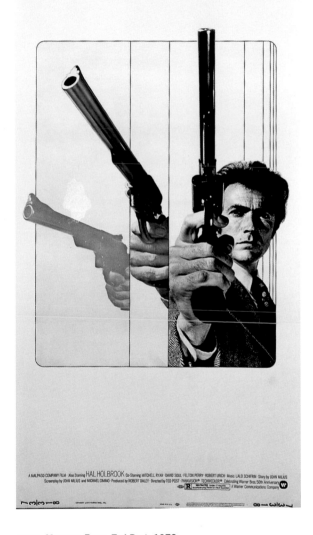

ABOVE *Magnum Force*, Ted Post, 1973. **POSTER** Bill Gold, USA Presenting the firearm as the star of the *Dirty Harry* series, this poster portrays Eastwood as steely-eyed but decidedly secondary. The use of black and white creates the sense of a movie rooted in gritty realism.

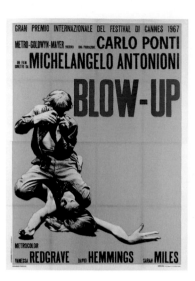

ABOVE *Blow-Up*, Michelangelo Antonioni, **1966.** POSTER **UK** In order to achieve an air of heightened reality Antonioni had the outdoor sets of *Blow-Up* painted so that grass became greener and tarmac blacker. This series of posters refers to the film's hyperreal palette.

RIGHT *Zabriskie Point*, **Michelangelo Antonioni, 1969.** POSTER **Milton Glaser, USA** The designer Milton Glaser is best known for his work on Bob Dylan's 1967 *Greatest Hits* album. Functioning somewhat like a record cover, this image is a metaphor for the theme of the film.

Michelangelo Antonioni

The films of Michelangelo Antonioni (b. 1912) fuse surreal plots and bourgeois manners. After making a name for himself in Italy, notably with *L'avventura* (1960), Antonioni was engaged by producer Carlo Ponti to make a series of three international co-productions, *Blow-Up* being the first.

Starring David Hemmings, *Blow-Up* tells the story of a fashion photographer loosely based on photographer and 1960s celebrity David Bailey. The film's murder-mystery plot is little more than an excuse to create a metaphor for the crisis of values that Antonioni saw at the heart of "swinging London". Hemmings's character captures evidence of wrongdoing on film but he does nothing. The character is revealed as thoroughly superficial. The real appeal of *Blow-Up* lies in its portrayal of modish London life. Girls and cars play significant roles and the action

between model and photographer portrayed on the poster is among the sexiest of non-sex scenes.

Antonioni's follow-up was *Zabriskie Point*. Hoping to attract a young counter-culture audience, MGM invested a huge amount in this story of political injustice, civil warfare, and moral extremes. The result was a disaster. Audiences both establishment and anti- found *Zabriskie Point* pretentious and embarrassing. The film's climactic moment is the explosion of the opulent desert retreat of a real-estate tycoon. A metaphor for the imminent demise of mainstream America, Milton Glaser's poster shows tokens of US culture being flung mid-air and casting no more than a cursory shadow. In spite of making a partial comeback in 1975 with *The Passenger*, Antonioni's international career never recovered from *Zabriskie Point*.

Stanley Kubrick

The career of Stanley Kubrick (1928–1999) is one of great variety. Appointed by Kirk Douglas to replace Anthony Mann as director of *Spartacus* (1960), at the age of 22 he found himself in charge of one of the most expensive films ever made. He followed it up with a series of thematically and artistically ambitious movies including *Lolita*, *Dr Strangelove*, and *2001: A Space Odyssey* (1968).

Having worked with Saul Bass on *Spartacus*, Kubrick turned to Bert Stern for the publicity pictures for *Lolita*. Stern, renowned as the photographer on Marilyn Monroe's last session in 1962, took the famous picture of the teenager in heart-shaped glasses. This photograph of actress Sue Lyon has taken on an independent existence, allying Lolita with the cute rather than the perverse.

Dr Strangelove is a black comedy set on the brink of nuclear war. Illustrator Tomi Ungerer's political consciousness was formed during his childhood in Nazi-occupied Alsace; his *Dr Strangelove* poster is a memorable image of the world's unthinking oligarchs. For *A Clockwork Orange*, Kubrick commissioned the illustrator Philip Castle to design the posters as well as to work on the sets for the film. As a result the movie's bulbous 1970s modernist aesthetic is translated seamlessly into its publicity.

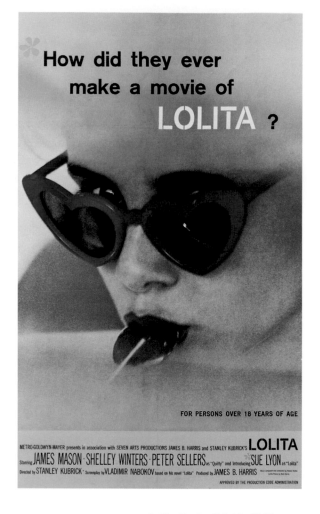

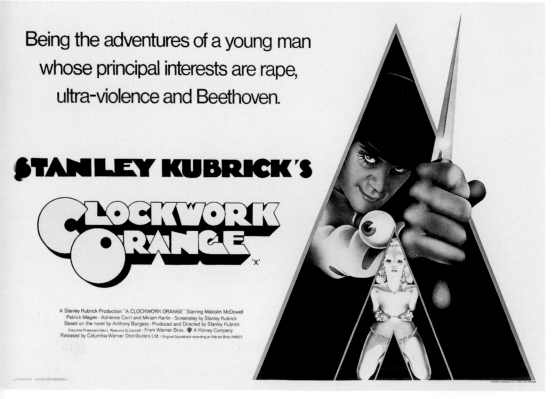

ABOVE *Lolita*, Stanley Kubrick, 1961. POSTER Bert Stern (photographer), USA The answer to the question "How did they ever make a movie of *Lolita*?" might be "They didn't". It does not take a Nabokovian purist to realize that the teenage Sue Lyon is no Lolita.

LEFT *A Clockwork Orange*, Stanley Kubrick, 1971. POSTER Philip Castle, UK The movie version of Anthony Burgess's novel was unavailable for viewing in the UK for 27 years, withdrawn by Kubrick himself after reports of copycat killings in the British press. Castle's famous airbrush image has iconic status, all the more threatening for its association with censorship.

RIGHT *Dr Strangelove*, Stanley Kubrick, 1963. POSTER Tomi Ungerer, USA Although the Cold War is over, Ungerer's image of the world in the shadow of the nuclear threat remains apt 40 years later. So too does his portrayal of the besuited men in charge of our fate.

Peter Sellers · George C. Scott
in Stanley Kubrick's

Dr. Strangelove

Or:
How
I Learned
To
Stop
Worrying
And
Love
The
Bomb

the hot-line suspense comedy

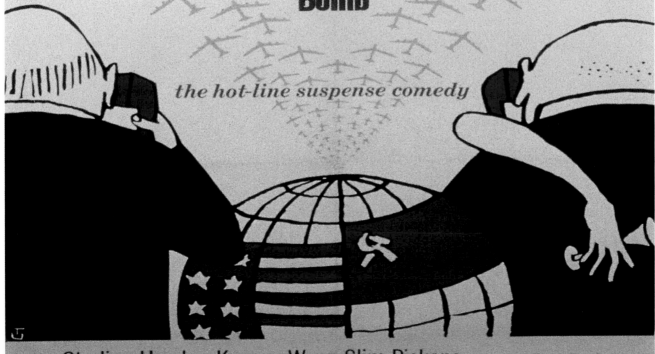

also starring Sterling Hayden · Keenan Wynn · Slim Pickens and introducing Tracy Reed as "Miss Foreign Affairs"
Screenplay by Stanley Kubrick, Peter George & Terry Southern Based on the book "Red Alert" by Peter George
Produced & Directed by Stanley Kubrick · A Columbia Pictures Release

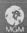

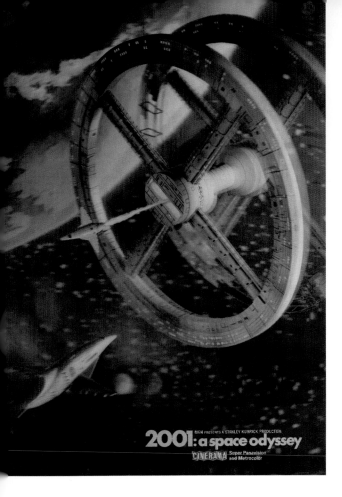

LEFT **2001: A Space Odyssey**, **Stanley Kubrick, 1968.** POSTER USA Used as a subsidiary style during the film's initial release, this poster became the primary advertising image for the film's 1970s outings, by which time audiences had been heavily exposed to space-age vistas.

ABOVE LEFT **2001: A Space Odyssey, Stanley Kubrick, 1968.** POSTER USA This poster is a lenticular that creates a 3-D image when saturated with light. It was the first time that such a technique had been used in film promotion and the poster is now very rare.

ABOVE **2001: A Space Odyssey (2001: Odyseja Kosmiczna), Stanley Kubrick, 1968.** POSTER **Wyetor Gorka, Poland** The all-knowing, sweet-talking computer HAL plays a large part in 2001. Artist Wyetor Gorka imagines the brushed-metal features of the film's faceless mechanical voice.

2001: A Space Odyssey

2001: A Space Odyssey is an adaptation of Arthur C. Clarke's 1948 story *The Sentinel*. Co-written by Clarke and director Stanley Kubrick, the film follows a symbolic rather than a narrative course, spanning many millennia. It met with mixed reviews, but its reputation grew and by the eponymous year 2001 it was an undisputed classic.

Despite a running time of more than two hours, *2001* contains only about 40 minutes of dialogue. Classical music takes the place of speech, and audiences gaze at a series of extraordinary tableaux rather than being whisked through conventional action sequences. One of the best-known scenes sees planets and spacecraft dancing a slow, circumnavigatory waltz to Strauss's *Blue Danube*. There have been more technologically-sophisticated representa-

tions of outer space since Kubrick made *2001*, but no one has matched it for pure interplanetary poetry. Its space-age interiors remain influential to designers worldwide. By making frequent references to everyday brands, Kubrick not only generated a chunk of his production budget, he also rooted his fantasy in a part-familiar world.

Kubrick was known for his ambition to control every aspect of film-making. He authorized the pictures used for *2001*'s worldwide campaign, concentrating on the wheel-shaped spaceship and the astronauts making their moon landing, although the latter image now seems dated. In recent years the film's theme of human evolution has trumped that of space travel, and the floating embryo has become the most popular associated image.

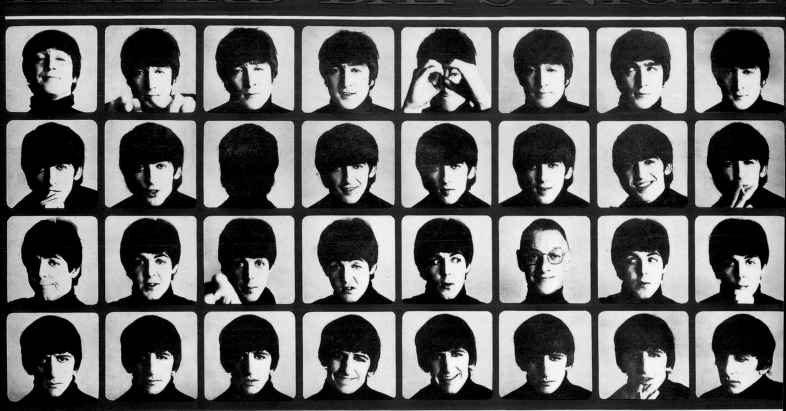

The Beatles

The Beatles made several films, fusing fiction and documentary with varying degrees of success. These movies created quasi-independent characters out of John, Paul, George, and Ringo, as demonstrated in *The Beatles Yellow Submarine*, in which their voices are spoken by actors.

The first Beatles film, *A Hard Day's Night*, was directed by American expatriate Richard Lester, responsible for the transfer of *The Goon Show* from BBC radio to television. Working with writer Alun Owen, he settled on a "day in the life" format and, though black and white was probably chosen for budgetary rather than aesthetic reasons, achieved a documentary look that suits the Beatles' low-key antics. The UK poster is in keeping with the mood of the film. Designed by experienced Beatles photographer Robert Freeman, it uses a multi-frame device that allows

the characters to appear distinct yet related, a format that has since been widely copied. The cover for the British *A Hard Day's Night* album uses the same design, but with a reduced 4 x 5 grid. Freeman also created the titles of the film, which relate closely to the album and poster.

Czech-born graphic designer and illustrator Heinz Edelmann was the art director on *The Beatles Yellow Submarine*. The realization of the animated feature took a huge team of illustrators and animators, but overall the look remained faithful to Edelmann's original vision. Like most *Yellow Submarine* posters, this Japanese image uses an adaptation of Edelmann's art. Cleverly collaging various sequences into a single image and elegantly integrating Japanese and non-Japanese text, it is one of the most successful promotional images for the film.

LEFT *A Hard Day's Night*, **Richard Lester, 1964.** POSTER **Robert Freeman** (photographer), **UK** Although the "fifth Beatle" title usually goes to former band member Stuart Sutcliffe or producer George Martin, here the role is given to the director, Richard Lester (six along, three down).

BELOW *The Beatles Yellow Submarine*, **George Dunning, 1968.** POSTER **Heinz Edelmann** (illustrator), **Japan** The "Blue Meanies" (middle right) were intended to be red: according to Edelmann an assistant switched the shade and, intentionally or not, altered the film's political overtones.

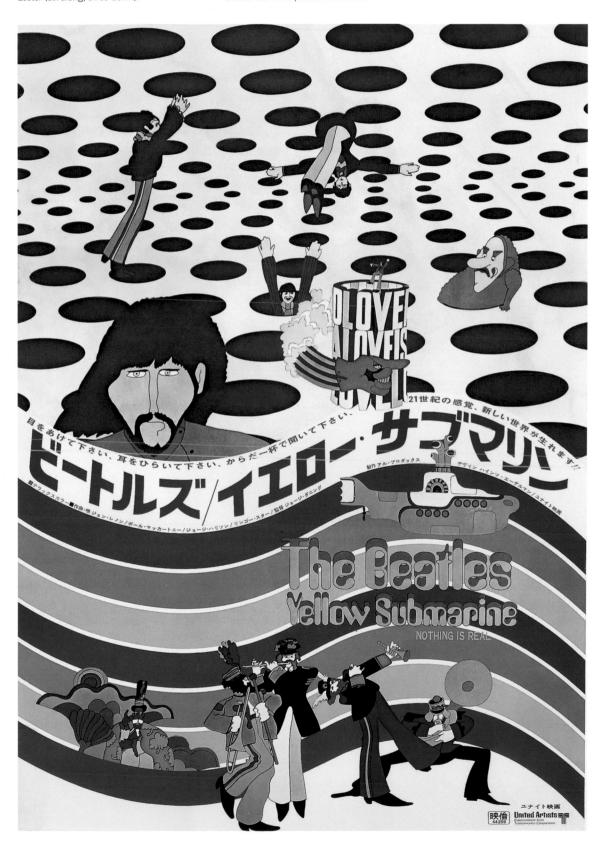

Exhibitionists

Made several decades ago, Jack Hazan's film *A Bigger Splash* and Andy Warhol's *Chelsea Girls* both anticipate the turn-of-the-millennium obsession with on-screen reality. *A Bigger Splash* is a semi-fictionalized documentary of the activities of artist David Hockney (b. 1937) in the early 1970s. It was made during Hockney's preparation for a large show, but rather than focus on art-making it foregrounds the collapse of the artist's relationship. Featuring a homosexual love scene explicit for its times, the movie created a sensation that Hockney found hard to live down.

There is a 1967 Hockney painting titled *A Bigger Splash*, but this is not the one used on the poster. Instead the painting has the softer lines of work made during the period in which the film was shot. The photograph laid on top is of Hockney's boyfriend, the young sculptor Peter Schlesinger. A beautiful boy and a sun-splashed pool should be a happy scene: instead it is somewhat poignant.

The most successful of the authored films of Andy Warhol (1928–1987), *Chelsea Girls* was inspired by New York's infamous Chelsea Hotel and the idea that, behind its walls, various unconstrained existences were being conducted in parallel. The film is shown split-screen with the projectionist choosing the running order of several half-hour mini-movies. Warhol's exhibitionists were very different from Hockney and Schlesinger: while the former lovers fled the reaction to their film, Warhol's superstars lived off the notoriety generated by their screen appearances. Designer Alan Aldridge's splayed-leg girl/hotel is illustrative of a lack of boundary between public and private self and of the harm inflicted by that transgression.

BELOW *A Bigger Splash*, Jack Hazan, 1974. POSTER David Hockney (painter and photographer), UK Juxtaposing photography and painting, this poster s evidence of Hockney's concern with a range of media. Later in his career he paid increasing attention to photography.

RIGHT *Chelsea Girls*, Andy Warhol, 1968. POSTER Alan Aldridge, UK Although witty, this poster suggests an upsetting degree of sexual violence. Winning a British Design and Art Directors' award in 1968, it harks back to a period when public sensibility on this issue was quite different.

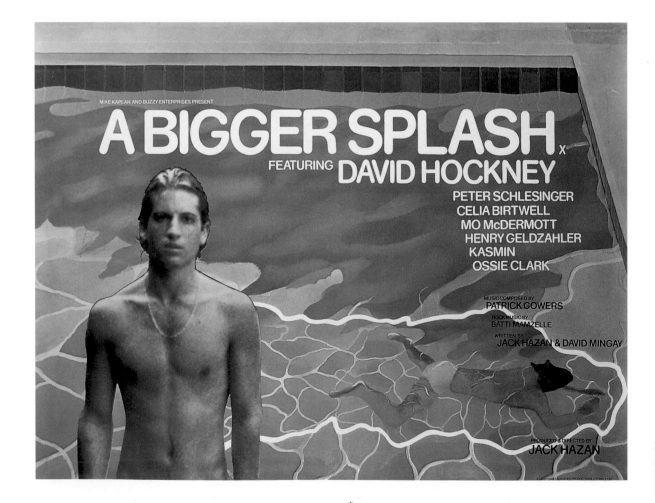

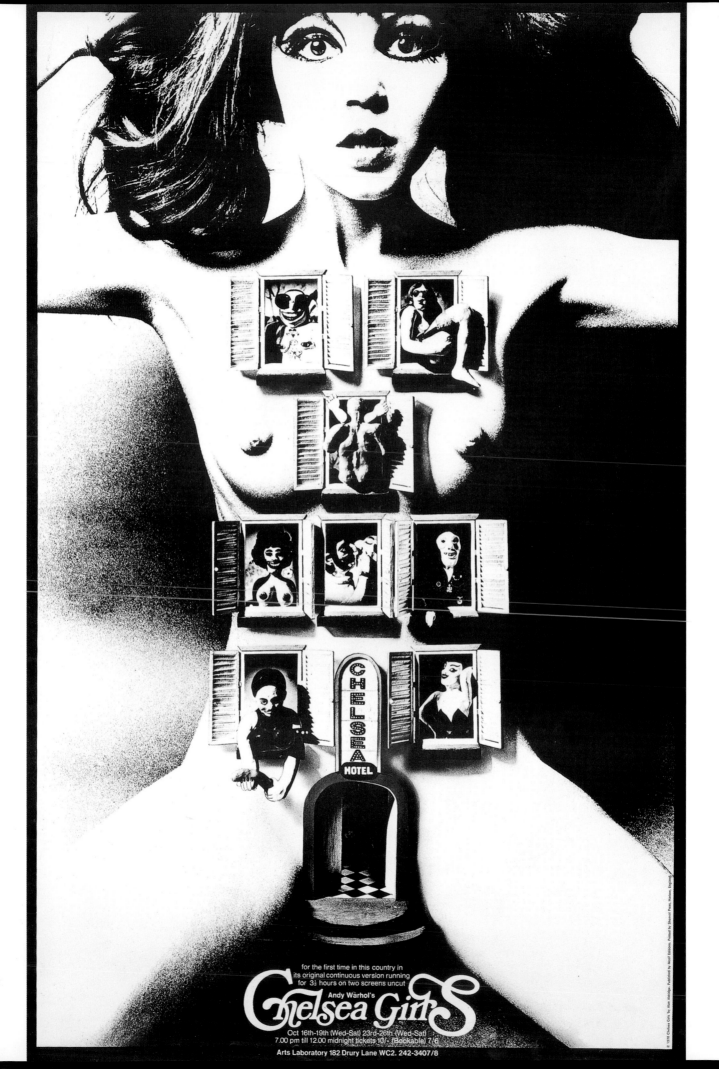

for the first time in this country in
its original continuous version running
for 3½ hours on two screens uncut
Andy Warhol's
Chelsea Girls
Oct 16th-19th (Wed-Sat) 23rd-26th (Wed-Sat)
7.00 pm till 12.00 midnight tickets 10/- (Bookable) 7/6
Arts Laboratory 182 Drury Lane WC2. 242-3407/8

US Counter-Cultural Cinema

By the late 1960s audiences were tiring of blockbusters, and a few low-budget productions surprised the industry by pulling in many times what they cost to make. Tapping into the youth market, studios produced a spate of cheap films on counter-culture themes.

The Graduate, the tale of the romantic misadventures of recent graduate Benjamin Braddock (Dustin Hoffman), seemed to sum up the uncertainty felt by a generation of young Americans. The original illustrated poster shows a small figure in an academic gown swamped by a suggestive, high-heeled leg; the poster was soon replaced with a photographic version that made the respective positions of the graduate and the bare leg more explicit.

Two years later Peter Fonda and Dennis Hopper made *Easy Rider*, a road movie in which the heroes travel across the United States on motorbikes. They meet with both acceptance and prejudice, but the film ends in tragedy. As in most counter-cultural films, the concerns of *Easy Rider* are typically American and highly masculine. Viewing the era through the lens of such films it becomes apparent that, although it was a time of cultural revolt, the parameters of agitation were extremely traditional.

Counter-cultural cinema spawned a generation of charismatic male leads including Jack Nicholson and Dustin Hoffman, and regenerated the career of others, such as Paul Newman and Robert Redford. Late 1960s movies also flirted with experimental techniques, accompanied by youthful sounds. Story, style, and sound combined to create a sense of excitement and freshness in US cinema that has not been matched since.

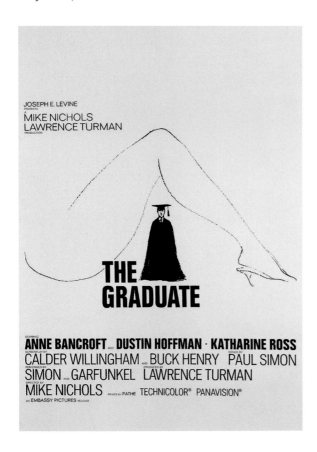

ABOVE *The Graduate*, Mike Nichols, 1967. POSTER USA Although it was soon replaced by a photographic version, the original illustrated poster, shown here, remains closely associated with the film. Its low-key aesthetic seems in keeping with the film's Simon and Garfunkel theme tune.

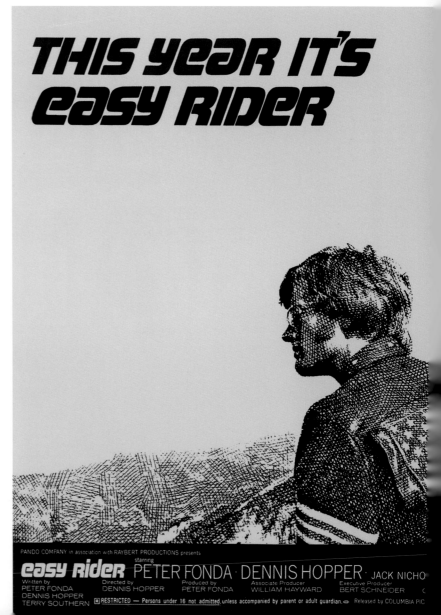

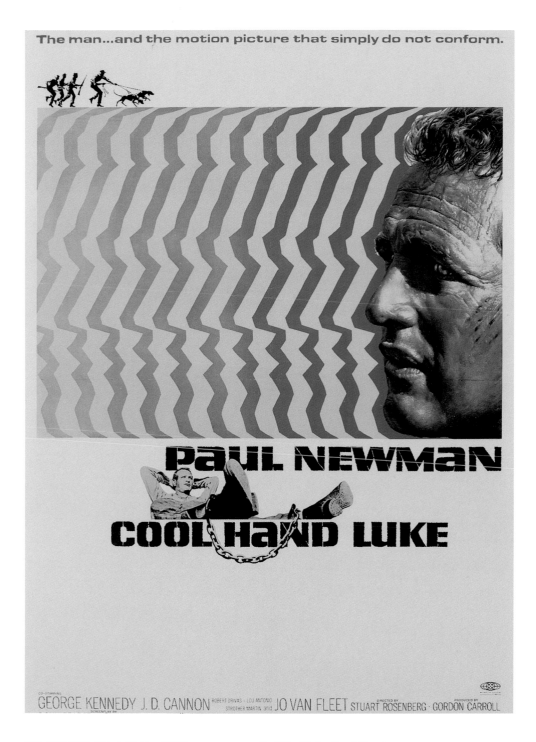

The man...and the motion picture that simply do not conform.

PAUL NEWMAN
COOL HAND LUKE

GEORGE KENNEDY J. D. CANNON ROBERT DRIVAS · LOU ANTONIO JO VAN FLEET STUART ROSENBERG · GORDON CARROLL

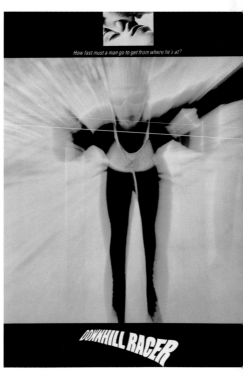

LEFT *Easy Rider*, Dennis Hopper, 1969. POSTER USA One-colour and typographic in emphasis, this poster fits the low-budget aesthetic of the film. Although no vehicles are visible, the combination of Fonda's jacket and the typographic style creates a strong biker feel.

ABOVE *Cool Hand Luke*, Stuart Rosenberg, 1967. POSTER USA The bars emanating from Paul Newman's profile symbolize both his imprisonment and his escape. The message of the film concerns the essential freedom of the human spirit: to resist capture one must remain true to oneself.

DUSTIN HOFFMAN

W FILMIE AMERYKANSKIM NAGRODZONYM OSKAREM

NOCNY KOWBOJ

REŻYSERIA:
JOHN SCHLESINGER

W POZOSTAŁYCH ROLACH:
JOHN VOIGHT, SYLVIA MILES,
BRENDA VACCARO

PRODUKCJA: JEROME HELLMAN
—UNITED ARTISTS

Midnight Cowboy

Very much of its time, *Midnight Cowboy* includes cinematic devices such as highly choreographed dream sequences, extended flashbacks, and long passages of flickering television, the last intended as a negative comment on consumerism. But for all its modish features, the film is a classic fish-out-of-water cum buddy tale. It is the story of town mouse and country mouse, played by humans and with the addition of sex.

The American publicity for *Midnight Cowboy* adopted a gritty realist mode. On the US poster for the film Dustin Hoffman's "Ratso" and Jon Voight's "Cowboy Joe Buck" huddle in the filth of the run-down New York building that they have made their home. Although the film itself is in colour, the black and white of the poster is appropriate, creating a documentary feel that is echoed by director John Schlesinger's unswerving interrogation of the bleak and grubby. As different as can be in looks, physique, and style of dress, Hoffman and Voight are shown on this poster as the epitome of odd-coupledom.

The illustrated Polish poster adopts a very different approach. Rather than concentrating on the film's take on friendship, it explores its portrayal of sex. In pursuit of a career as a hustler, naive Texan Buck becomes involved in many sordid sexual acts. These attempts to make money from prostitution invariably misfire and, rather than being the exploiter, Jon Voight's character is reduced time and time again to the role of the exploited. Like the faceless red-lipped cowboy in Waldemar Swierzy's image, he is treated as a depersonalized dispenser of sexual pleasure.

LEFT *Midnight Cowboy (Nocny Kowboj)*, John Schlesinger, 1969. POSTER Waldemar Swierzy, Poland Working from the mid-1950s on, Swierzy is among the most prominent of Polish poster artists. A powerful summary of the sexual theme of *Midnight Cowboy*, this poster is typical of his work.

BELOW *Midnight Cowboy*, John Schlesinger, 1969. POSTER Steven Shapiro (photographer), USA There was a feeling in the late 1960s that New York City, the rightful capital of the Western world, had all but ground to a halt. Like the film, this poster shows the city as run down and sordid.

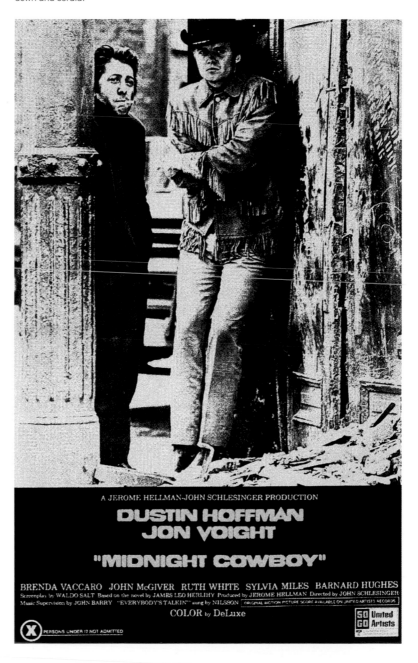

A JEROME HELLMAN-JOHN SCHLESINGER PRODUCTION
DUSTIN HOFFMAN
JON VOIGHT
"MIDNIGHT COWBOY"

BRENDA VACCARO JOHN McGIVER RUTH WHITE SYLVIA MILES BARNARD HUGHES
Screenplay by WALDO SALT Based on the novel by JAMES LEO HERLIHY Produced by JEROME HELLMAN Directed by JOHN SCHLESINGER
Music Supervision by JOHN BARRY "EVERYBODY'S TALKIN'" sung by NILSSON ORIGINAL MOTION PICTURE SCORE AVAILABLE ON UNITED ARTISTS RECORDS

COLOR by DeLuxe

United Artists

(X) PERSONS UNDER 17 NOT ADMITTED

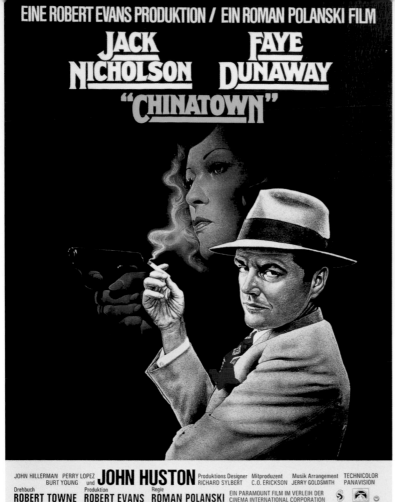

EINE ROBERT EVANS PRODUKTION / EIN ROMAN POLANSKI FILM

JACK NICHOLSON FAYE DUNAWAY

"CHINATOWN"

JOHN HILLERMAN · PERRY LOPEZ · BURT YOUNG und **JOHN HUSTON** Produktions Designer RICHARD SYLBERT · Mitproduzent C.O. ERICKSON · Musik Arrangement JERRY GOLDSMITH · TECHNICOLOR PANAVISION

Drehbuch **ROBERT TOWNE** · Produktion **ROBERT EVANS** · Regie **ROMAN POLANSKI** · EIN PARAMOUNT FILM IM VERLEIH DER CINEMA INTERNATIONAL CORPORATION

ABOVE *Chinatown*, Roman Polanski, 1974.
POSTER Richard Amsel, Germany This
German poster uses the American artwork by
Richard Amsel. A plume of smoke reveals
Faye Dunaway in a languid, Art Nouveau
style that refers to the film's 1930s setting.

BELOW *The Shining*, Stanley Kubrick, 1980.
POSTER UK A composition of eyes, mouths,
and blades, this image sums up the tension
of the film: his narrow-eyed lunacy against
her wide-eyed terror; his axe against her
kitchen knife; his leer against her scream.

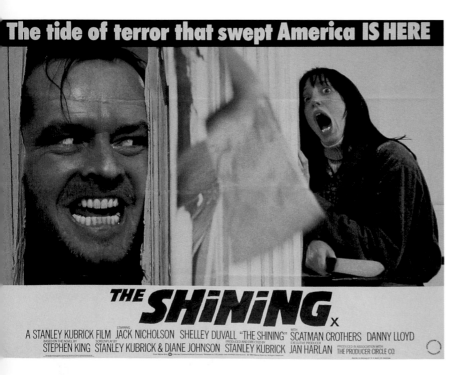

The tide of terror that swept America IS HERE

THE SHINING x

A STANLEY KUBRICK FILM · JACK NICHOLSON · SHELLEY DUVALL "THE SHINING" WITH SCATMAN CROTHERS · DANNY LLOYD
BASED ON THE NOVEL BY STEPHEN KING · SCREENPLAY BY STANLEY KUBRICK & DIANE JOHNSON · PRODUCED AND DIRECTED BY STANLEY KUBRICK · EXECUTIVE PRODUCER JAN HARLAN · PRODUCED IN ASSOCIATION WITH THE PRODUCER CIRCLE CO.

Jack Nicholson

Born in 1937, Jack Nicholson emerged as an international
star at the relatively ripe age of 32 after playing the hedo-
nistic Southern lawyer in Dennis Hopper and Henry
Fonda's *Easy Rider* (1969). Nicholson's celebrity is
founded on his maniacal qualities and many of his films
centre on explosive outbursts of fury or insanity. Similarly,
the posters for Nicholson's films tend to focus on the
actor's extraordinary, forever-on-edge features. The wide
mouth with its upturned corners, the narrow, penetrating
eyes, and, most of all, the irrepressible peaked eyebrows
add up to a face that demands attention.

Nicholson made most of his best work in the 1970s.
As private eye Jack Gittes in Roman Polanski's *Chinatown*,
he delivers a brilliant riff on the cynical detective of
1940s Hollywood *film noir*. His elegant negotiation of the
film's ever-twisting plot and his super-dry delivery render
the film a masterpiece. Nicholson next teamed up with
another European director, the Czech Milos Forman, to
make *One Flew Over the Cuckoo's Nest*. Based on the
novel by counter-cultural writer Ken Kesey, the film tells
the story of a convict who feigns insanity in order to spend
time in a mental hospital rather than serve a prison sen-
tence. The glee with which Nicholson's character under-
mines the repressive order of the hospital makes the film a
pleasure to watch in spite of its many harrowing scenes.
Nicholson ended the decade by slipping into self-parody.
Stanley Kubrick's *The Shining* relied heavily on his "mad
Jack" expression and, as the poster suggests, the film was
sold mainly on the bravura of his performance.

RIGHT *One Flew Over the Cuckoo's Nest*,
Milos Forman, 1975. POSTER USA Leaning
casually against the barbed-wire and mesh
fence, Nicholson's wayward psychiatric
patient adopts a mild grin and casts his eyes
to the sky. This expression suggests mental
freedom in the face of bodily imprisonment.

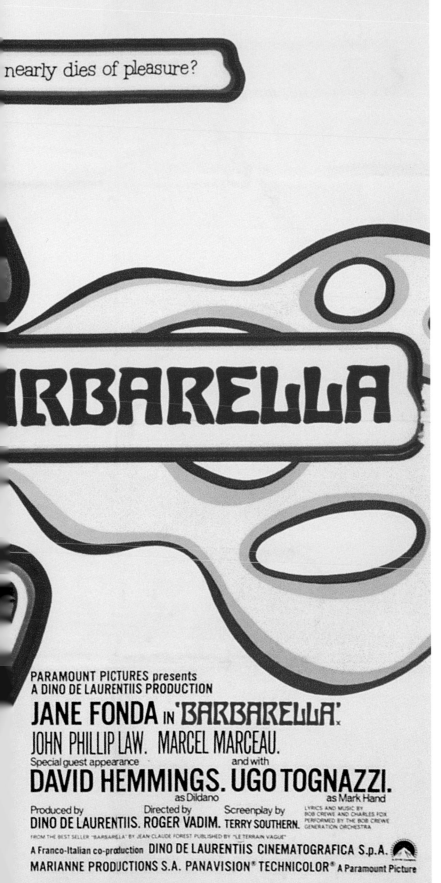

nearly dies of pleasure?

BARBARELLA

PARAMOUNT PICTURES presents
A DINO DE LAURENTIIS PRODUCTION
JANE FONDA IN 'BARBARELLA'.
JOHN PHILLIP LAW. MARCEL MARCEAU.
Special guest appearance and with
DAVID HEMMINGS. UGO TOGNAZZI.
 as Dildano as Mark Hand
Produced by Directed by Screenplay by LYRICS AND MUSIC BY
 BOB CREWE AND CHARLES FOX
DINO DE LAURENTIIS. ROGER VADIM. TERRY SOUTHERN. PERFORMED BY THE BOB CREWE
 GENERATION ORCHESTRA
FROM THE BEST SELLER "BARBARELLA" BY JEAN CLAUDE FOREST PUBLISHED BY "LE TERRAIN VAGUE"
A Franco-Italian co-production DINO DE LAURENTIIS CINEMATOGRAFICA S.p.A.
MARIANNE PRODUCTIONS S.A. PANAVISION® TECHNICOLOR® A Paramount Picture

Barbarella

Roger Vadim's *Barbarella* was based on a character from a French science-fiction comic strip, a sexually adventurous space explorer with catholic erotic tastes. Never entirely three-dimensional, Barbarella has had an extensive official and unauthorized two-dimensional existence. Drawn by Robin Ray, this British poster is only one of many illustrated versions of the underclad space babe. Diffuse and episodic, it harks back to the comic-book format in its juxtaposition of images and its use of speech bubbles.

Around the time that Ray illustrated this poster, Derek Birdsall designed the now famous September 1968 *Nova* magazine cover in which the modern woman bemoaned her lot. Dressed entirely in red and smoking a cigarette, she complained, "I have taken the pill. I have hoisted my skirts to my thighs, dropped them to my ankles, rebelled at university, abused the American Embassy, lived with two men, married one, earned my keep, kept my identity and, frankly ... I'm lost." Consciously influenced or not, the *Barbarella* poster blurb relates closely to this diatribe, but, unlike her earthbound sister, Barbarella has given up the pill and, what is more, she has taken sex to outer space. Implicitly she declares that prosaic women's dilemmas involving professional, political, and marital status are redundant. According to Barbarella, the only legitimate concerns of "the girl of the 21st century" are where and how she receives and dispenses pleasure.

Unsurprisingly *Barbarella* proved an irritant to late 1960s and early 1970s feminists, including Jane Fonda herself in her later politically conscious incarnation. However, in the 21st century, the original 21st-century girl seems more of a decorative post-feminist plaything than a serious barrier to women's rights.

LEFT *Barbarella*, **Roger Vadim, 1968.**
POSTER **Robin Ray, UK** Ray's illustration
was influenced by British psychedelia.
This poster for *Barbarella* displays the
graphic tics of the late 1960s design group
Hapshash laundered through a mainstream
comic-book aesthetic.

Apocalypse Now

Francis Ford Coppola

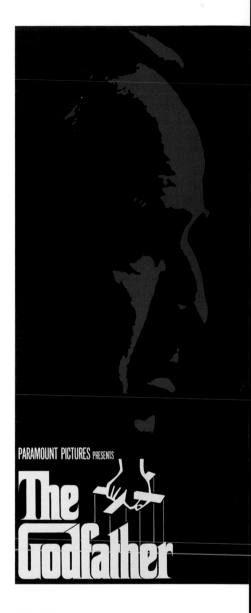

After graduating with a degree in film from UCLA, Francis Ford Coppola (b. 1939) began to work in the industry as a writer, a producer, and a director. Forty years on, he is still active in all these fields. Among Coppola's earliest films was the 1972 triumph *The Godfather*, a production that won the film-maker the best original screenplay Oscar. Not only an artistic success, the movie also enjoyed record earnings at the box office. Coppola has not always found it easy to live up to this emphatic début in big-league film-making. His portfolio is strikingly uneven and he has acquired the reputation of one of the United States' most erratic film-makers.

Coppola's 1979 film *Apocalypse Now* was viewed in a mixed light at the time of its release. The production had gone way past schedule and budget, nearly breaking the spirit of the director and the finances of his production company. The grandeur of the film ensured its immediate recognition as a creative achievement, earning it a nomination for the best picture Oscar, but potential audiences were not so sure and first-run attendance was lacklustre. Since then, however, successive generations have rediscovered the film and it now holds a secure place in the cinematic canon. In 2001 Coppola released his own cut of the movie under the title *Apocalypse Now Redux*.

The money and time involved in the making of *Apocalypse Now* generated a myth well before the film's release. In keeping with this buzz, the launch became something of an event and respected illustrator Bob Peak was commissioned to create five promotional images. The artwork shown here is Peak's favourite of the series.

ABOVE *The Godfather*, Francis Ford Coppola, 1972. POSTER UK The stylized puppeteer's hand in this poster is a glib metaphor for the manipulative power of Marlon Brando's Mafia boss. Next to the dramatic two-colour portrait of the actor, it appears gimmicky and somewhat otiose.

FAR LEFT *Apocalypse Now*, Francis Ford Coppola, 1979. POSTER Bob Peak, USA Typical of Peak's style, this poster is a montage of scenes from the film. In line with the demands of marketing, Peak concentrated on the star, Marlon Brando, emphasizing what he has described as Brando's "marvellous head".

Martin Scorsese

Martin Scorsese (b. 1942) grew up on New York's Lower East Side and many of his films, including *Mean Streets*, *Raging Bull*, and *Goodfellas* (1990), document his childhood environment. Scorsese has also been profoundly influenced by the history of film. As well as exploring traditional genres such as the gangster film and the costume drama in his work, he is active in the maintenance and promotion of the cinematic canon.

The advertising campaigns for Scorsese's films reflect his keen awareness of visual currents both in the world of cinema and beyond. The poster for *Mean Streets* is an elegant, Art Deco-style design, in keeping with graphic trends of the time. Likewise the photorealist painting for *Taxi Driver* by Guy Peellaert was at the height of mid-1970s graphic fashion: in 1973 Peellaert had exhibited his paintings of music and movie celebrities at the London store Biba. Later in his career Scorsese made an explicit reference to film history by employing the graphic-design veteran Saul Bass to create posters for films including *Cape Fear* (1991) and *The Age of Innocence* (1993).

BELOW *Mean Streets*, Martin Scorsese, 1973. POSTER USA This poster uses Herb Lubalin's 1970 typeface Avant Garde to great effect. The sloping sides of the letters perfectly complement the stylized plume of the smoking gun and the silhouetted New York City landscape.

RIGHT *Taxi Driver*, Martin Scorsese, 1976. POSTER Guy Peellaert, USA This was the first film poster created by the Belgian artist Guy Peellaert. Since Scorsese's initial commission, he has created posters for a number of other directors including Chantel Ackerman and Wim Wenders.

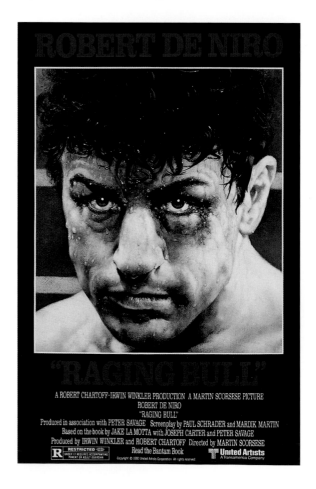

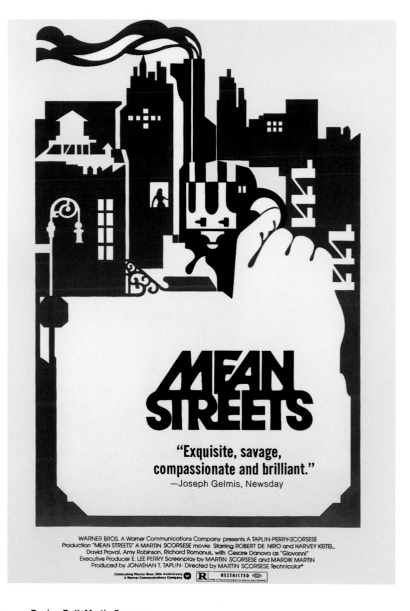

LEFT *Raging Bull*, Martin Scorsese, 1980. POSTER Kunio Hagio, USA Using a photorealist style similar to that of Guy Peellaert, illustrator Kunio Hagio emphasizes the battered face and dripping brow of Robert De Niro as Jake La Motta.

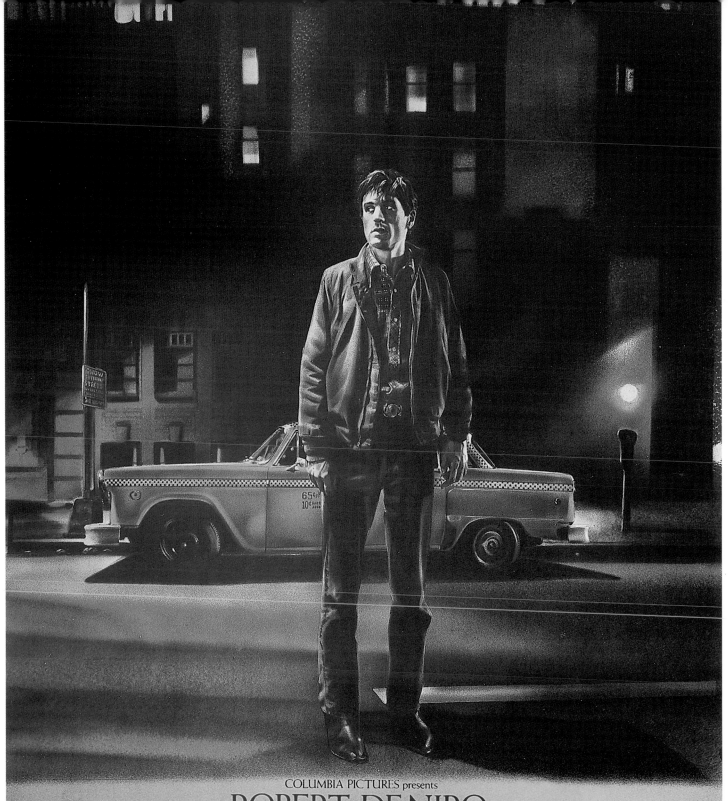

COLUMBIA PICTURES presents

ROBERT DE NIRO
TAXI DRIVER

A BILL/PHILLIPS Production of a MARTIN SCORSESE Film

JODIE FOSTER ALBERT BROOKS as "Tom" HARVEY KEITEL
LEONARD HARRIS PETER BOYLE as "Wizard" and

CYBILL SHEPHERD as "Betsy"

Written by PAUL SCHRADER Music BERNARD HERRMANN Produced by MICHAEL PHILLIPS
and JULIA PHILLIPS Directed by MARTIN SCORSESE Production Services by Devon/Persky-Bright

Columbia
Pictures

R RESTRICTED
Under 17 requires accompanying Parent or Adult Guardian

WOODY ALLEN'S

MANHATTAN

Woody Allen

Woody Allen was born in the Bronx in 1935. Originally called Allan Stewart Konigsberg, he changed his name at the age of 16, ostensibly to make it more suited to show business. Allen began his career writing for comedy and soon graduated to performing his own material, both live and on television. His first venture into cinema was *What's New Pussycat?* (1965). In spite of writing the script and playing a major supporting role in this film, Allen's input was highly compromised and the final product bears very few of his characteristic qualities. He débuted as director in 1966 with the film *What's Up, Tiger Lily?* Most of Allen's best-known films were made in the 1970s, including *Bananas* (1971), *Sleeper* (1973), *Annie Hall*, and *Manhattan*. It was during this decade that Allen forged a directorial identity quite unlike that of any other, one that hinges on autobiographical concerns.

The credits to Woody Allen films tend to conform to a single format, something akin to a silent-movie title card. Similarly, Allen's posters are often self-consciously underplayed. The *Annie Hall* advertisement is a simple black-and-white still, showing Diane Keaton as the eponymous Annie, dressed in a style that sporadically returns to fashion and is forever associated with Allen's film. The line between Keaton and her character in this film was never entirely clear, and the actress claimed to find her acting in this instance emotionally embarrassing. The *Manhattan* poster also relies on a single black-and-white image, although in this case the city takes precedence over the characters. This couple contemplating the Brooklyn Bridge is among cinema's most evocative images of New York.

LEFT *Manhattan*, **Woody Allen, 1979.**
POSTER USA The customized *Manhattan* logo – casting the first A as the Chrysler building, the H as the Twin Towers, and so on – is a well-contained element of exuberance in what is, overall, a highly minimal piece of design.

BELOW *Annie Hall*, **Woody Allen, 1977.**
POSTER USA The tagline "A nervous romance" marks this poster as an advertisement from the film's original release. Later versions were given the much blander tag "A new comedy".

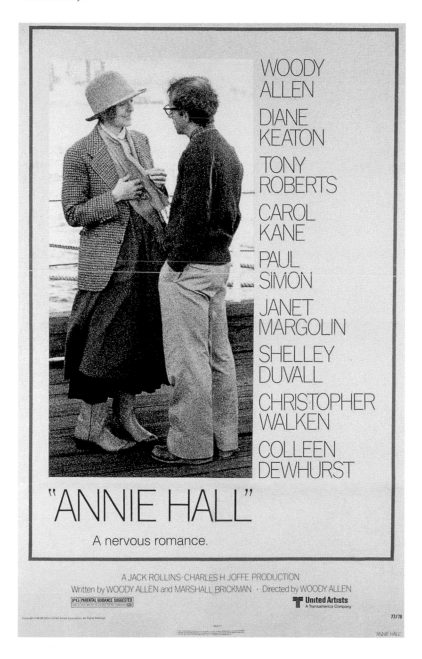

Last Tango in Paris

Last Tango in Paris, directed by Bernardo Bertolucci, has acquired emblematic status. In its bid to be a grown-up exploration of graphic sexuality, it has become the butt of countless juvenile – though often very funny – jokes. In particular the butter scene, in which Marlon Brando's character Paul employs the dairy product as a lubricant, has achieved a runaway notoriety, forever associating butter with seditious sexual activity. Although now more likely to raise laughs, at the time this scene, alongside the movie's other frank representations of sexual acts, was regarded as indecent. There were attempts to have the film banned both in the United States and in Europe.

Nothing in Bertolucci's background could have prepared him for the reputation garnered with *Last Tango*. Born in 1940, the son of celebrated Italian poet Attilio Bertolucci, he enjoyed a liberal, artistic upbringing. Before moving into film he published an award-winning volume of poems and throughout his cinematic career his approach to film-making has been decidedly authorial. Bertolucci has either written his own screenplays or adapted them from literary novels, such as Alberto Moravia's *Il Conformista* or Paul Bowles's *The Sheltering Sky*. Interviewed several years after the event, Bertolucci admitted to having been emotionally unprepared for the reception of *Last Tango*.

The poster for the British release of *Last Tango in Paris* presumes its notoriety. Inert and mostly obscured by shadow, Brando deliberately undersells the film, allowing a primed prospective audience to make up the shortfall. The reclining actor takes on the aspect of a sexual predator indulging in a moment's rest between bouts of frenzied erotic activity. The grubby skirting-boards visible at the border of the photograph lend the poster a squalid, scene-of-the-crime feel that is in keeping with the general atmosphere of the movie.

RIGHT **Last Tango in Paris**, **Bernardo Bertolucci, 1972.** POSTER UK Making a virtue of the film's X rating, this poster places the X after the title as if it were an enticing little kiss. By the time of its British release the film was coasting on its reputation and needed no other tagline.

Marlon Brando

Last Tango in Paris

x

John Cassavetes

FAR RIGHT *The Killing of a Chinese Bookie*, **John Cassavetes, 1976.** POSTER Sam Shaw (photographer) This glorious photograph celebrates a rare instance of Cassavetes working in colour.

John Cassavetes (1929–1989) trained as an actor and his first film, *Shadows*, was based on improvisations emerging from his drama workshop. Made on a very small budget and shot on 16 mm film, *Shadows* was re-edited for commercial release after an initial art-house run. The film won Cassavetes international acclaim, prompting French film writers to claim him as a cousin of their own New Wave. Cassavetes was invited to work in Hollywood but, after directing a couple of features, he vowed never to accept the compromises of the studio system again.

From the mid-1960s on, Cassavetes concentrated on creating his own brand of intimate, unembellished, and morally complex cinema. He distributed these films through his own company and the posters reflect their idiosyncratic, low-budget origins. Cassavetes gathered a devoted group of performers and co-workers around him, including his wife and the star of many of his movies, Gena Rowlands, and the distinguished actor Peter Falk. The photographer Sam Shaw took the images that appear on many Cassavetes posters and appears to have been part of the director's core group of collaborators. Cassavetes' films are distinguished by their meandering, unresolved nature. Similarly the posters for these movies are atmospheric and intriguing rather than show-stopping.

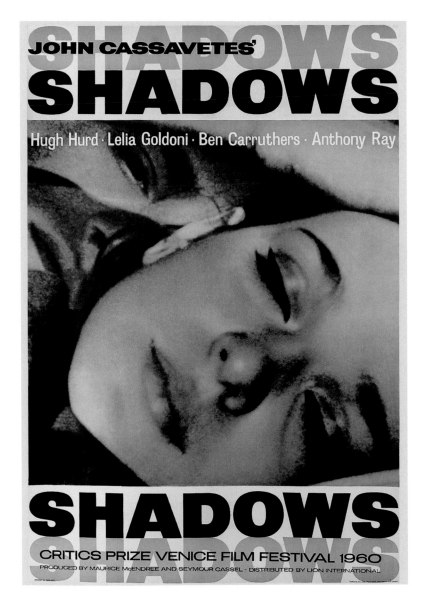

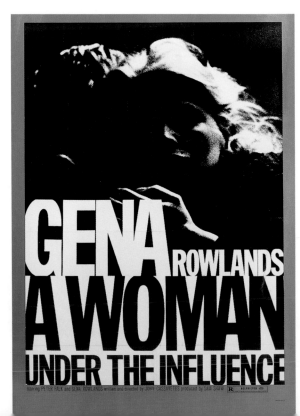

ABOVE *Shadows*, **John Cassavetes, 1960.** POSTER Sam Shaw (photographer), UK The sleeping woman on this poster appears very vulnerable, particularly in light of the more alert male figure over her shoulder. Around the border bold black type is shadowed by pale grey type, in an analogy of the title.

RIGHT *A Woman Under the Influence*, **John Cassavetes, 1974.** POSTER Sam Shaw (photographer), USA Gena Rowlands stars as a woman on the verge of breakdown. Contrasting bold type with an image of a fraught-looking Rowlands, the poster casts her frailty into even greater relief.

STARRING
BEN GAZZARA
The KILLING OF A
CHINESE BOOKIE

PHOTO / SAM SHAW

STYLE B

Faces Distribution Corp. Presents / an AL RUBAN Production / A New Film by JOHN CASSAVETES

Bollywood

Since the early 1970s India has been the world's largest maker of feature films. Imported films take only a small slice of the domestic box office and the country's exports do as well as and sometimes better than Hollywood movies in many North African, Middle Eastern, and Far Eastern states. During the 1950s film played an important role in creating an identity for the newly formed Indian nation, mainly through a series of realist melodramas, productions that aspired to the ideal of the "All-India" film. *Mother India* (1957) is the best known of these movies and has been called the cornerstone of Indian commercial cinema.

The Indian film industry celebrated its fiftieth anniversary in 1963 and by that point it was sustaining several different genres, from large-scale melodrama, through comedy, to less commercial art-house productions. The industry also gave birth to a flock of celebrities, among them the actresses Nargis and Nutan and the actors Dev Anand and Dilip Kumar. The early 1970s saw the rise of one of Indian film's greatest stars, Amitabh Bachan. Known for playing "angry young men", Bachan stormed through a series of films in the 1970s and early 1980s, until he briefly became a politician in 1984.

Indian film posters are celebrated for their lavish style of illustration and their tendency to portray melodrama. Usually focusing on the all-important star, they often montage the faces of the lead players with vignettes of the action. The poster for the 1970s Bachan movie *Zameer* typifies what is expected; the more low-key advertisements for *Tere Gharke Samne* and *Bandini* demonstrate that such clichéd assumptions are not always correct.

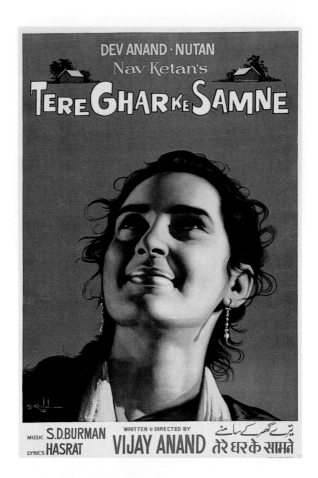

RIGHT *Bandini*, Bimal Roy, 1963.
POSTER India This film is a serious work about the experiences of a falsely accused female prisoner made by well-known Indian producer/director Bimal Roy. The illustrated poster is restrained, focusing on the stars Ashok Kumar and Nutan.

LEFT *Tere Gharke Samne*, Vijay Anand, 1963. POSTER India Photographic rather than illustrated, the advertisement for this low-key comedy focuses solely on the face of Nutan. Too slim to be a conventional Indian beauty, she brimmed with character and charm, as this poster makes clear.

BELOW *Zameer*, Ravi Chopra, 1974. POSTER India Among Amitabh Bachan's earliest films, this production addresses the inner fight between a man and his conscience. All pursed lips and knitted brows, this poster portrays Bachan's internal struggle.

147

Star Wars

Set "a long time ago in a galaxy far, far away", the first *Star Wars* film achieved a success that exceeded all expectations. The movie earned hundreds of millions of dollars by attracting both science-fiction and general audiences. Director/producer George Lucas's ambitions expanded with the next two films, each outdoing the last in special effects and high drama. As the reputation of the series grew, Lucas began making ever greater claims for the movies. In particular, he emphasized references to essential mythology, often citing academic Joseph Campbell whose theory hinges on the idea that all myths and religions emerge from fundamental characteristics of the human psyche. Many considered that Lucas was making too hefty a claim in taking these arguments on-board and the result was a backlash from critics and journalists.

There was a 16-year gap between the last of the *Star Wars* trilogy, *The Return of the Jedi* (Richard Marquand, 1983), and the first of the two "prequels", *The Phantom Menace*. During these years the members of the initial audience had grown up, and not only did they return to see the new *Star Wars* film, they brought their children with them. This generational span made Lucas's father-and-son epic all the more potent. The build-up to *The Phantom Menace* was without precedent in the film world and the teaser image of Anakin Skywalker, Darth Vadar's childhood incarnation, looking vulnerable but casting an ominous shadow, added to the pre-release excitement. To an extent, the poster for *The Phantom Menace* is misleading: it suggests a spare and moving story, whereas the film itself is more concerned with extravagant special effects and extraordinary costumes. Among all the *Star Wars* posters produced over the years, the closest match between filmic style and graphic image is probably achieved by Roger Kastel's high-octane illustration for *The Empire Strikes Back*, pictured opposite.

BELOW LEFT *Star Wars*, George Lucas, **1977.** POSTER Howard Chaykin, USA This poster was designed to advertise *Star Wars* at the 1976 World Science Fiction Convention in Kansas, where the film was given a preview showing. The comic-book style is aimed at science-fiction fans.

BELOW *Episode I: The Phantom Menace*, George Lucas, 1999. POSTER USA Lucas filmed the first part of his episodic drama after completing parts four, five, and six. In this teaser, young Anakin Skywalker's Darth Vadar shadow reveals a fate that audiences already know.

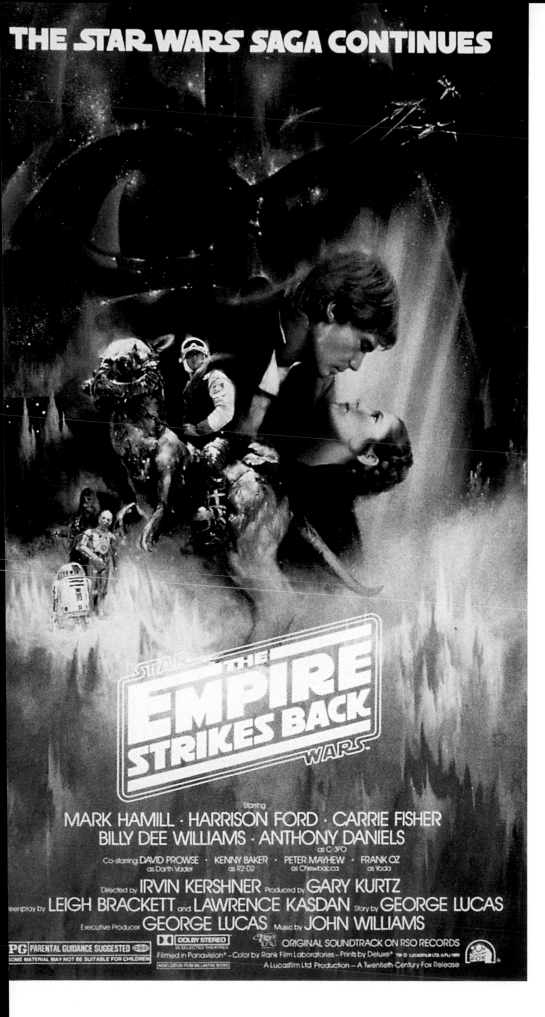

THE STAR WARS SAGA CONTINUES

LEFT *The Empire Strikes Back*, Irvin Kershner, 1980. POSTER Roger Kastel, USA
Playing up the romance between Carrie Fisher's Princess Leia and Harrison Ford's Han Solo, this poster aimed to attract a broader audience, in particular more women, to the second film in the trilogy.

Bob Peak

Like many of his fellow Hollywood designers, Bob Peak (1927–1992) studied at the Art Center College of Design in Los Angeles. Graduating in 1951, he initially moved to New York to work in advertising, and his career took off with the design of the Old Hickory Whiskey campaign in 1953. Peak's first work for Hollywood was an illustrated alternative to Saul Bass's schematic campaign for *West Side Story* (1961). Subsequent notable posters include *My Fair Lady* (1964) and *Apocalypse Now* (1979).

Although he had worked in the movies since the late 1950s, Peak's Hollywood career reached its zenith in the late 1970s. Sometimes described as "the father of the modern movie poster", Peak had a style that perfectly fitted the overblown, almost camp nature of the mainstream cinema of that era. The essence of the 1970s is summed up in the style and format of posters such as those for *Superman* and *Star Trek*. The chunky pictorial type, the airbrushed gradations of colour, and the futuristic swooshes are all firmly rooted in the decade of blue eyeshadow and polyester flares.

Bob Peak vacillated between two schools of movie poster design. While the first involved bringing together a number of different scenes from a film in a single illustrated collage, a method exemplified by his poster for *My Fair Lady*, the second required the summing up of a movie in a single dramatic image. All the posters shown here veer towards this latter school, and in the case of *Superman* a view of the airborne hero's natural environment is thought to be advertisement enough. Revealing very little about plot, these posters assume a familiarity with the film's subject-matter on the part of the potential viewer. Typically, the late 1970s blockbuster aimed to deliver thrills without surprises.

BELOW *Superman*, **Richard Donner, 1978.** POSTER **Bob Peak, USA** The unstated implication is definitely: "Is it a bird, is it a plane…?" In his transfer from page to screen, Superman retained his comic-book camp, and Peak's poster communicates the majestic silliness of the enterprise.

STAR TREK
THE MOTION PICTURE ™

THE HUMAN ADVENTURE IS JUST BEGINNING.

ures Presents A GENE RODDENBERRY Production A ROBERT WISE Film STAR TREK—THE MOTION PICTURE Starring WILLIAM SHATNER LEONARD NIMOY DeFOREST KELLEY
HAN GEORGE TAKEI MAJEL BARRETT WALTER KOENIG NICHELLE NICHOLS Presenting PERSIS KHAMBATTA and Starring STEPHEN COLLINS as Decker Music by JERRY GOLDSMITH
y by HAROLD LIVINGSTON Story by ALAN DEAN FOSTER Produced by GENE RODDENBERRY Directed by ROBERT WISE A Paramount Picture

LEFT *Rollerball*, Norman Jewison, 1975.
POSTER Bob Peak, USA A piece of pure
1970s futurism, this poster uses chunky
type and aggressive spikes to sum up an
alarming picture of a "not too distant
future". The theme was revisited in a very
poor 2002 remake.

ABOVE *Star Trek*, Robert Wise, 1979.
POSTER Bob Peak, USA The line may be
"The human adventure is just beginning",
but the real story is "Beam me up, Scotty".
Capitalizing on the TV series' most famous
gimmick, Peak shows the main characters
caught in a beam of rainbow light.

04 The Dawn of the Multiplex

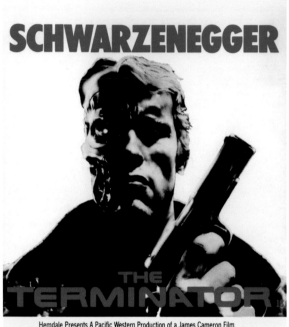

VIDEO CASSETTE RECORDERS (VCRs) first came on to the market in the mid-1970s and by the early 1980s they had fallen in price sufficiently to become part of many peoples' domestic technology in both the United States and Europe. This, alongside the introduction of cable television at around the same time, significantly altered patterns of movie consumption. In response, the studios concentrated investment on the production of blockbusters to an even greater extent, aiming to smooth out their income streams by repackaging these big-budget films for home viewing. The impact of these shifts on movie posters has been largely negative. Now part of larger marketing campaigns, poster images are required to be reusable in a number of formats and for the most part they have lost any stand-alone quality. The need to appeal to the eye flicking along the shelves of the video stores has led to uniformity and blandness.

In its early days, it was thought that the VCR would kill off cinema attendance, but this has been far from the case. In fact the late 1980s and 1990s saw the construction of a large number of multiplex cinemas, and there are now more cinema screens available in the United States than at any time since before the Great Depression. Many mourn the movie palaces of yore, but the multiplexes have brought many benefits. Chiefly their abundance of screens allows the distribution of smaller-scale independent movies that might otherwise be ignored. Typically, during peak periods such as summer and Christmas, all screens are occupied by big-budget fare, but at other times they are freed for alternative

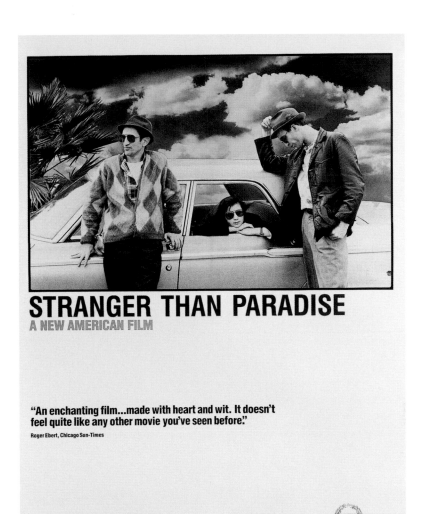

FAR LEFT *The Terminator*, James Cameron, **1984.** POSTER USA Although ostensibly a cyborg, Schwarzenegger's role in this film was that of a white male killing machine. In the 1992 sequel the Terminator was re-cast as a good guy, a role more in keeping with Schwarzenegger's burgeoning celebrity.

LEFT *E.T. The Extra-Terrestrial*, Steven Spielberg, **1982.** POSTER John Alvin, USA The just-meeting fingertips on this poster refer to Michelangelo's *Creation of Man*. Comparing it to the original composition, it seems odd that the extra-terrestrial's hand is in the position of that of Adam and the child's in a pose similar to that of God's.

RIGHT *Stranger Than Paradise*, Jim Jarmusch, **1984.** POSTER USA Showing three characters doing very little, this photograph is typical of the film's low-key story-telling style. The poster's understated typography and extensive white space is in keeping with the mood of the image.

productions. These developments have given rise to parallel schools of film-making. Big bombastic block-busters coexist with small-scale, independent movies.

The biggest criticism of the modern blockbuster is its plot-compromising dependence on new technology. Ninety ninety-one's biggest grosser, *Terminator 2: Judgment Day*, amazed audiences with its endlessly morphing protagonist, but special effects such as these have steeply diminishing returns, and a single outing exhausts the possibilities of most new tricks. Take away the technology and little is left but reheated allegories of Cold War anxiety and unthinking triumphalist rubbish. Anthony Lane, the film critic of the *New Yorker*, speculated that the events of 11 September 2001 would spell the end of the all-action blockbuster – that the

disaster movie might "be shamed by disaster". This has not been the case. Of course it would be wrong to argue that big always means bad. Some directors, notably Steven Spielberg, have taken blockbuster-making to new heights, creating films that are all but irresistible. In particular *E.T. The Extra-Terrestrial* (1983) tugged the heartstrings while expressing complex anxieties about the relationship between innocence and experience.

Since the 1980s, movie audiences have become younger and younger, and it is said that a film's success depends on the reactions of the teenage boys that crowd to see it in its first weekend. With this demographic in mind, studios have come up with largely undifferentiated streams of teen-centred movies: films that explore sex, violence, and everything in between. Such a tendency to

underestimate audiences is occasionally challenged by the success of a film such as *Reservoir Dogs* (1992). Quentin Tarantino's intelligent film tempered extreme violence with intelligence and playfulness and in doing so won a huge worldwide audience.

Few independent film-makers have enjoyed Tarantino's commercial profile, but his triumph has ensured a place in the Hollywood system for other young directors such as Richard Linklater and Joel and Ethan Coen. Many of these independent film-makers form their own production companies, among the most successful of which is Spike Lee's 40 Acres and a Mule. Lee's company is dependent on the distribution networks of the large studios, but all the same it ensures him the freedom to determine the nature of his output. Lee's films are known

for their unswerving focus on sensitive cultural and political issues, and his singular achievement has been to ally these concerns with financial success.

Hollywood films now attract at least 80 per cent of audiences in most Western nations. This is bad news for most national industries, but, often with the help of state funding, non-Hollywood film-making has survived. The aim of many international film-makers is to make movies that are driven by local concerns but also connect with an international audience. Spanish director Pedro Almodóvar has been particularly successful in this endeavour. Under the umbrella of his production company El Deseo, he has made a series of extraordinary films; seemingly set in a universe all of their own, they nonetheless allow global audiences a window into the

cultural concerns of post-Franco Spain. Eventually many successful international film-makers are drawn to Hollywood. In some cases this leads to the obliteration of any distinctive non-Hollywood attributes, but in others national and mainstream filmic traditions fuse to great effect. The German director Wim Wenders has a long-standing interest in American popular culture, working in Hollywood on and off since the late 1970s. His film *Paris, Texas* (1984) adopted the well-established form of the road movie, but confounded audience expectation with its meditative pace and hyper-real cinematography.

There is a tendency among film theorists and critics to characterize cinema as an art form in perpetual crisis; film is constantly posed at death's door for one reason or another. This alarmist talk runs counter to all of the evidence suggesting that film is a remarkably hardy medium. But, be that as it may, as a graphic-design critic I must put in my two-pennies' worth. Film may be alive and well, but film posters are in a state of limbo. By and large, even the most experimental of films are promoted with the blandest of graphic devices. Very few film-makers concern themselves with the promotion of their movies and instead this job falls into the hands of marketing divisions that rely purely on received wisdom. Those responsible for film advertising need to try much harder. Posters in general are the wallpaper of urban life, and film posters in particular create the environment of anticipation in which new releases are best enjoyed. The banality of contemporary film graphics represents a squandered opportunity.

Spike Lee

Born in 1957, Spike Lee grew up in New York where his father worked as a jazz musician. He attended New York University's Film School and his graduation movie won an Academy Student Award in 1983. Lee made his feature début in 1986 with *She's Gotta Have It*. Exploring the relationship between a forthright young black woman and her three lovers, this film was a huge critical and commercial success, winning Lee an international reputation. Since then he has made a series of good-looking, provocative films including *School Daze* (1988), *Do The Right Thing* (1989), and *Malcolm X* (1993). Lee never shies away from controversy and his treatment of issues regarding America's black community has made an important contribution to contemporary discussions about race.

Lee is an inveterate film buff and his movies often make reference to 20th-century European and American cinema. For all his urge to bring political issues to the screen, he never neglects questions of style. The director's emphasis on the visual is reflected in the posters for all Spike Lee productions. *She's Gotta Have It* was distributed on a very small budget, but all the same it was advertised with an appealing poster, all sexy black-and-white photography and funky colourful type. The poster for *Do the Right Thing* adopts an unusual perspective, quite literally, with the contested streets of the Bed-Stuy district of Brooklyn being viewed from above. The teaser image for *Malcolm X* is among the most effective of all Lee's posters. Stripped down to its essentials, it assumes a certain degree of audience anticipation and announces the imminent arrival of the film in a bold, uncompromising manner.

RIGHT *Mo' Better Blues*, **Spike Lee, 1990.** POSTER **USA** Telling the story of a jazz trumpeter, this film saw Lee revisiting childhood territory. The director is shown here in the role of impresario, smartly dressed in eye-catching shoes and a stylish hat, announcing his own production.

RIGHT *Do the Right Thing*, **Spike Lee, 1989.** POSTER **USA** On the left is Italian-American pizzeria owner Sal, and on the right is African-American delivery boy Mookie (played by Lee). The title down the centre of the poster represents the line of battle that emerges during the film.

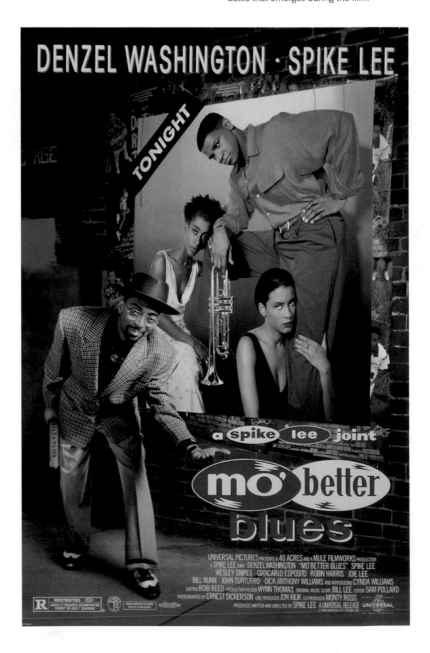

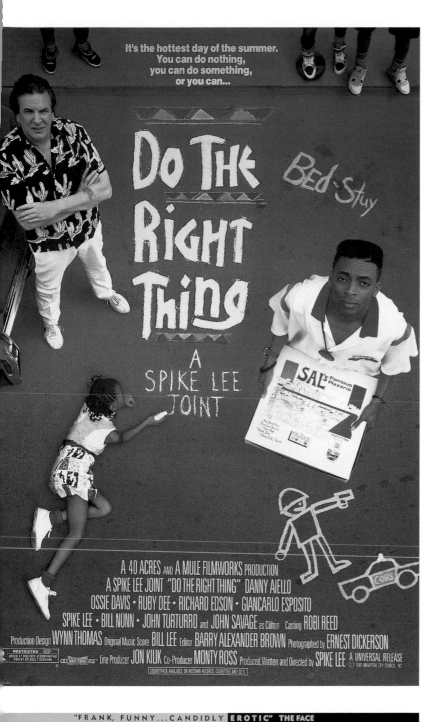

BELOW *Malcolm X*, Spike Lee, 1993. POSTER USA This movie is Lee's most ambitious project to date. Malcolm X was a black American political activist and the emphatic minimalism of the teaser image reflects the seriousness with which the film treats its politically explosive subject.

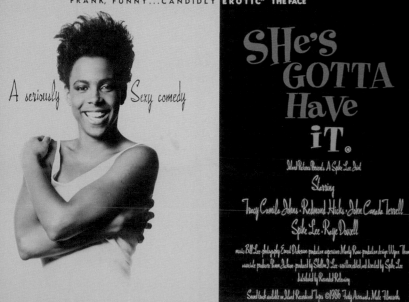

LEFT *She's Gotta Have It*, Spike Lee, 1986. POSTER UK This poster focuses on lead actress Tracy Camilla Johns in her role as the independent and lusty Nola Darling. A large part of the film's success derived from the spirit of Johns's performance.

Wings of Desire

Born in 1945, Wim Wenders graduated from the Munich Academy of Film and Television in the late 1960s. He considers that his career as a professional director truly began with his second movie, *The Goalkeeper's Fear of the Penalty Kick* (*Die Angst des Tormannes beim Elfmeter*, 1971), which looks at a murderously unhappy episode in the life of an estranged footballer. Wenders attracted international attention with *Alice in the Cities* (*Alice in den Städten*, 1974), which also examines the idea of dislocation, but is more appealing to general audiences.

In spite of Wenders's ambivalent attitude to the mainstream movie business, he has enjoyed international success with a string of films including *Paris, Texas* (1984) and *Wings of Desire* (*Der Himmel über Berlin*). The first of these, set in the American desert, allowed Wenders to revisit his favourite genre, the road movie. The latter is based in Berlin and, instead of taking a trip through space, it saunters through time. The dual subjects of *Wings of Desire* are the city of Berlin and the relationship between wisdom and experience. While the German and Italian (*Il cielo sopra Berlino*) titles emphasize urban history, the English and French (*Les Ailes du désir*) names concentrate on the movie's more intimate theme, a difference in emphasis that is also reflected in the posters for the film. In 1998 *Wings of Desire* was remade in America under the title *City of Angels*. The sappy result only serves to emphasize Wenders's ability to convey emotion without lapsing into sentimentality.

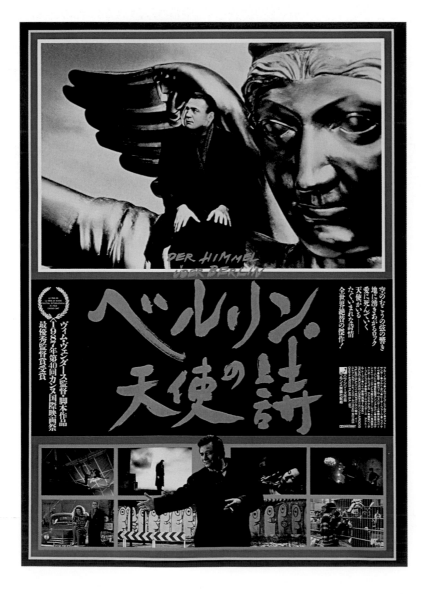

RIGHT *Les Ailes du désir*, **Wim Wenders, 1987.** POSTER **France** The object of angel Damiel's desire is the circus performer Marion. Seen here flying on her trapeze in a winged costume, she is an appropriate object of angelic lust.

LEFT *Wings of Desire*, **Wim Wenders, 1987.** POSTER **Japan** Like many Japanese film posters, this advertisement shows various scenes from the film, each in a discreet frame. The overriding image is that of Bruno Ganz as the discontented angel Damiel, sitting on the shoulder of the gilded angel that stands high above Berlin's Tiergarten.

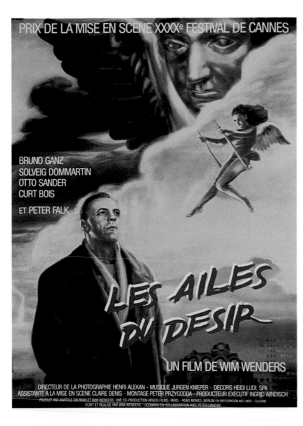

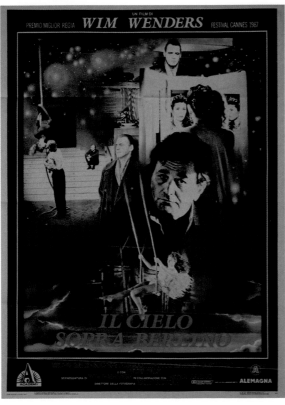

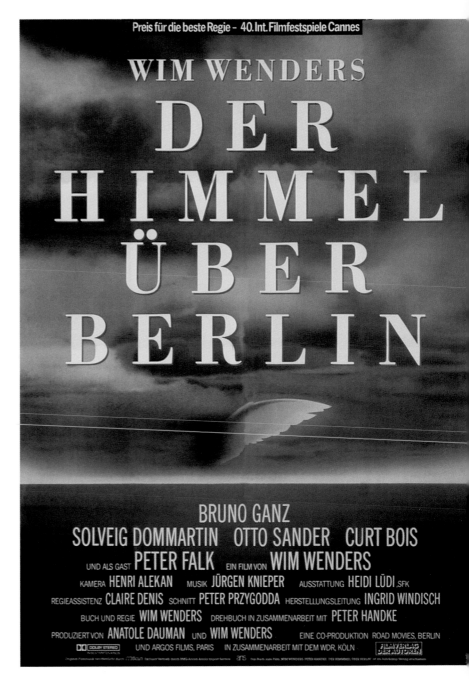

LEFT *Il cielo sopra Berlino*, Wim Wenders, **1987.** POSTER **Italy** Rather than concentrating on the lead angels Damiel and Cassiel, this poster foregrounds actor Peter Falk, billed in the film as "Himself". It is Falk's job to explain the pleasures of human experience to the disembodied angel.

ABOVE *Der Himmel über Berlin*, **Wim Wenders, 1987.** POSTER **Germany** This authoritative German version is the least figurative and most elegant of all the posters for this film. The single wing emerging from a brooding sky is all that is needed to convey the essence of the movie.

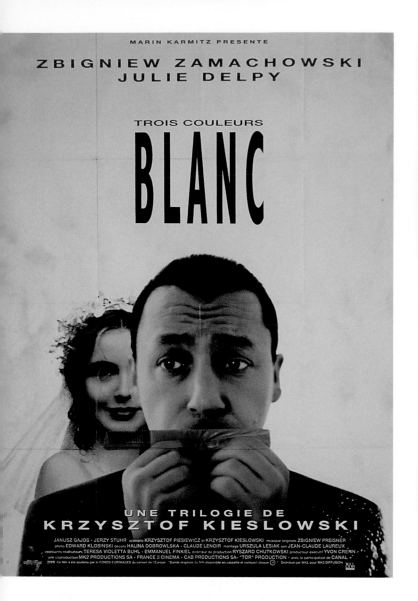

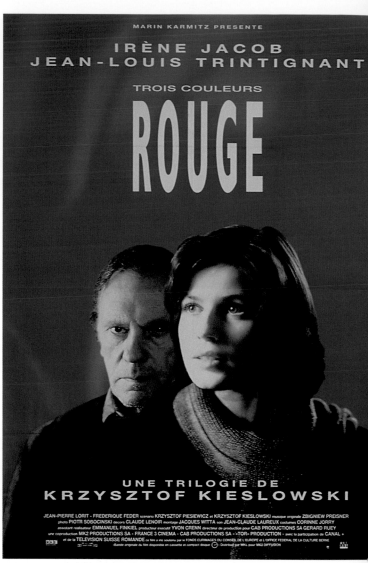

Krzysztof Kieslowski

In the late 1980s the Polish director Krzysztof Kieslowski (1941–1996) created ten short films for Polish television collectively titled *Dekalog* (*The Decalogue*). Each film addressed one of the Ten Commandments and they were given systematic titles: *A Short Film About Love*, *A Short Film About Killing*, and so on. In the early 1990s, having emigrated to France, he turned his attention to a more modern set of instructions. Picking up on the ideals of the French Revolution (liberty, equality, and fraternity) and using the colours of the French tricolore, Kieslowski made a trilogy that addressed each of the three symbolic qualities in turn: *Three Colours: Blue* (*Trois Couleurs: Bleu*) concerns liberty, *Three Colours: White* (*Blanc*) explores equality, while *Three Colours: Red* (*Rouge*) teases out contemporary notions of fraternity.

The trilogy was made over two-and-a-half years and the films were premiered at international festivals within six months of each other. In this way they were presented to worldwide audiences as a set, reflected in the uniformity of their posters. Each has a similar format: a portrait of the film's star or stars and an emphasis on the pertinent hue. The bias towards character on the *Three Colours* posters is indicative of the nature of the films which deal with the concepts of liberty, equality, and fraternity on an individual level rather than a political or social one. Kieslowski believed that personal values are more broadly shared than political ideals, and by concentrating on the intimate he hoped to communicate across national boundaries. Each film was shot in a different country, Kieslowski arguing that stories and locations were interchangeable.

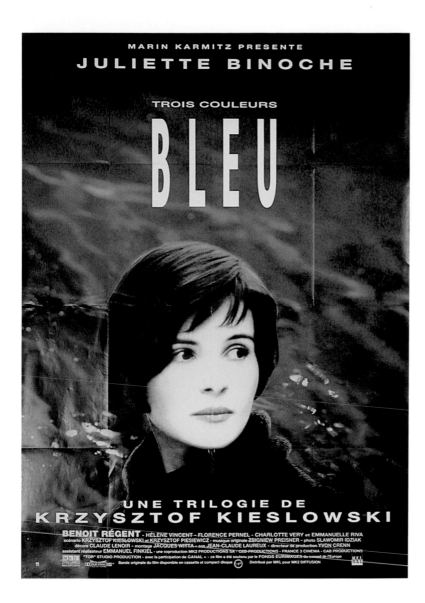

BELOW *Le Decalogue*, **Krzysztof Kieslowski, 1988.** POSTER France Instead of the stone tablets, this poster shows a carved hand, presumably that of God, or perhaps of Moses, pointing toward the films' collective title. The image emphasizes the Biblical origins of Kieslowski's series.

FAR LEFT *Trois Couleurs: Blanc*, **Krzysztof Kieslowski, 1994.** POSTER France Each film in the trilogy was shot by a different cameraman. In combination with the beauty of actresses Julie Delpy, Irène Jacob, and Juliette Binoche, these cinematographers gave the movies their distinctive looks.

LEFT *Trois Couleurs: Rouge*, **Krzysztof Kieslowski, 1994.** POSTER France
Red was the last movie in the series and the darkest in tone, addressing frustration as well as optimism. This was Kieslowski's final film and is thought by many to be his masterpiece.

ABOVE *Trois Couleurs: Bleu*, **Krzysztof Kieslowski, 1993.** POSTER France Set against a rippling blue background, Binoche has never looked more beautiful than she does in this poster, or indeed in this film. The aqueous theme runs through the movie as the actress is shown struggling home under the weight of several litres of water and swimming in a pool.

China's Fifth Generation

Born in 1950 and 1952 respectively, Zhang Yimou and Chen Kaige are part of what is known as Chinese film-making's "fifth generation". They were both educated at the Beijing Film Academy in the late 1970s. Chen was a member of China's cultural élite, the son of a film director and an actress, and his entry into the academy was smooth. Zhang was the son of an unfavoured official and at the onset of the Cultural Revolution in 1966 was sent to work in the countryside. In 1978 he was denied entry to film school for being over the age limit; after pleading that he had lost 10 years of his life to the Cultural Revolution, he was finally admitted as student of cinematography.

Many fifth generation film-makers have chosen to look back to the 1930s and 1940s, supposedly the most glorious chapter of the Communist Revolution. Chen's first film, *Yellow Earth*, on which Zhang was the cinematographer, was set during China's war with Japan and told the story of a soldier who is sent to the countryside to collect heroic local songs. Deceptively simple, this film not only questioned historical orthodoxy, it also offered a rich comment on contemporary Chinese life. Zhang's films, including *Red Sorghum* (1987) and *Raise the Red Lantern*, conform more to the tenets of popular entertainment, but are equally challenging of China's ideology.

Unsurprisingly Zhang and Chen have an uneasy relationship with the Chinese authorities and have often experienced censorship. These directors have won loudest acclaim on the European and American festival circuit, and it is no coincidence that both the posters shown here were intended for art-house promotions.

'ONE OF THE MOST THRILLING DEBUT FEATURES OF THE 80'S ... BREATHTAKINGLY BEAUTIFUL IMAGES ... A TRULY HEROIC ACHIEVEMENT' TONY RAYNS TIME OUT

ICA PROJECTS PRESENTS

A FILM BY CHEN KAIGE

STARRING·XUE BAI·WANG XUEQI·TAN TUO·LIU QIANG

WRITTEN BY ZHANG ZILIANG

PHOTOGRAPHED BY ZHANG YIMOU

MUSIC BY ZHAO JIPING

DIRECTED BY CHEN KAIGE

DISTRIBUTED BY ICA PROJECTS

WINNER BFI AWARD MOST ORIGINAL & IMAGINATIVE FILM

YELLOW·EARTH

BELOW *Raise the Red Lantern*, **Zhang Yimou, 1992.** POSTER **UK** Red is a particularly potent shade in China, signifying both tradition and revolution. This poster is a handsome reflection of the film's overriding colour scheme and a strong indication of Zhang's cinematographical skills.

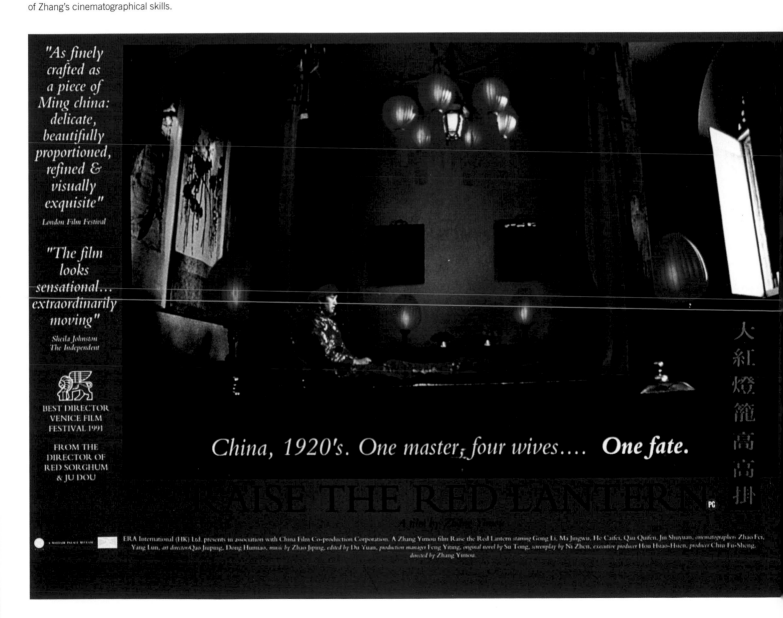

"As finely crafted as a piece of Ming china: delicate, beautifully proportioned, refined & visually exquisite"
London Film Festival

"The film looks sensational... extraordinarily moving"
Sheila Johnston
The Independent

BEST DIRECTOR
VENICE FILM
FESTIVAL 1991

FROM THE
DIRECTOR OF
RED SORGHUM
& JU DOU

China, 1920's. One master, four wives.... **One fate.**

大紅燈籠高高掛

ERA International (HK) Ltd. presents in association with China Film Co-production Corporation. A Zhang Yimou film Raise the Red Lantern *starring* Gong Li, Ma Jingwu, He Caifei, Qau Quifen, Jin Shuyuan, *cinematographers* Zhao Fei, Yang Lun, *art director* Qao Jiuping, Dong Huimao, *music by* Zhao Jiping, *edited by* Du Yuan, *production manager* Feng Yiting, *original novel by* Su Tong, *screenplay by* Ni Zhen, *executive producer* Hou Hsiao-Hsien, *producer* Chiu Fu-Sheng, *directed by* Zhang Yimou.

LEFT *Yellow Earth*, **Chen Kaige, 1984.** POSTER **UK** This poster focuses on the face of actress Xue Bai, who plays a girl who hopes to escape an arranged marriage by joining the Communist army. The girl is let down by Communism and her fate becomes a metaphor for the fate of modern China.

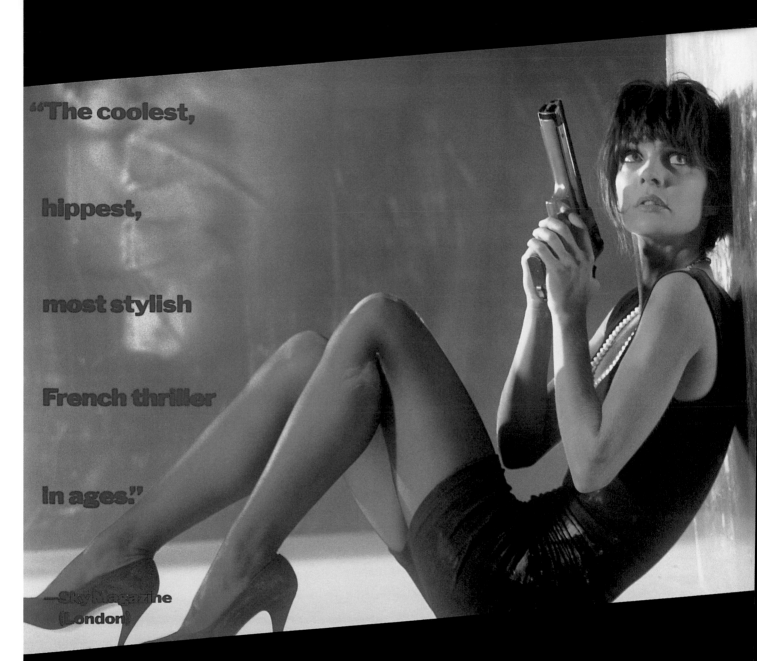

THE HIT OF PARIS AND LONDON HAS COME TO AMERICA.

"The coolest,

hippest,

most stylish

French thriller

in ages."

—Sky Magazine
(London)

la femme
NIKITA

THE SAMUEL GOLDWYN COMPANY and GAUMONT present ANNE PARILLAUD
JEAN-HUGUES ANGLADE TCHEKY KARYO A Film by LUC BESSON LA FEMME NIKITA with JEANNE MOREAU JEAN BOUISE
JEAN RENO PHILIPPE LEROY-BEAULIEU ROLAND BLANCHE JACQUES BOUDET Music by ERIC SERRA
A FRENCH-ITALIAN COPRODUCTION GAUMONT, GAUMONT PRODUCTION, CECCHI GORI GROUP TIGER CINEMATOGRAFICA

1980s French Style

Directors Jean-Jacques Beineix (b. 1946) and Luc Besson (b. 1959) created a 1980s French cinema suffused with style, sex, and the strains of *amour fou*. Beineix's 1981 film *Diva* could be seen as the cornerstone of the French style thriller and it remains a reference for all film-makers who aim to fuse violence with modish interior décor. Besson's *La Femme Nikita* was very much in the same school, featuring a convicted female killer who is forcibly recruited as a government hitman. Assassinations occur in high-fashion surroundings and Nikita (Anne Parillaud), is required to wear short skirts and high heels throughout.

Moving away from violence into the territory of insanity, Beineix's unhinged sex goddess of *Betty Blue* (*37°2 Le Matin*) became the superstar of the student bedroom for many years. And what Betty did for boys, Jean-Marc Barr's dolphin-man Jacques, star of *The Big Blue* (*Le Grand Bleu*), did for girls and gay men two years later. The plot of neither film bears too much analysis, but both throw up seductive images of beautiful but inaccessible individuals. Posters for Beineix and Besson films became icons for a generation and Béatrice Dalle's pout is one of the most recognizable cinematic motifs of the 1980s.

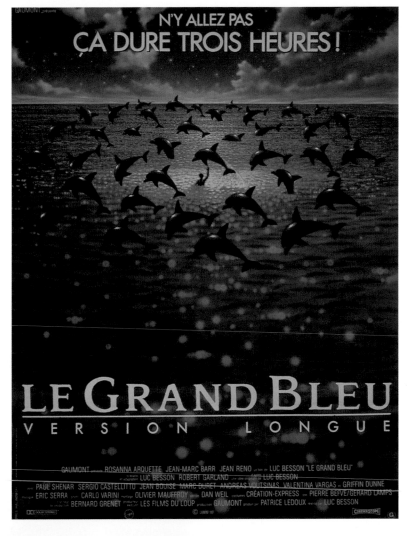

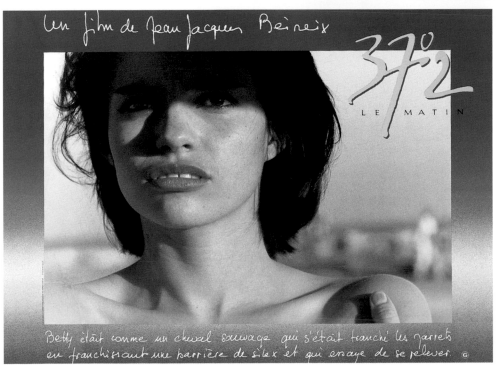

ABOVE *Le Grand Bleu*, Luc Besson, **1988.** POSTER Andrzej Malinowski, France A three-hour movie might seem more of a threat than a promise, but levels of enthusiasm for actor Jean-Marc Barr were such that he could sustain a film of almost any length.

LEFT *37°2 Le Matin*, Jean-Jacques Beineix, **1986.** POSTER France There were several French posters for this film. Some concentrated on the extraordinary colours of the film's landscape, but most focused on the mesmerizing features of the film's star, Béatrice Dalle.

FAR LEFT *La Femme Nikita*, Luc Besson, **1990.** POSTER USA Besson's film had already done the rounds in France and Great Britain before it reached the United States. American audiences are solicited with high heels, miniskirts, and firearms.

Ridley Scott

After studying film at London's Royal College of Art, Ridley Scott (b. 1937) took a job as a set decorator at the BBC. Within a couple of years, he graduated to production designer and then to full-blown television director. Among other shows, Scott was responsible for several episodes of the landmark police drama *Z Cars*.

In the mid-1960s Scott branched out into the more lucrative field of directing commercials. He enjoyed enormous success in this area and spent more than a decade directing advertisements before realizing his ambition of breaking into feature films. Scott's début *The Duellists* (1977) was well received, although some critics felt the director betrayed his origins as a designer, creating a series of well-crafted tableaux rather than a fully realized film. Scott silenced his critics with his next feature, *Alien*. While leaving audiences in no doubt as to Scott's concern with appearance, the film called into question the idea that style and story are at odds. *Alien* is an extremely effective science-fiction thriller that derives its impact from writing, staging, and performance in equal parts.

Given Scott's track record in advertising, the highly effective promotions for his films should come as no surprise. The *Alien* tagline "In space no one can hear you scream" has become part of common culture, a means of summoning fears of the distant and scary; equally the visual motif of an egg hatching the agents of unknown terror has taken on the status of popular myth. In comparison, the guns-and-girls approach of the poster for *Blade Runner* seems somewhat overblown. All the same, John Alvin's illustration is an elegant collage of many of the film's most seductive ingredients, in particular its futuristic city setting.

RIGHT *Blade Runner*, Ridley Scott, 1982.
POSTER John Alvin, USA Alvin would have preferred to concentrate on the character played by Rutger Hauer, the powerful Teutonic android Roy Batty. However, marketing considerations prompted an alternative focus on rising superstar Harrison Ford as agent Rick Deckard.

RIGHT *Alien*, Ridley Scott, 1979.
POSTER Steve Frankfurt and Philip Gips, USA Ridley Scott is unusually involved in the promoting of his films. He was particularly keen that the poster for *Alien* should tantalize audiences with a chilling tagline, but give away very little about the creature.

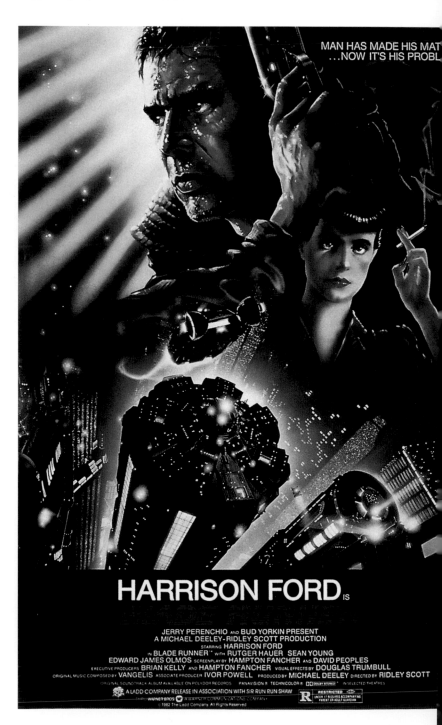

A L I E N

In space no one can hear you scream.

Julian Schnabel

Before embarking on his film career, Julian Schnabel (b. 1951) was a voluble, self-promoting member of the art world. He had his first solo show in New York in 1979 and enjoyed considerable success in the 1980s, becoming known for works made from broken plates glued to wooden panels and daubed with paint. Schnabel's painterly *oeuvre* lapsed from favour in the 1990s. Although he continues to paint and his 1980s work reaches high prices at auction, his film output has begun to eclipse his artistic career.

Schnabel had no experience in film-making when he made *Basquiat*. His motive as much as anything was to document the life of his friend and fellow painter Jean-Michel Basquiat, who had died of a drug overdose in 1988 at the age of 27. The Haitian-born artist was a romantic figure, a controversial genius consumed by the overheated 1980s New York art environment. The film was appreciated for its portrayal of that extraordinary decade, in particular for David Bowie's performance as Andy Warhol. The poster for *Basquiat* is suggestive of the neo-Expressionist painterly styles that held sway during the era.

Buoyed by the success of *Basquiat*, Schnabel embarked on another biographical film, an account of the life of the Cuban poet Reinaldo Arenas. Based on Arenas's autobiography of the same name, *Before Night Falls* tells of the poet's persecution, largely on account of his homosexuality, his eventual exile, and his death from AIDS in 1987. The most prominent feature on the poster for the film is the type. Set in a forthright but elegant fashion, it echoes Arenas's care with words and his ability to form simple, beautiful prose.

RIGHT *Basquiat*, Julian Schnabel, 1996.
POSTER USA Concentrating on Jeffrey Wright as Jean-Michel Basquiat, this poster offers a credible semblance of a well-known face. More than that, it manages to create a painterly texture that is suggestive of the artist's work without being a pastiche.

RIGHT *Before Night Falls*, Julian Schnabel, 2002. POSTER USA Concerning the poet Reinaldo Arenas, this film is set mainly in Cuba in the 1960s and 1970s. The washed-out photographic texture of the poster immediately harks back to those decades.

Jim Jarmusch & Andrzej Klimowski

Permanent Vacation (Nieustajace Wakacje), Jim Jarmusch, 1982. POSTER Andrzej Klimowski, Poland The film tells of a young man who finds it hard to connect with day-to-day normality. Using the title to create a cleavage between face and head, the poster offers a metaphor for his condition.

Jim Jarmusch (b. 1953) studied film at New York University and worked with Wim Wenders before making his low-budget first feature, *Permanent Vacation*, in 1982. His follow up was *Stranger Than Paradise*, a low-key black-and-white tale of the adventures of a purposeless threesome. Also shot in black and white and dealing with an ineffectual trio, Jarmusch's next feature was *Down by Law*, a music-led film structured around the Screamin' Jay Hawkins song "I Put a Spell on You". As well as winning Jarmusch the Palme d'Or at Cannes, this movie secured him the adoration of independent film fans worldwide. Since then he has worked

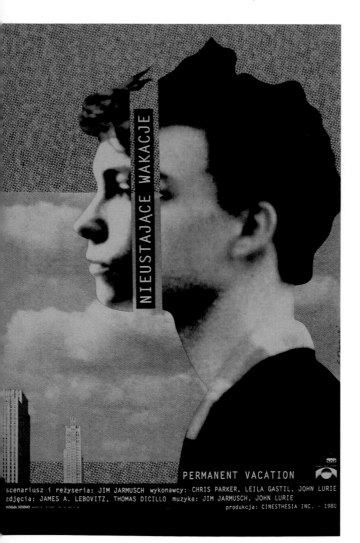

RIGHT *Stranger Than Paradise (Inaczej Niz W Raju)*, Jim Jarmusch, 1984. POSTER Andrzej Klimowski, Poland The figures in the poster are the movie's three principal characters. Elongated and facing away from us, they communicate loneliness, melancholy, and lack of purpose.

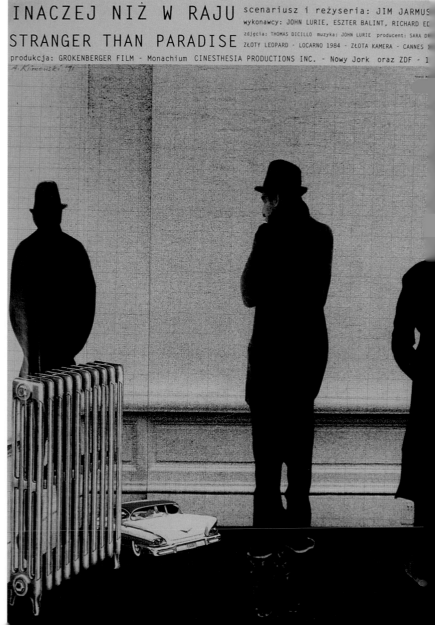

on an increasingly large scale, his most recent feature being *Ghost Dog* (1999).

The posters shown here were designed as a set in 1991. Their purpose was to promote the Polish art-house release of Jarmusch's early films and they were commissioned by Polish poster historian turned film distributor Edmund Lewandowski. The choice of designer Andrzej Klimowski was inspired. Klimowski was already a well-known illustrator and poster designer and his quiet, poetic collages proved a perfect match for Jarmusch's filmic style. Each of these images refers to the big theme of the film in question, but does so in a way that is subtle and metaphorical rather than loud and literal. Klimowski was pleased to hear that Jarmusch himself approved of the designs. These images could be described as the last gasp of the Polish film poster. In the early 1990s in Poland only art-house films were allowed custom-designed posters and more recently even they have been advertised with images from their country of origin.

BELOW *Down by Law (Poza Prawem)*, **Jim Jarmusch, 1986. POSTER Andrzej Klimowski, Poland** Telling the tale of a trio of jailbreakers, this film concentrates on music above all else, two of the three lead players being musicians rather than actors. On the poster Klimowski sticks these characters together, cheek by jowl, a reflection of the enforced camaraderie of their escape.

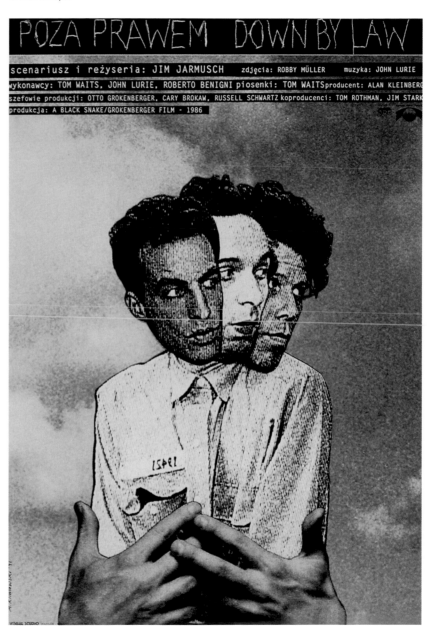

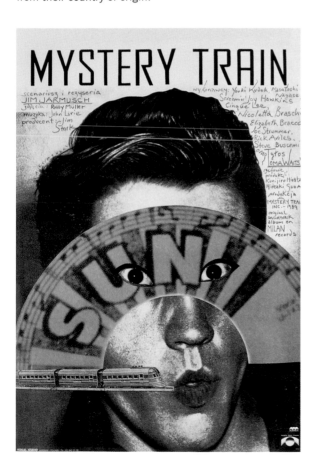

ABOVE *Mystery Train*, **Jim Jarmusch, 1989. POSTER Andrzej Klimowski, Poland** This poster refers to the section of this three-part film that deals with two young Japanese Elvis fans. The obscured photograph is of a youthful Elvis and the train emerging from his mouth represents the film's title song.

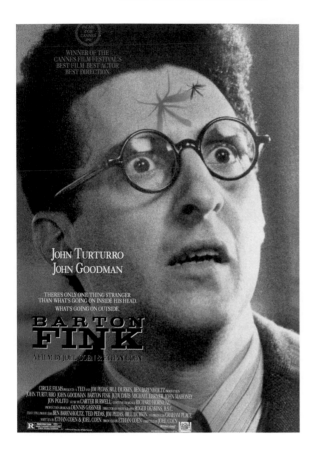

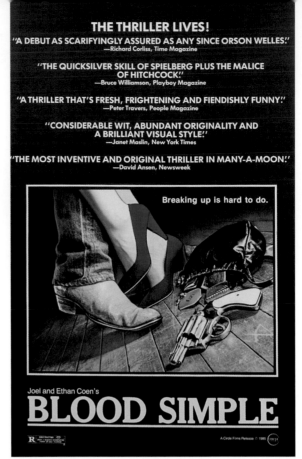

ABOVE *Blood Simple*, Joel and Ethan Coen, 1984. POSTER USA This film concerns the complications that ensue after a husband hires a hitman to kill his wife and her lover; the title *Blood Simple* proves an oxymoron. The red shoes on this poster illustrate the movie's twin themes: infidelity and murder.

RIGHT *Fargo*, Joel and Ethan Coen, 1996. POSTER Karen Swann, Eric Kintler, and John Waxel, USA This poster expresses the tagline "a homespun murder story". The violence of the film's climax is made bearable only by the comforting presence of a pregnant cop.

The Coen Brothers

Brothers Joel (b. 1954) and Ethan (b. 1957) Coen have worked as a team, writing, producing, directing, and editing films, since the early 1980s. Their début was *Blood Simple* (1984), for which Joel took the director credit and Ethan the producer credit, sharing the writing credit. They adopted similar roles in subsequent movies, including *Raising Arizona* (1987), *Miller's Crossing* (1990), *Fargo* (1996), and *The Man Who Wasn't There* (2001).

The Coen brothers are very concerned with the look of their films and each one has a distinct cinematic texture. In *Barton Fink* (1991) the overall appearance of the movie is determined by the endless, orange-tinged corridors of the hotel in which the writer Fink is lodged during his sojourn in Los Angeles; in *Fargo* the colour and atmosphere of the film is derived from the bleak snowy plains of

Minnesota; and *The Man Who Wasn't There* is imbued with the dust-filled, gently run-down atmosphere of the small-town barber's shop that is at the centre of the film.

Following this concern with appearance through to the billboard, posters for Coen brothers movies tend to be highly original and evocative. Eschewing the standard photographic collage of major players and events, these advertisements use a variety of media in pursuit of a single compelling image. The best-known poster is that for *Fargo*. Just as the film tempers violence with the common-sense warmth of the heavily pregnant cop Marge (played by Frances McDormand), so the poster portrays death in the cosy medium of needlepoint. *Fargo*'s concession to cosiness earned the Coen brothers their biggest commercial and critical success to date.

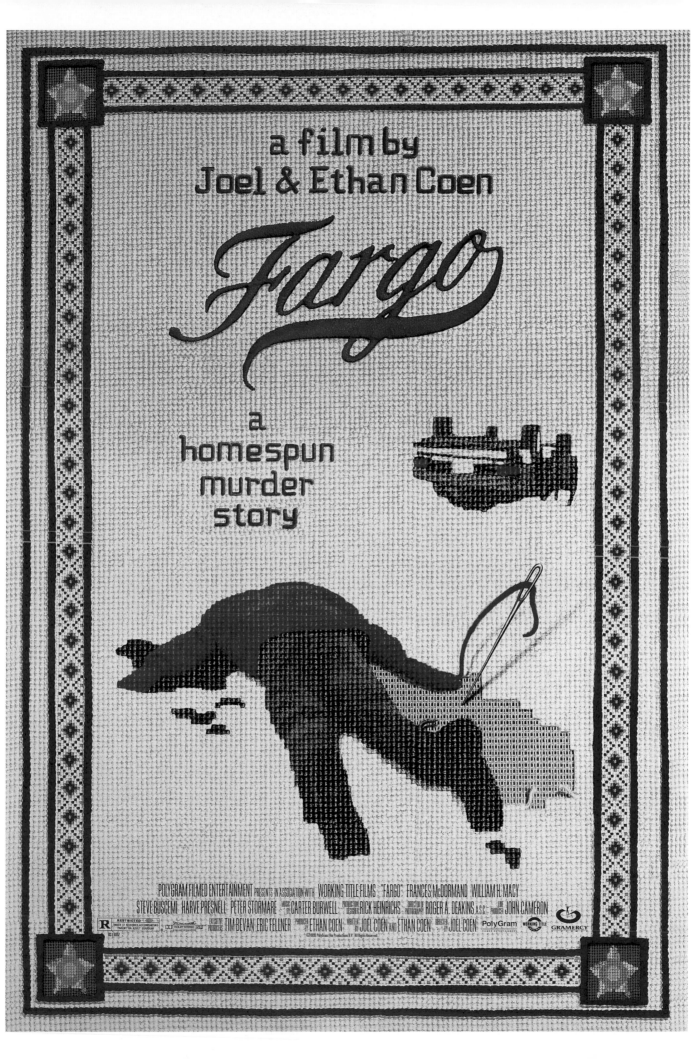

David Lynch

Born in 1946, David Lynch began experimenting with film as a fine-art student at Pennsylvania Academy in the 1960s. His short film *The Grandmother* (1970), made with a grant from the American Film Institute, won him further funding, and he spent five years at the Center for Advanced Film Studies in Los Angeles making the movie that would eventually be *Eraserhead*. Entirely shot in black and white, *Eraserhead* is an unsettling study of family life, a cruel take on Lynch's own experiences.

On seeing the freakish visions of *Eraserhead*, Mel Brooks asked Lynch to direct the tale of the 19th-century misfit *The Elephant Man* (1980). This film took Hollywood by storm, earning Best Screenplay and Best Director Oscar nominations. Asked to take the helm of the third *Star Wars* movie, Lynch rejected the offer in favour of a personal quest to film the epic science-fiction novel *Dune*. The screen version of *Dune* (1985) was considered a disaster, not least by Lynch himself, and marked the end of the director's involvement with the Hollywood mainstream.

Blue Velvet opened a new chapter in Lynch's career, which has included the television series *Twin Peaks* (1991–92) and the critic-pleasing *Mulholland Drive* (2002). Lynch takes pleasure in exposing the oddity and unpleasantness concealed by the thin veneer of the everyday. This theme has made him a cult favourite and posters for all Lynch films, from *Blue Velvet* on, are designed to appeal to a sardonic and visually literate audience.

FAR RIGHT *Lost Highway*, **David Lynch, 1997.** POSTER **USA** This film relies on the conceit that one character might evolve into another, a device that unsurprisingly led to a degree of confusion and alienated much of the audience. By showing only a partial portrait of the film's main players, the poster picks up on the theme of uncertain identity.

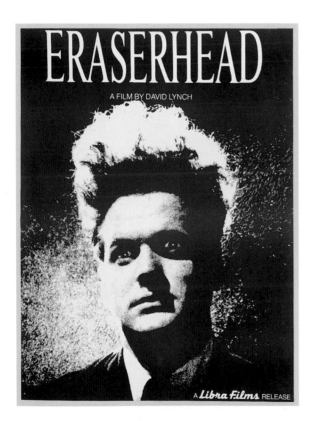

ABOVE *Eraserhead*, **David Lynch, 1977.** POSTER **Ben Barenholtz, USA** Ben Barenholtz worked for Libra Films, the New York-based art-house company that first distributed *Eraserhead*. Part of his role was designing this poster, a process he has described as little more than photocopying a still from the film.

RIGHT *Blue Velvet*, **David Lynch, 1986.** POSTER **Germany** The white picket fence and the lustrous roses stand both as an emblem of the everyday and as a symbol of threatening sexuality. This image was used only in the German promotion for the film.

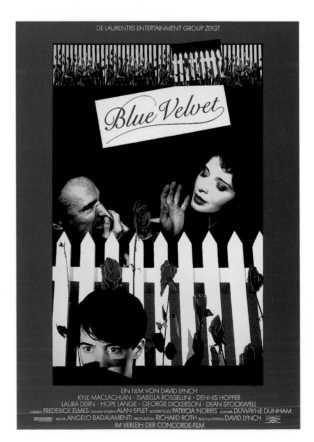

BILL PULLMAN

PATRICIA ARQUETTE

BALTHAZAR GETTY

A FILM BY DAVID LYNCH

LOST HIGHWAY

OCTOBER FILMS PRESENTS A CIBY 2000/ASYMMETRICAL PRODUCTION A DAVID LYNCH FILM ... PATRICIA ARQUETTE BALTHAZAR GETTY "LOST HIGHWAY" ROBERT BLAKE NATASHA ... SON WAGNER WITH GARY BUSEY AND ROBERT LOGGIA MUSIC COMPOSED AND CONDUCTED BY ANGELO BADALAMENTI EDITED BY MARY SWEENEY PRODUCTION DESIGN ... PETER DEMING CASTING BY JOHANNA RAY C.S.A. AND ELAINE J. HUZZAR PRODUCED BY DEEPAK NAYAR THOMAS STERNBERG MARY SWEENEY

DAVID LYNCH BARRY GIFFORD DAVID LYNCH

"LOST HIGHWAY" WEB SITE
www.lost-highway.com

CIBY 2000

ASYMMETRICAL

OCTOBER FILMS

Steven Spielberg

Steven Spielberg (b. 1947) is a self-taught film-maker, who dropped out of college and began directing for television at age 22. Now one of the most powerful people in Hollywood, according to some critics he owes his success as much to his ability to tap into the contemporary mood as to his film-making talent. He arrived on the Hollywood scene at a point when the audience's appetite for action, horror, and fantasy was expanding. Spielberg took advantage of this moment with movies such as *Jaws* (1975), *Close Encounters of the Third Kind* (1977), and *Raiders of the Lost Ark* (1981). Having amassed considerable movie-making muscle, he explored more meditative genres, producing ostensibly thoughtful films such as *The Color*

Purple (1985) and *Empire of the Sun* (1987). Spielberg's latest productions attempt to reconcile the serious with the entertaining. Including *AI: Artificial Intelligence* (2001) and *Minority Report* (2002), these films address major philosophical themes, but do so on the run. Uniting Spielberg's entire output is an obsession with father/son relationships: sometimes figurative, often literal.

As represented by their posters, it becomes apparent that Spielberg's movies have inspired many of the late 20th century's most iconic images. The rising open-mouthed shark and the alien-bearing bicycle are etched in the public imagination. Usually avoiding the conventional action collage (although the advertisements for the Indiana Jones series follow this format exactly), Spielberg posters often succeed in boiling down a movie to its graphic essence. In the case of the poster for *E.T.*, the design was so successful that Spielberg adopted it as the logo of his production company Amblin. The flying bicycle not only summed up the film, it expressed the nature of Spielberg's life-long project.

ABOVE *Jaws*, Steven Spielberg, 1975. **POSTER USA** Endlessly parodied, this famous image is as current today as it was in 1975. *Jaws* was a sensation at the time of its release and to this day it remains a cornerstone of contemporary horror.

A STEVEN SPIELBERG FILM

E.T.
THE EXTRA-TERRESTRIAL
IN HIS ADVENTURE ON EARTH

A STEVEN SPIELBERG FILM E.T. THE EXTRA-TERRESTRIAL
EE WALLACE · PETER COYOTE · HENRY THOMAS AS ELLIOTT · MUSIC BY JOHN WILLIAMS
RITTEN BY MELISSA MATHISON · PRODUCED BY STEVEN SPIELBERG & KATHLEEN KENNEDY
DIRECTED BY STEVEN SPIELBERG · A UNIVERSAL PICTURE · SOUNDTRACK AVAILABLE ON MCA RECORDS AND TAPES
READ THE BERKLEY BOOK ©1982 UNIVERSAL CITY STUDIOS, INC.

BELOW *A.I. Artificial Intelligence*, Steven Spielberg, 2001. POSTER USA This poster suggests the mechanical nature of the robotic child Daniel, cut from the A to form the I. This film was not well received, many believing that its powerful philosophical theme was smothered by sentimentality.

David is 11 years old.
He weighs 60 pounds.
He is 4 feet, 6 inches tall.
He has brown hair.

His love is real.

But he is not.

A.I.

A STEVEN SPIELBERG FILM
ARTIFICIAL INTELLIGENCE

LEFT *Jurassic Park*, Steven Spielberg, 1993. POSTER Chip Kidd (illustrator), Tom Martin (designer), USA Although this was marketed as a kid's movie, the scenes of dinosaurs attacking humans are as savage as scenes from *Jaws*. Kidd is a book-jacket designer with an enthusiasm for comics.

ABOVE *E.T. The Extra-Terrestrial*, Steven Spielberg, 1982. POSTER USA Spielberg withdrew these posters from circulation when he decided to use the flying bicycle as his production company logo. As a result this poster is extremely rare and highly collectable.

EL DESEO, S. A. LAURENFILM presentan

MUJERES
al borde de un ataque de NERVIOS

un film de ALMODOVAR

Carmen Maura • Antonio Banderas • Julieta Serrano
María Barranco • Rossy de Palma • Guillermo Montesinos • Kiti Manver • Chus Lampreave
Yayo Calvo • Loles León • Angel de Andrés López *y la colaboración de* Fernando Guillén
figurinista José M.ª de Cossío *sonido* Guilles Ortión *jefa de producción* Ester García *montaje* José Salcedo
música Bernardo Bonezzi *director de fotografía* José Luis Alcaine *productor asociado* Antonio Lloréns *productor ejecutivo* Agustín Almodóvar

guión y dirección Pedro Almodóvar
Película subvencionada por el Ministerio de Cultura

DISEÑO GRAFICO: STVDIO GATTI

Pedro Almodóvar & Juan Gatti

Since the mid-1980s, Spanish director Pedro Almodóvar (b. 1951) has worked exclusively with designer and photographer Juan Gatti (b. 1950) in the creation of graphic identities for his films. From title sequences to posters, the pair have drawn heavily from the history of film design in putting together a series of motifs that not only link film promotion to the film itself, but also serve to define Almodóvar's entire body of work as a single, distinct unit.

Gatti's background is not in film but in fashion. Before teaming up with Almodóvar he worked largely as a fashion photographer and, after designing the titles and poster for *Women on the Verge of a Nervous Breakdown* (*Mujeres al borde de un ataque de nervios*), he was asked to art-direct Italian *Vogue*. Equally, Almodóvar has a design sensibility that stretches well beyond the world of film. Spending months searching for objects to furnish his sets, the director has also collaborated with designers from other fields, such as the fashion designer Jean-Paul Gaultier. Common to all of Almodóvar's films is a bright-coloured, slick-surfaced look, an appearance that the director credits to the influence of the Pop artists that he admired during his youth in the 1960s.

The joint aim of Almodóvar and Gatti is to create notable film graphics in the tradition of the designer Saul Bass or the James Bond movies. Discussing their working method, Almodóvar has said: "We normally sit at a table and flick through books, magazines and collections of film posters to find images which might start us off. I steal a lot of ideas, but there's a great difference between the image we start from and the one we end up with and that's where Juan comes in."

The achievement of the Gatti/Almodóvar collaboration is the creation of a body of work that is varied but utterly recognizable. Gatti is eclectic in his choice of motifs,

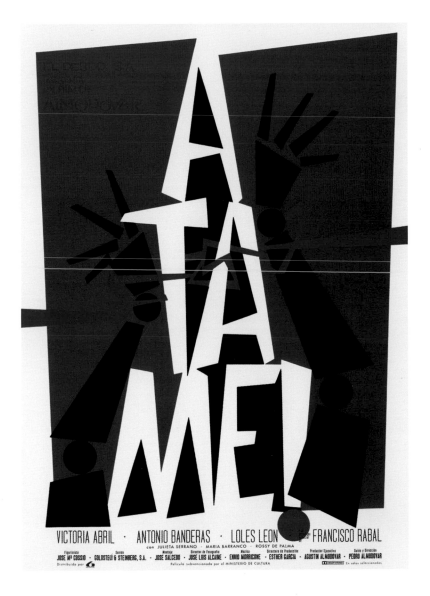

FAR LEFT *Mujeres al borde de un ataque de nervios*, Pedro Almodóvar, 1987. POSTER Juan Gatti, Spain Inspired by the opening sequence to Stanley Donen's *Funny Face*, Gatti and Almodóvar set about constructing a collage of femininity from women's magazines from the 1950s and 1960s.

ABOVE *A Ta Me!* (*Tie Me Up! Tie Me Down!*), Pedro Almodóvar, 1989. POSTER Juan Gatti, Spain The motif on this poster was directly inspired by the posters and titles designed by Saul Bass for the director Otto Preminger, such as *The Man with the Golden Arm* or *Anatomy of a Murder*.

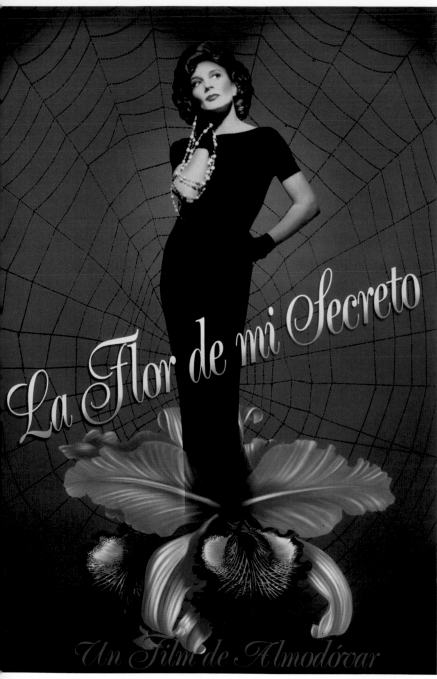

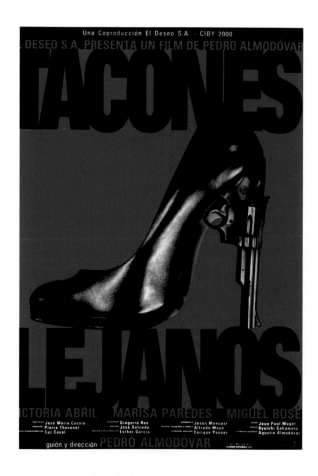

LEFT *La flor de mi Secreto* (*The Flower of my Secret*), Pedro Almodóvar, 1995. POSTER Juan Gatti, Spain The juxtaposition of flower with spider's web sends an ambiguous message. Both are symbols of sexuality, but the latter suggests much more dangerous appetites than the former.

ABOVE *Tacones Lejanos* (*High Heels*), Pedro Almodóvar, 1991. POSTER Juan Gatti, Spain Starker than most of the Almodóvar/Gatti posters, this poster uses a dominant red that conforms to the colour scheme of the entire film.

RIGHT *La flor de mi Secreto* (*The Flower of my Secret*), Pedro Almodóvar, 1995. POSTER Juan Gatti, Spain The film's main character, Leo, is a secret writer of romantic novels. Here she appears at her typewriter silhouetted against a flower-strewn heart, a symbol of her literary territory.

running from abstract graphic devices, through pretty pink flowers, to found photography. Binding together this range of imagery is a bold use of colour and an emphatic typographic style. Some of Gatti's posters, such as the heart made of roses, are instantly appealing; others, for example the cruel gun/shoe combination, are much more repellent; but common to them all is the direct transmission of a complex message. Gatti's unique talent is to grab a potential audience's attention and then convey something that is much more than a one-liner. In keeping with the spirit of Almodóvar's films Gatti's posters are instantly seductive while remaining highly ambiguous. Like the film-maker the designer brings everything to the surface in a manner that inspires both delight and giddiness.

Peter Greenaway

Born in 1942, Peter Greenaway trained as a fine artist and brings a painterly sensibility to all his films. He dismisses cinematic conventions as restrictive and unnecessary. Instead of trying to present a tame illusion of reality, he strives to create rich and overwhelming experiences. Greenaway's aim is no less ambitious than the reinvention of contemporary cinema.

Greenaway first attracted widespread attention with the 1982 feature *The Draughtsman's Contract*. Set in the English countryside in 1694, it follows the progress of a draughtsman, Mr Neville, who has been commissioned to make 12 drawings of a large country house. Various events ensue, including sexual bribery and murder, but the connections between them are never quite clear. The film is a puzzle without a solution, a kind of avant-garde hoax. Many of Greenaway's subsequent films follow a similar formula: an elaborate setting, a number of extraordinary events, and no discernible plot. Greenaway's best-known works include *A Zed and Two Noughts* (1985), *Drowning by Numbers* (1988), *The Belly of an Architect* (1987), and *The Cook, The Thief, His Wife and Her Lover* (1989).

Posters for Greenaway's films reflect his sensibility, each being a framed composition built of several different elements. That said, Greenaway did not approve of most of these images. Taking the utmost care to frame every shot of his films, he tends to find the independent input of graphic designers unwelcome. Greenaway pays close attention to the design of posters for his productions, often suggesting an image of his own, but in the past he has been thwarted by the conditions imposed by marketing departments. Designers working for Greenaway report a mix of awe and respect for his talent, combined with a certain amount of frustration. Greenaway actively resists the kind of summary that a movie poster demands.

BELOW *Prospero's Books*, Peter Greenaway, **1991.** POSTER The Creative Partnership, UK In keeping with the title of the film, this poster has the look of a book illustration. The composition of old man (the film's star John Gielgud) and maid is meticulously arranged and utterly static.

BOTTOM RIGHT *The Belly of an Architect*, Peter Greenaway, **1987.** POSTER Martin Huxford, UK Designer Martin Huxford built the wooden frame and placed three-dimensional emblems from the film inside. Greenaway is said to have had a "mild explosion" when he saw the results.

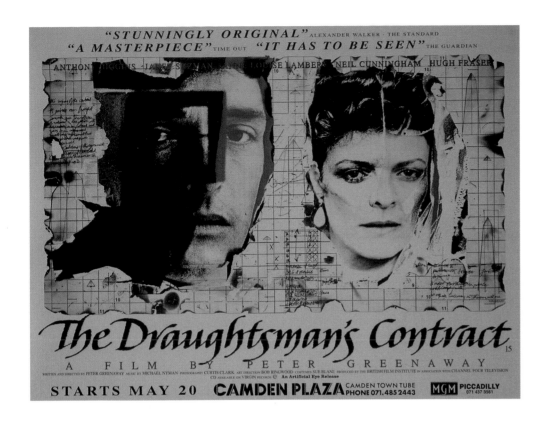

LEFT *The Draughtsman's Contract*, Peter Greenaway, 1982. POSTER Mike Coulson, UK The background to this complex photographic collage of the lead players is the paper used by the draughtsman. The burnt edges anticipate the film's dramatic, if mystifying, denouement.

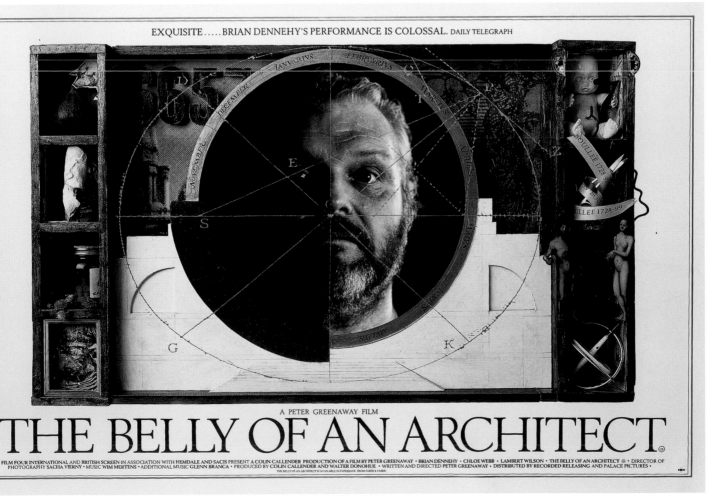

Trainspotting 18

THIS FILM IS EXPECTED TO ARRIVE...

23:02:96

From the team that brought you Shallow Grave

#2 BEGBIE

#3 DIANE

#4 SICK

Trainspotting

Akin to its early 1960s counterparts, the British film
Trainspotting is the adaptation of a book of the same
name. Written by Scottish author Irvine Welsh, the novel
recounts events in the lives of a group of young Edinburgh
drug-users. The hobby of trainspotting is a metaphor for
the tedium of a non-chemically enhanced existence.

The process of bringing novels of this kind to the
screen is fraught with difficulty. On the page characters
can be compelling while remaining true to life, but on
screen they require a sheen of glamour in order to be ren-
dered watchable. Famously the lead actor Ewan McGregor
lost weight and built muscle for the part of a drug addict.
He plays the character Renton with an athletic intensity
that is not the typical demeanour of a chemical dependent.
Charges of glamorization apart, *Trainspotting* is a highly
successful film, which, as this poster conveys, derives its
triumph from a handful of strong, idiosyncratic perform-
ances. McGregor's Renton is the centrepiece of the film
and proved a career-grounding role for the 25-year-old
actor, but all the supporting actors, especially Robert
Carlyle as Begbie, make comparably forceful appearances.

The photographic manner of the *Trainspotting* poster
was very familiar to the film's intended mid-1990s youth
audience. Adopting the visual mores of the style press of
the time, the portraits emphasize a seductive dose of atti-
tude above conventional good looks. Pretty girls snarl and
good-looking boys grimace, giving the overall impression
of a perversely careless beauty. The film attracted a wide
audience and left anti-drug activists fretting over the
implications of this kind of popular representation.

WINNER·BEST PICTURE·1994 CANNES FILM FESTIVAL

PULP FICTION

a Quentin Tarantino film

10¢

produced by
Lawrence Bender

JOHN TRAVOLTA
SAMUEL L. JACKSON
UMA THURMAN
HARVEY KEITEL
TIM ROTH
AMANDA PLUMMER
MARIA de MEDEIROS
VING RHAMES
ERIC STOLTZ
ROSANNA ARQUETTE
CHRISTOPHER WALKEN
and
BRUCE WILLIS

MIRAMAX FILMS PRESENTS A BAND APART and JERSEY FILMS PRODUCTION A FILM BY QUENTIN TARANTINO PULP FICTION MUSIC SUPERVISOR KARYN RACHTMAN
COSTUME DESIGNER BETSY HEIMANN PRODUCTION DESIGNER DAVID WASCO EDITOR SALLY MENKE DIRECTOR OF PHOTOGRAPHY ANDRZEJ SEKULA
CO-EXECUTIVE PRODUCERS BOB WEINSTEIN HARVEY WEINSTEIN RICHARD N. GLADSTEIN EXECUTIVE PRODUCERS DANNY DEVITO MICHAEL SHAMBERG
STACEY SHER STORIES BY QUENTIN TARANTINO & ROGER AVARY PRODUCED BY LAWRENCE BENDER WRITTEN AND DIRECTED BY QUENTIN TARANTINO

R RESTRICTED
UNDER 17 REQUIRES ACCOMPANYING
PARENT OR ADULT GUARDIAN

FILMED IN
PANAVISION

SOUNDTRACK AVAILABLE ON MCA. LP's, CASSETTES & CDs

DOLBY STEREO
DIGITAL

MIRAMAX
FILMS

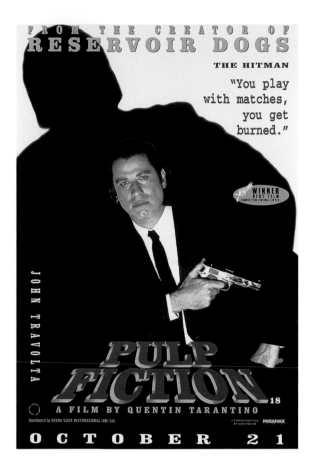

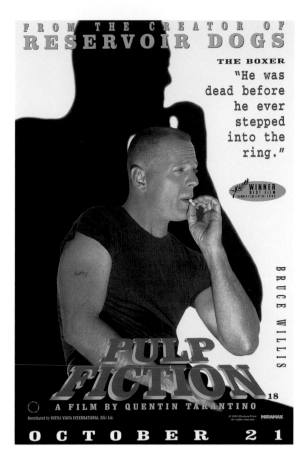

LEFT *Pulp Fiction*, Quentin Tarantino, 1994. POSTER Firooz Zahedi (photographer), USA Dented close to the would-be spine and chewed-looking on the edge, this book-cover parody conveys the blatantly sensationalist nature of the film's substance. Lovers of subtlety are warned off.

ABOVE *Pulp Fiction*, Quentin Tarantino, 1994. POSTER The Creative Partnership, Firooz Zahedi (photographer), UK Firooz Zahedi, a celebrity photographer who took pictures for Andy Warhol's *Interview*, captures the brooding intensity of John Travolta (left) and Bruce Willis (right).

Quentin Tarantino

Quentin Tarantino (b. 1963) came to public attention in 1992 with his directorial début *Reservoir Dogs*. The film has a fairly traditional bungled-heist plot, but it startled audiences with its fast-paced dialogue, cruel humour, and easy violence. Tarantino has a unique ability to take a range of familiar cinematic references, blend them with an extremely retro aesthetic, and still emerge with movies that appear fresh and original. *Pulp Fiction* was the eagerly awaited follow-up to *Reservoir Dogs*. Distinguished by its brilliant characterization, well-written dialogue, and clever plotting, the film confirmed Tarantino's mastery. Between them, these two movies represent the most significant development in popular cinema in the early 1990s. Tarantino's 1997 movie *Jackie Brown* (an adaptation of

the Elmore Leonard novel *Rum Punch*) did not enjoy the commercial success of its predecessors, although many believe it is the director's most mature work to date. Whether Tarantino will sustain a career to match his early success remains in question.

The publicity campaigns for *Pulp Fiction* concentrate on the film's individual characters. Played by a cast including John Travolta, Bruce Willis, and Samuel L. Jackson, each of the main players has a claim to star status and each delivers a career-defining performance. In 1994 the decision to cast John Travolta seemed extremely unlikely. It is testament to the success of Tarantino's reinvigoration of Travolta's career that it has become hard to remember the actor's fallow years

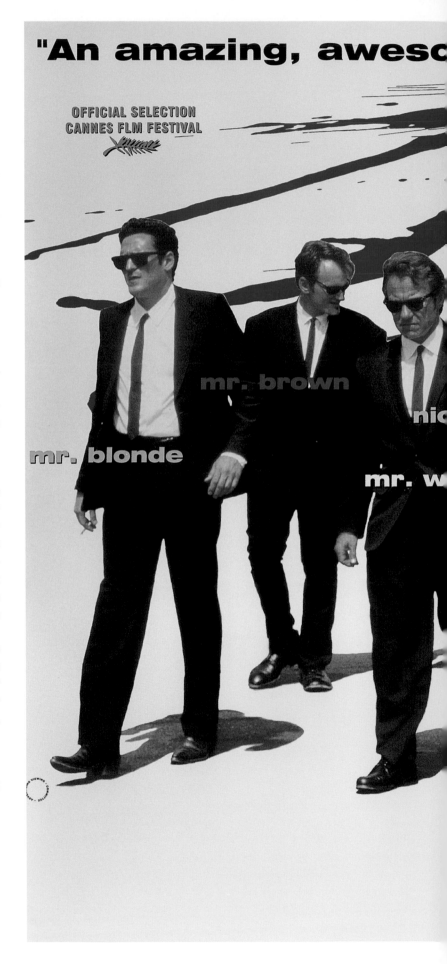

between the mid-1980s and early 1990s. The basis of all the *Pulp Fiction* posters is a set of images taken by celebrity photographer Firooz Zahedi. Set in a mock-up of a cheap paperback cover, Uma Thurman broods like a traditional movie temptress; "the hitman" Travolta holds his gun to his heart; and "the boxer" Willis (a corrupted sportsman) looks left, avoiding our gaze.

The obvious reference for the *Reservoir Dogs* poster is the publicity for the well-known rat-pack movie *Ocean's 11* made more than 30 years earlier. In the 1960 image a group of besuited criminals stroll down a city street, apparently relaxed, but with an air of menace. Their 1992 counterparts are more shoddy and downbeat. They are dressed uniformly in black suits and thin ties, but it is obvious that some of the garments are poorly fitting, and several of the characters adopt the awkward, unprepossessing gait of the ill at ease. Like *Ocean's 11*, Tarantino's film glamorizes criminals, but it does so in a twisted manner. The director takes the sordid and unpleasant and injects it with an energy that renders it utterly compelling.

The tag on each character on the *Reservoir Dogs* poster refers to their alias in the film: Mr Blonde, Mr Brown, Mr White, and so on. These references to colour stand in marked contrast to the monochrome nature of the criminals' dress and provide some relief from the black-and-red colour scheme of the image. The hues also hint at the respective roles of the film's main players: for example Mr White, played by Harvey Keitel, is the only one of the bunch to display a degree of conscience.

Apart from the film's 18 certificate (R rating), the biggest warning of its disturbing level of violence is the slash of blood across the top of the posters. Expressive of Tarantino's unsqueamish take on brutality, this trail of gore is not abstracted or prettified. Instead it trails, drips, and splatters just like the real thing.

RIGHT *Reservoir Dogs*, **Quentin Tarantino, 1992.** POSTER **The Creative Partnership, UK** Itself inspired by the original line-up on the poster for the 1960s movie *Ocean's 11*, in turn this poster influenced the campaign for that film's 2001 remake. In particular, the new version of *Ocean's 11* used the black-and-red colour scheme that has become strongly associated with Tarantino's movie.

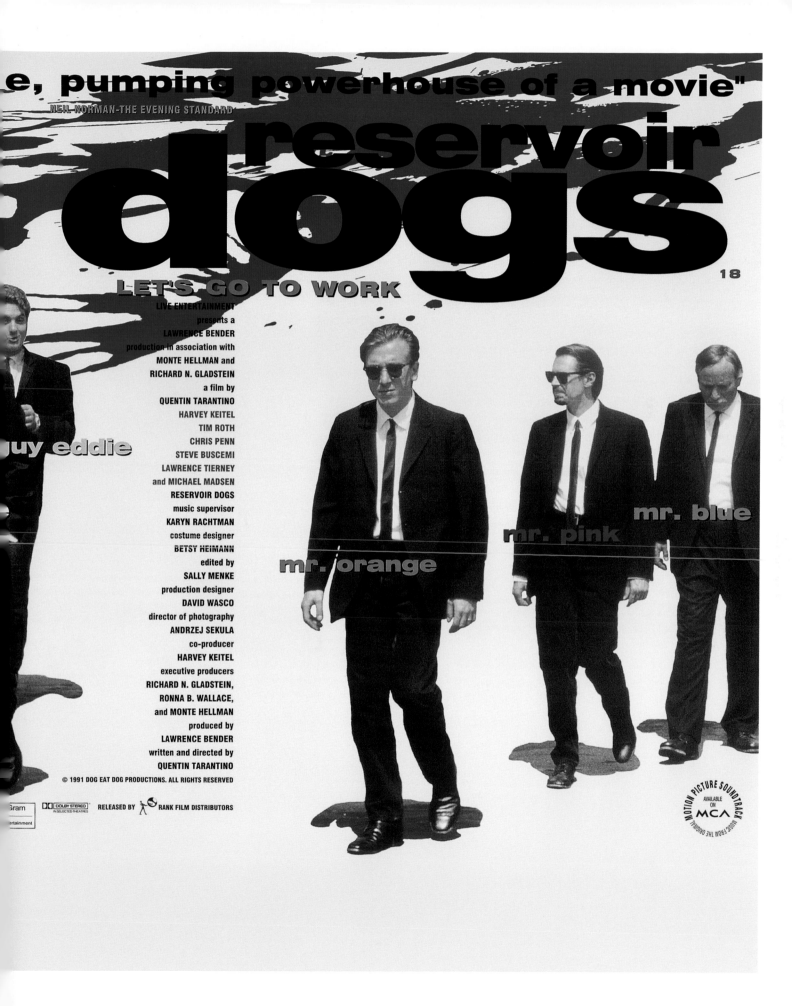

"...e, pumping powerhouse of a movie"

NEIL NORMAN-THE EVENING STANDARD

reservoir dogs

18

LET'S GO TO WORK

LIVE ENTERTAINMENT
presents a
LAWRENCE BENDER
production in association with
MONTE HELLMAN and
RICHARD N. GLADSTEIN
a film by
QUENTIN TARANTINO
HARVEY KEITEL
TIM ROTH
CHRIS PENN
STEVE BUSCEMI
LAWRENCE TIERNEY
and MICHAEL MADSEN
RESERVOIR DOGS
music supervisor
KARYN RACHTMAN
costume designer
BETSY HEIMANN
edited by
SALLY MENKE
production designer
DAVID WASCO
director of photography
ANDRZEJ SEKULA
co-producer
HARVEY KEITEL
executive producers
RICHARD N. GLADSTEIN,
RONNA B. WALLACE,
and MONTE HELLMAN
produced by
LAWRENCE BENDER
written and directed by
QUENTIN TARANTINO
© 1991 DOG EAT DOG PRODUCTIONS. ALL RIGHTS RESERVED

Gram | DOLBY STEREO | RELEASED BY RANK FILM DISTRIBUTORS
IN SELECTED THEATRES
ertainment

MOTION PICTURE SOUNDTRACK
AVAILABLE ON
MCA
MUSIC FROM THE ORIGINAL

guy eddie

mr. orange

mr. pink

mr. blue

The Silence of the Lambs

In the 16th century the word "moth" had a figurative meaning: something that eats away, gnaws, or wastes silently and gradually. In addition to this definition, the death's head moth, the insect shown in this image, has an established place in folklore, the combination of its skull-and-crossbones markings and its unexpectedly loud cry (reminiscent of lambs at the slaughter) casting it as a harbinger of war, pestilence, and death. The appearance of a death's head moth in a candle-lit room is considered an omen of imminent doom.

Drawing on both of these interpretations, the death's head moth placed over the mouths of the male and female leads in the posters for the horror film *The Silence of the Lambs* (Jonathan Demme, 1991) creates a chilling image. In the case of the female character, Jodie Foster as FBI recruit Clarice Starling, the moth appears to be engaged in an act of gradual consumption. The young woman's whitened aspect suggests a slow drawing of blood. In contrast to Starling's ashen features, the face of Anthony Hopkins as the cannibalistic killer Dr Hannibal Lecter is flushed bright red. The moth might be transferring the blood from the one character to the other.

The death's head moth makes an appearance in the climactic scene of Demme's film. Starling pieces together Lecter's clues and locates the house of his murderous colleague. As the agent enters the dusty dwelling, a moth flutters through the gloom to confirm the presence of death. The film ends with Starling having solved her case but Lecter still at large, available for the 2001 sequel *Hannibal* directed by Ridley Scott.

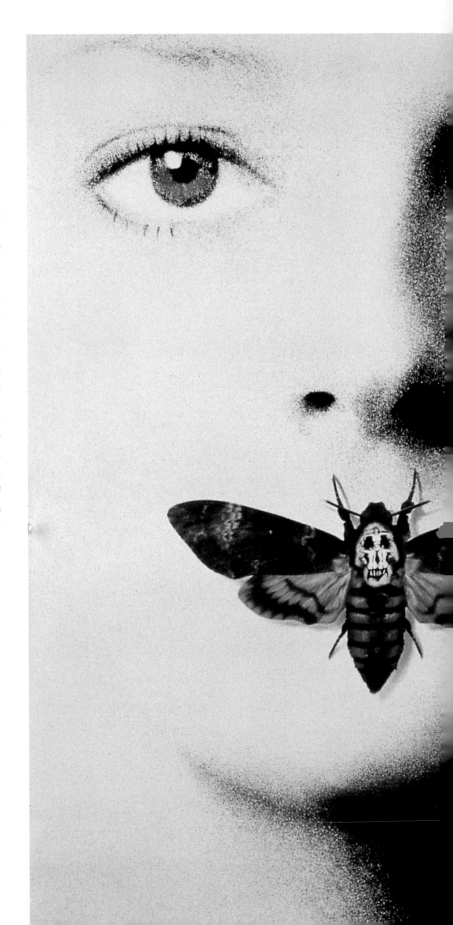

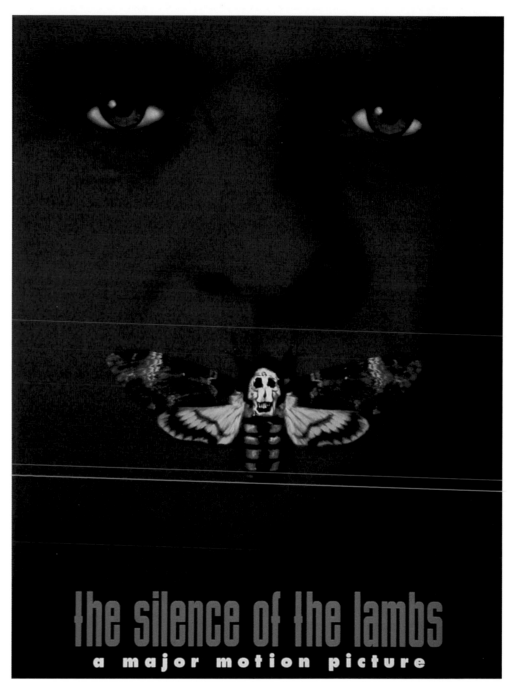

ABOVE *The Silence of the Lambs*, Jonathan Demme, 1991. POSTER UK The twin of the teaser shown left, this advance has the look of a book jacket. Bearing its title at its foot and carrying a restrained, metaphorical image, the poster reinforces the movie's literary credentials.

LEFT *The Silence of the Lambs*, Jonathan Demme, 1991. POSTER UK This teaser image has held a consistently high rank in surveys of successful movie posters. Drawing its power from the implied rather than the explicit, the image achieves a triumphant simplicity.

Dogme 95

The Dogme manifesto was drawn up in 1995 in Denmark by a Copenhagen-based film-directors' collective, whose members included Lars von Trier and Thomas Vinterberg. The subject of the manifesto was the process of film-making, and it contained clauses banning cinematic norms such as the use of sound not generated by on-screen activities and the dependence on superficial action. Although the terms of what Dogme called its "vow of chastity" were spectacularly restrictive, the manifesto deliberately ignored the marketing and distribution of the films, activities described by Vinterberg as the "afterlife". The first Dogme product to reach the cinemas was Vinterberg's own *Festen* in 1998. Ignoring the film's ideological and artistic aspirations, the publicity campaign concentrated on a conventional ensemble image.

Graphic designer and design educator Stuart Bailey is a keen supporter of the principles of Dogme 95, but feels that the collective's neglect of publicity was a mistake. Arguing that films should be promoted in a manner that reflects their content, he challenged his students at the Gerrit Rietveld Academie, Amsterdam, The Netherlands, to come up with pieces of graphic design that were in keeping with the spirit of Dogme. The result is a series of low-key posters, many of which are hand-drawn. Unlike Dogme films, these images are not intended as a rebuke to contemporary technology. Rather, they are meant simply as an appropriate means of expression.

FAR RIGHT *Idioterne* (*The Idiots*), **Lars von Trier, 1998.** POSTER **Daphne Correll, The Netherlands** The densely scribbled surface of this poster (2001) could be read as an analogy for the texture of the film. Many people felt the meaning of *The Idiots* was obscured by the constant flurry of absurdity.

RIGHT, TOP *Idioterne* (*The Idiots*), **Lars von Trier, 1998.** POSTER **Serge Rompza, The Netherlands** This poster (2001) makes a feature of the more publicity-friendly aspects of Lars von Trier's film. It is a parody of a hard sell that could act inadvertently as the real thing.

RIGHT *Idioterne* (*The Idiots*), **Lars von Trier, 1998.** POSTER **Chantal Hendriksen, The Netherlands** Balancing the sober delivery of information with tipsy hand-drawn lettering, this poster (2001) acts as a metaphor for the relationship between the rational and irrational in the film itself.

Jean-Pierre Jeunet & Marc Caro

Born in 1955, Jean-Pierre Jeunet is a self-taught film-maker with a taste for fantasy. He began his career in the mid-1970s, directing adverts, music videos, and short films. He soon teamed up with Marc Caro, a director, designer, cartoonist, writer, and occasional actor. They have evolved a distinctive style, characterized by a mix of live action and animation, a combination of squalor and pure frippery, and a near morbid attention to detail.

Jeunet and Caro's first feature was *Delicatessen*. The pair took joint director credit for this film, Jeunet concentrating on guiding the actors, Caro on marshalling the elements of the film's design. Set in a post-apocalyptic butcher's shop and the apartments above, the scenery is as much the film's star as any of its lead players. The poster is deceptively innocuous, the wooden-pig shop sign being among the least disturbing symbols that could be drawn from the film. Jeunet and Caro's début was a surprise international hit, enabling them to realize a project that had been ten years in development. *The City of Lost Children* (*Le Cité des enfants perdus*) concerns an evil plan to steal the dreams of young people, a story used by Jeunet and Caro as a chance to exploit extravagant special effects. Reflecting the retro-futurist look of the film, the poster apes the form of a old-time theatre bill.

In 2001 Jeunet went solo to direct the huge box-office draw *Amélie*. This film is more character-driven than Jeunet/Caro joint productions, an emphasis that is reflected in the portrait-style poster. Amélie's coy good looks are a cocktail of two erstwhile movie queens: Audrey Hepburn and Louis Malle's character Zazie.

BELOW *Le Cité des Enfants Perdus*, Jean-Pierre Jeunet and Marc Caro, 1995. POSTER USA Resembling a playbill stuck to a brick wall, this elaborate poster reflects Marc Caro's design vision, emphasizing his idiosyncratic filmic landscape and his proclivity towards bizarre props.

BELOW RIGHT *Delicatessen*, Jean-Pierre Jeunet and Marc Caro, 1991. POSTER France The rich tones of this poster echo the striking colour scheme of the film itself. Tinged brown throughout, the movie has an old-world look that belies its futuristic plot.

RIGHT *Le Fabuleux Destin d'Amélie Poulain*, Jean-Pierre Jeunet, 2001. POSTER France Not only does Audrey Tautou's Amélie look like a grown-up version of Louis Malle's Zazie, but the tinted photograph is also reminiscent of the image that advertised Malle's 1960 movie.

LEFT *Waking Life*, Richard Linklater, 2001. POSTER UK This poster frames various images from the film as if they were paving stones on what appears to be a sweeping suspension bridge. Possibly the bridge represents the transition between a waking and a sleeping state.

RIGHT *Slacker*, Richard Linklater, 1991. POSTER UK This poster places a disaffected, androgynous youth of the late 1980s against a psychedelic background more in keeping with the late 1960s. The juxtaposition implies some kind of correspondence between the two eras.

FAR RIGHT *Dazed and Confused*, Richard Linklater, 1993. POSTER USA While the background to this poster is a tie-dye pattern, the ultimate 1976 texture, the type over the top is the most fashionable of all early 1990s typefaces, Barry Deck's Template Gothic.

Richard Linklater

Born in 1962, Richard Linklater's earliest films draw directly from his experience. His directorial début, *It's Impossible to Learn to Plow by Reading Books* (1988), dealt with the aimless existence of a nomadic twenty-something and reflects an episode in Linklater's life during which he suspended his university education and filled time in a haphazard fashion. Emphasizing the point, Linklater played the lead role in the film.

Linklater's next production, *Slacker*, showed a group of young people, many of them ex-university students, drifting around the small Texan town of Austin. At the time Linklater made the movie he was living in Austin, himself a recent graduate of the local university. Unsurprisingly, he appears in this film too.

Slacker was a film festival hit and helped Linklater raise the funds to make the larger-scale follow-up *Dazed and Confused*. Focusing on the class of 1976, this film dealt with the experiences of a group of people slightly older than Linklater and is seen largely through the admiring eyes of a younger brother.

Posters for Linklater's films tend to use the graphic currency of their day. *Slacker* and *Dazed and Confused* were released at a time when colour-suffused, multi-layered graphics were popular, and the advertisements for both adopt that style. The poster for Linklater's later film, *Waking Life*, raises slightly different issues. The movie is a technologically pioneering combination of live action and animation that follows a young man through various levels of a dream state. The poster displays the many different styles of animation used in the film, some verging on the photorealist, others tending towards the abstract.

Harmony Korine

Born in 1974, Harmony Korine wrote the screenplay for Larry Clark's 1995 début feature *Kids*. According to film lore, Clark discovered Korine while he was skateboarding in Washington Square Park. Korine stood out from his peers owing to his knowledge of European film, and proved to have a keen ear for language and an aptitude for writing.

Korine directed his own first feature at the age of 22. Set in the fictional Middle American town of Xenia, Ohio, in the aftermath of a tornado, *Gummo* paints an unrelenting picture of alienated youth. The film's protagonists spend their days bike-riding, glue-sniffing, and paying for sex with female acquaintances. *Gummo* veers between the scripted and the improvisational; rather than following a conventional plot, it is composed of a series of loosely connected episodes. The poster reflects the film's parched landscape and its cast of extraordinary youths.

In making his second film *Julien Donkey-Boy* (1999), Korine adopted the rules of the Danish Dogme 95 collective. The result is another broadly non-narrative film, this time shot on a hand-held digital camera. As with Korine's other productions, its main subject is disaffected youth.

RIGHT *Gummo*, **Harmony Korine, 1997.**
POSTER **UK** The juxtaposition of crude hand-written type and apparently self-styled hair allow this poster to communicate youth's rough edges. Like the poster, the film presents an uncompromising portrait.

LEFT *Kids*, **Larry Clark, 1995.**
POSTER **USA** Each of the colour–suffused photographs represents one of the film's major characters. Chloë Sevigny, bottom right, has since become an ever-present movie/fashion celebrity.

MATT DILLON | KELLY LYNCH

DRUGSTORE COWBOY

AVENUE PICTURES Presents MATT DILLON in "DRUGSTORE COWBOY" KELLY LYNCH JAMES REMAR JAMES LE GROS HEATHER GRAHAM
and WILLIAM BURROUGHS Music by ELLIOTT GOLDENTHAL Production Designer DAVID BRISBIN Director of Photography ROBERT YEOMAN
Executive Producer CARY BROKAW Produced by NICK WECHSLER and KAREN MURPHY Written by GUS VAN SANT & DAN YOST Directed by GUS VAN SANT

RECORDED IN
ULTRA·STEREO

IVE INTERNATIONAL
VIDEO
ENTERTAINMENT
INC.

AVENUE
PICTURES

Gus Van Sant

A graduate of Rhode Island School of Design, Gus Van Sant (b. 1952) is a writer, photographer, and musician as well as a film director. His approach to film-making is decidedly non-mainstream, both in terms of subject matter and approach. Van Sant's cinematic début was *Mala Noche* (1985), an account of a young white man's unreturned affection for a teenage Mexican immigrant set in Portland, Oregon. Follow-ups include *Drugstore Cowboy* (1989), the story of a group of 1960s junkies who hold up small-town stores in order to finance their habits, and *My Own Private Idaho* (1991), the tale of a pair of troubled male hustlers who turn to one another for support. In spite of his unswerving marginal take, Van Sant has recruited well-known actors to his projects and has been able to secure worldwide distribution for most of his films. In the late 1990s he attracted the attention of Hollywood and his more recent output has included larger scale, more mainstream productions such as *Good Will Hunting* (1997).

The posters for Gus Van Sant's earlier films are in keeping with their low-key, art-house leanings. The *Drugstore Cowboy* image in particular concentrates on an unassuming, intimate portrait of the film's male and female leads, a picture that conveys a sense of warmth as well as offering an intimation of oncoming tragedy. The poster for *My Own Private Idaho* is more graphically complex. Portraying River Phoenix and Keanu Reeves in a series of vertically sliced images, it reflects the experimental techniques employed in the film and the heightened sense of dislocation that pervades the production. The titles for both films are presented in dirty, incomplete type, lending the sense of something made fast and on the cheap.

LEFT *Drugstore Cowboy*, Gus Van Sant, 1989. POSTER USA Visible on the wall behind the young lovers is a series of decorative 1960s-style scrawls. This communicates the sense of a long-gone, more gentle age, an era when even the graffiti was pretty.

BELOW *My Own Private Idaho*, Gus Van Sant, 1991. POSTER USA The long straight roads of Idaho, strips of tarmac that run towards the horizon, provide an important symbol in this film. They are places where the characters appear (and disappear) as if out of nowhere.

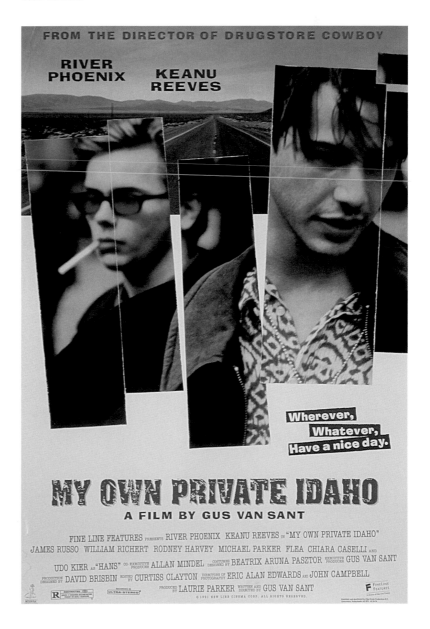

LEFT *All or Nothing*, Mike Leigh, 2002.
POSTER UK Played by Timothy Spall, the minicab driver Phil is a reprise of several of his previous Leigh characters. Possibly Leigh's on-screen alter ego, he is the well-meaning man who grapples ineffectually with the trials of life.

RIGHT *Naked*, Mike Leigh, 1993.
POSTER UK This poster juxtaposes a trendy typeface (an adaptation of Zuzana Licko's Modula) with a grim scene. The film itself is a discomforting portrait of early 1990s Britain and this twinning of the cool and the grimy is an accurate reflection of its setting.

BELOW *Secrets and Lies*, Mike Leigh, 1996. POSTER UK *Secrets and Lies* won several awards and is the most accessible of all Leigh's films. As a result it was marketed internationally as a mainstream movie, hence the bland typography and slightly facile taglines on this poster. All the same, the tightly cropped portraits of the female leads do justice to their performances.

Mike Leigh

Mike Leigh was born in Manchester, England, in 1943 and trained as an actor, then as a film-maker. Working initially for theatre and television, he made his feature début with *Bleak Moments* in 1971. Leigh is celebrated for his unusual method of directing. Gathering his cast together several weeks before any filming takes place, he conducts a series of improvisational sessions in which each actor invents his or her character. The aim is to create a style of filming that is akin to making a documentary, the sense that the events caught on camera are small snatches of an on-going existence. Leigh believes that a director must understand the entire world of his characters, every last detail, including what they ate for breakfast.

Given Leigh's technique, it is not surprising that the posters for his films tend to be spontaneous-looking and character-based rather than highly composed. The most attention-grabbing of the bunch is the poster for *Naked*. Juxtaposing Katrin Cartlidge in a state of undress and David Thewlis prowling one of London's more unpleasant back streets, this image is particularly unsettling. In the film Cartlidge plays Sophie, a perpetual victim, and this poster makes that role quite clear. The advertisement for *All or Nothing* is much easier to take. Timothy Spall's everyman makes a direct and sympathetic appeal to the film's potential audience. The type placed around Spall's head looks like a graphic expression of frustration and bewilderment. Likewise, actresses Claire Rushbrook, Brenda Blethyn, and Marianne Jean-Baptiste present a set of intriguing natural expressions with which to promote *Secrets and Lies*.

BELOW *The Apple*, Samira Makhmalbaf, **1998**. POSTER **UK** Brought up in complete isolation, the twin girls in this film were the subject of news stories in Iran. Samira Makhmalbaf allowed them to re-enact their story, a task they undertook with great spirit. This poster reveals their characters.

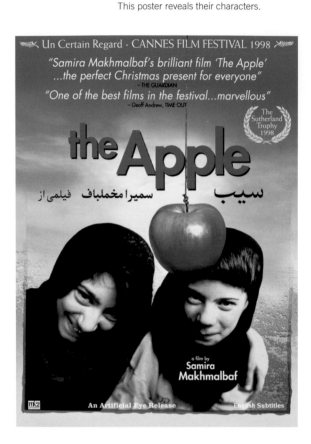

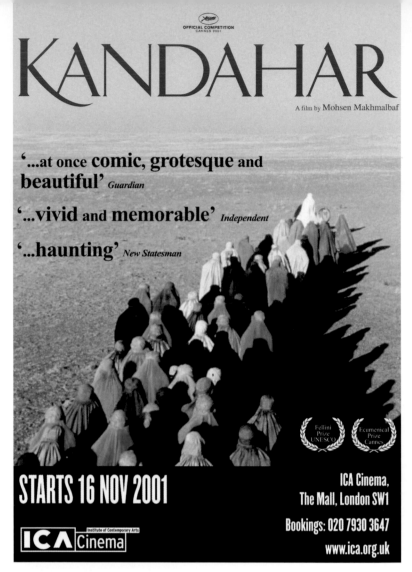

ABOVE *Kandahar*, Mohsen Makhmalbaf, **2001**. POSTER **UK** This film is a fiction/documentary hybrid that explores the plight of Afghani refugees through the eyes of a young woman returning to Afghanistan from Canada. The poster shows a crowd of women apparently going nowhere.

RIGHT *Blackboards*, Samira Makhmalbaf, **2000**. POSTER **UK** Set in the mountains between Iraq and Iran, *Blackboards* tells the story of two itinerant teachers who walk the land with the tools of their trade tied to their backs. This poster communicates the oddity and isolation of this nomadic existence.

The Makhmalbafs

The Makhmalbaf family is a cinematic phenomenon. Born in Iran in 1957, Mohsen Makhmalbaf was a militant young Muslim who dropped out of school to join the fight against the Shah's regime. He was imprisoned for stabbing a policeman at the age of 17 and had served most of a five-year prison sentence when the 1979 Iranian revolution brought an Islamic government to power, and with it his freedom. On his release, Makhmalbaf started writing novels and plays, and during the mid-1980s he produced a series of didactic films concerning Islamic values.

In the late 1980s Makhmalbaf's perspective shifted. His 1987 film *The Peddler* attracted international attention, raising complex moral and social questions. Makhmalbaf pursued these themes and in 1998 left Iran for Tajikistan in order to work without censorship. In 2001 he made

Kandahar, an extraordinarily timely film about the Taliban rule of Afghanistan. Makhmalbaf has also encouraged the career of his daughter Samira (b. 1980). Samira Makhmalbaf's début, *The Apple*, is a re-enactment of real events by the people in question. The result is spare, located mostly in a single small apartment, but extremely humane and very effective. Her follow-up, *Blackboards*, is on a grander scale and makes much of the parched mountains of its Kurdistan setting.

The posters for Makhmalbaf films tend to employ the graphic qualities of the desert landscape, Islamic dress, and, in the Arabic versions, the elegance of the script. For the most part these images are unembellished but compelling. Like the films themselves, they achieve a balance between the sweeping and the intimate.

FROM THE ACCLAIMED DIRECTOR OF 'THE APPLE'

BLACKBOARDS PG

تخته سیاه
(Takhté Siah)

a film by **Samira Makhmalbaf**

کارگردان: سمیرا مخملباف

"MASTERLY!...CONFIDENT...ASTONISHING"
Philip French THE OBSERVER

"POWERFUL..."
Geoff Andrew TIME OUT

"Brilliantly assured"
Roger Clarke THE INDEPENDENT

"SUPERB...the final sequences are BREATHTAKING"
Nick James SIGHT AND SOUND

WINNER
GRAND PRIX DU JURY
CANNES FILM FESTIVAL 2000

برندهٔ جایزه داوران فستیوال کن

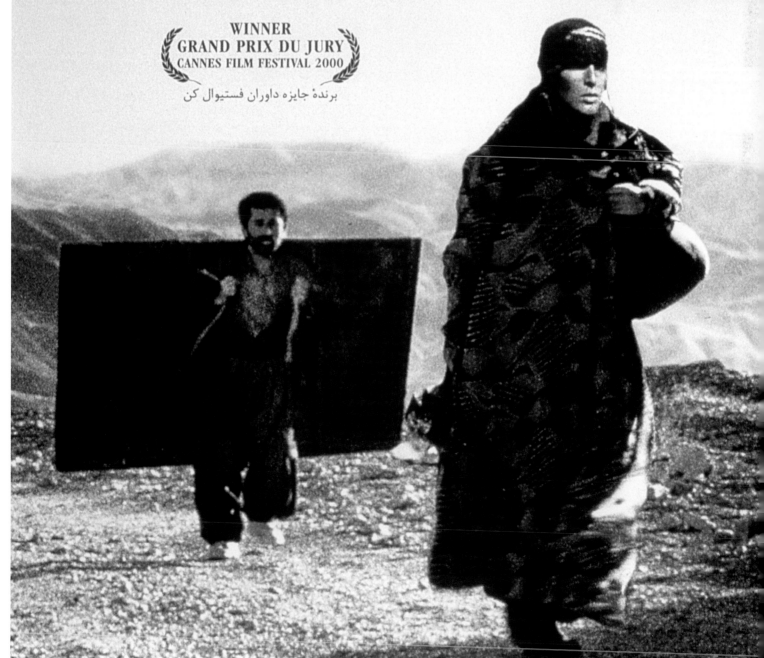

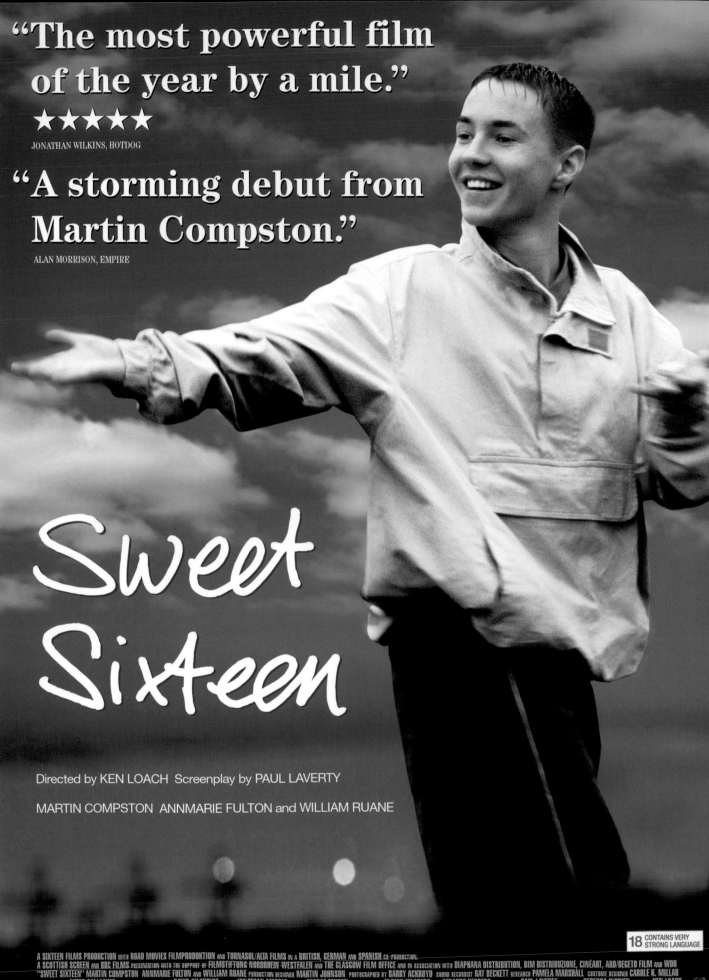

Ken Loach

Although he is often allied with British director Mike Leigh, Ken Loach (b. 1936) is a much more political film-maker than his compatriot. Where Leigh hopes that his characters communicate an ambiguous message, Loach is an unashamed campaigner. All the same, Loach's films are not weighed down by his politics. Instead of being reduced to mouthpieces for various sentiments, the director's characters remain complex and three-dimensional.

After graduating from Oxford University, Loach began to work in television, making the celebrated 1966 docu-drama *Cathy Come Home*. This short film explores the life

of a young woman who loses her husband, her home, and then her child, offering a trenchant picture of the British welfare system. The movie prompted changes in the housing law and the formation of the charity Shelter. Loach's first two feature films were based on socially conscious 1960s novels: *Poor Cow* (1967) on a book by Nell Dunn and *Kes* on a story by Barry Hines. The literary origins of *Kes* are suggested by the emphasis on text that occurs in most of the posters for the film.

Loach's career suffered in the 1970s and 1980s, but was rekindled in the early 1990s. *Sweet Sixteen* is the latest in a decade-long string of successes. Focusing on a teenage boy, the film inevitably harks back to *Kes*. Just as *Kes*'s Billy was played by untrained actor David Bradley, so *Sweet Sixteen*'s Liam is played by Martin Compston, a teenager recruited from the Glasgow estates in which the film is set. The poster communicates his tenacious optimism, the saving grace of a grim tale.

LEFT *Sweet Sixteen*, Ken Loach, 2002. POSTER The Creative Partnership, UK
Posed against a blue sky with open arms and a spontaneous smile, Martin Compston appears heart-wrenchingly beautiful. This is a refreshing change; teenage boys from Glasgow estates are not often glamorized.

BELOW *Kes*, Ken Loach, 1969. POSTER USA
In the British poster, audiences were told that Billy "lies, cheats and steals ... and doesn't give a tupp'ny damn for anybody". This blurb was toned down for America: the quality of not giving a damn becomes that of an unbreakable spirit.

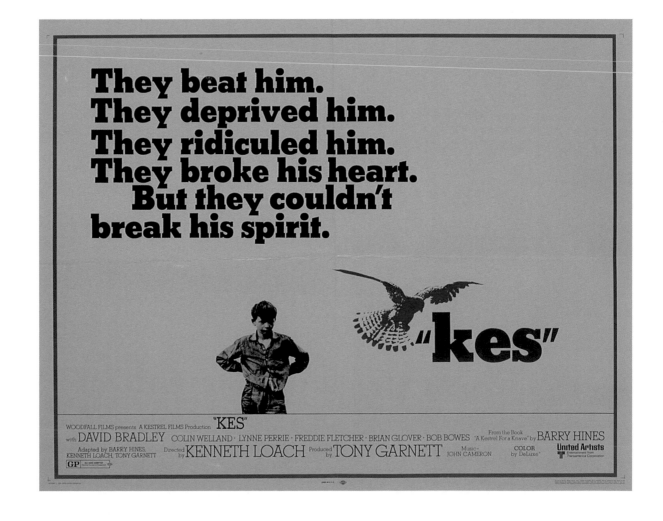

Tim Burton

Tim Burton (b. 1958) attended the California Institute of the Arts in the mid-1970s. After graduation he was drafted into the ranks of Walt Disney, where he worked as an animator and conceptual artist. Burton was not easily absorbed into Disney culture: his live-action short called *Frankenweenie* (1982), the tale of a boy who brings a deceased pet back to life, was given a PG certificate which precluded its release with mainstream Disney fare. Disney may not have been amused, but American comedian Paul Reuben, or Pee-Wee Herman, was – he asked Burton to direct his feature début *Pee-Wee's Big Adventure* in 1985.

Since the mid-1980s Burton has worked predominantly with live action, but his origins in animation remain evident. His *Batman* (1989) is barely three-dimensional and the tragically deformed character in *Edward Scissorhands* lives in an archetypally spooky Gothic castle that shadows a candy-coloured town. The deliberate flatness of these films is reflected in their promotional material, most of which shares a pared-down, uncomplicated look. In 1993 Burton returned to work with animation, creating conceptual drawings and writing the script for *The Nightmare Before Christmas* (Henry Selick). Based on Burton's own illustrations, the advertisements for this film are a set of elegantly spooky images that convey the very essence of the director's vision.

RIGHT *Ed Wood*, Tim Burton, 1994. POSTER USA Johnny Depp camps it up as the "worst director of all time" and inveterate wearer of angora sweaters Edward D. Wood, Jr. The film was somewhat overblown, but managed to be moving all the same.

LEFT *Edward Scissorhands*, Tim Burton, 1990. POSTER USA The tortured Edward Scissorhands is promoted as Burton's "newest creation". Unable to give or receive physical affection, he is a metaphor for adolescent male angst.

ABOVE *Tim Burton's The Nightmare Before Christmas*, Henry Selick, 1993. POSTER USA Several images were used to promote this film. Between them they introduce a range of characters, all of which emanated from Burton's otherworldly imagination.

ABOVE *Moulin Rouge*, Baz Luhrmann, **2001.** POSTER USA This teaser image twins the glittering lights of the Moulin Rouge with the message of freedom. The mill is posed as a beacon of absurdly heightened hope and despair. This is a grand claim that is not quite fulfilled by the film.

ABOVE RIGHT *Moulin Rouge*, Baz Luhrmann, **2001.** POSTER USA Poised on her static trapeze, Nicole Kidman's Satine looks every inch the consumptive seductress. The photograph is reworked to emphasize the contrast between the lustre of the diamonds and the pale sheen of the courtesan's skin.

RIGHT *William Shakespeare's Romeo and Juliet*, Baz Luhrmann, **1996.** POSTER USA The coloured, thunderous sky behind the lovers is a modish means of communicating the heartache to come. Luhrmann shows his facility for adaptation by using a line from Shakespeare as the film's tag.

Bazmark Films

Working partners since 1988 and a husband-and-wife team since 1997, Baz Luhrmann (b. 1962) and Catherine Martin (b. 1965) are responsible for a string of cinema's most spectacular recent experiences. Director Luhrmann and designer Martin met at college and produced several theatrical pieces before making their screen début with *Strictly Ballroom* in 1992. This film brought the pair worldwide attention and earned Martin a Bafta for best costume design. Since *Strictly Ballroom*, Martin has won awards and acclaim for each one of her cinematic and theatrical design projects.

The posters for Luhrmann's films are very much in keeping with their on-screen presence. Designed under the auspices of Martin and Luhrmann and their production company Bazmark, they translate the glorious extravagance of the Luhrmann cinematic experience into print. The image advertising *William Shakespeare's Romeo and Juliet* is a collage of photography and illustration of the kind that was current in the teen magazines of the mid-1990s. This creates an impression of an immoderately heightened reality that is very much in keeping with the film. Made five years later, *Moulin Rouge* departs from any notion of the real. The posters promote a romp in the realms of pure romantic fantasy and audiences with a taste for high camp were not disappointed. In interviews Martin has said that her husband shuns "artificial reality" in favour of "real artificiality". This healthy embrace of the fantastical is reflected in these images.

ABOVE *Harry Potter and the Chamber of Secrets*, Chris Columbus, 2002. POSTER UK
Although the film deals with the adventures of a teenage wizard, here the appearance and demeanour of the stars has little to do with their youth. Instead they are portrayed as fully realized action heroes.

21st-Century Escapism

The first year of the new century saw the launch of two film series: *The Lord of the Rings* and *Harry Potter*. From the outset both were intended as multi-parters, the former a trilogy, the latter pledging to follow author J.K. Rowling's ongoing output book for book. Unlike previous series, *Star Wars* for example, which allowed long gaps between productions and required that film-makers start afresh each time, the production schedules for *Harry Potter* and *The Lord of the Rings* were envisaged as continuous enterprises. Entire casts and crews have moved smoothly from one film to the next, in some cases working on two movies at once. The only hiccup so far appears to be the rapid growth of Daniel Radcliffe, the young actor playing Harry.

Although their target audiences are slightly different, the *Harry Potter* films being aimed at children and the *Lord of the Rings* trilogy seeking a public composed of teenage boys and young men, the advertisements for both series are somewhat similar. The principal means of promoting the new breed of escapism involves superimposing highly retouched photographs of attractive lead actors on dramatic pictures of imaginary landscapes. Spectacular, glossy, and unreal in every sense, these images offer potential audiences a very potent mix of fantasies.

ABOVE **The Lord of the Rings: The Two Towers**, Peter Jackson, 2002. POSTER USA
An emphasis on flowing locks is common to all of the characters on this poster, and their combined image creates a flowing river of hair. The association between hair and fantasy is long-standing and well-shorn mythic creatures are almost unknown.

LEFT **The Lord of the Rings: The Two Towers**, Peter Jackson, 2002. POSTER USA
Rather than showing the players, this poster concentrates on the setting, in particular on the towers themselves. Shot in New Zealand, the film merges dramatic landscapes with pioneering visual effects.

Selected Bibliography

Cushing, Lincoln, *Revolucion! Cuban Poster Art* (Chronicle Books, San Francisco, 2003)

Dwyer, Rachel, and Divia Patel, *Cinema India: The Visual Culture of Hindi Film* (Oxford University Press, Oxford, 2002)

Edwards, Gregory J., *The Book of the International Film Poster* (Tiger Books International, London, 1985)

Franchi, Rudy and Barbara, *Miller's Movie Collectibles* (Miller's, London, 2002)

Hollis, Richard, *Graphic Design: A Concise History* (Thames and Hudson, London, 1994)

Kael, Pauline, *I Lost It At The Movies* (Cape, London, 1966)

King, Emily, *Taking Credit: Film Title Sequences 1955–1965* (unpublished MA thesis, The Royal College of Art, London, 1993)

Kirkham, Pat, "Saul Bass and Billy Wilder: In Conversation" (*Sight and Sound*, Vol. V, Issue 6, June 1995)

Mount, Christopher, *Sternberg Brothers: Constructing a Revolution in Soviet Design* (Museum of Modern Art, New York, 1997)

Nourmand, Tony, and Hiroshi Kashiwagi, *Cinema Posters of the 20th Century* (Suntory Museum, Osaka, 2001)

Nowell-Smith, Geoffrey (ed.), *The Oxford History of World Cinema* (Oxford University Press, Oxford, 1996)

Rebello, Stephen, and Richard Allen, *Reel Art: Great Posters from the Golden Age of the Silver Screen* (Artabras, New York, 1988)

Schapiro, Steve, and David Chierichetti, *The Movie Poster Book* (Dutton, New York, 1979)

Thompson, Kristin, and David Bordwell, *Film History: An Introduction* (McGraw-Hill, Maidenhead, 1994)

Timmers, Margaret (ed.), *The Power of the Poster* (Victoria and Albert Museum, London, 1998)

Wolff, Mark H., and Tony Nourmand (eds), *Hitchcock Poster Art* (Overlook Press, New York, 2000)

Websites

artandculture.com

filmfour.com

imdb.com

learnaboutmovieposters.com

lib.berkeley.edu/~lcushing

polish-poster.com

posterpage.ch

reelposter.com

Biographies of Selected Artists

Gosta Aberg (1905–1981) Born in Sweden, Gosta Aberg was a pupil of the Swedish illustrator Eric Rohman. He was among the country's most prolific film-poster designers, creating campaigns for Swedish and imported movies.

Alan Aldridge (b. 1943) Alan Aldridge became the art director for modern fiction at Penguin Books in 1963. His illustrative style is strongly associated with London's "swinging sixties" and he is best known for *The Beatles: Illustrated Lyrics*, published in 1969.

John Alvin (b. 1946) John Alvin is particularly associated with his design for Spielberg, although he has created artwork for more than a hundred other campaigns. He has won numerous awards, including the Hollywood Reporter's Key Art Award's grand prize for his campaign for *E.T.*

Richard Amsel (1947–1985) Richard Amsel was born in Philadelphia and trained at the Philadelphia College of Art. His first commission was the campaign for the 1969 movie *Hello Dolly*, a job he won while still at art school. In the years that followed he created artwork for many prominent campaigns and painted a large number of celebrity portraits, many of which appeared on the cover of America's *TV Guide*.

Cardenas René Azcuy (b. 1939) Born in Havana, Cuba, Cardenas René Azcuy studied at the San Alejandro School of Art. His work has been shown worldwide and he has won awards in the International Poster Competition at the FilmExpo in Ottawa in 1972 and 1974, the International Poster Competition at Cannes in 1974, and the Hollywood Reporter (USA) International Film Poster Competition in 1982.

Eduardo Muñoz Bachs (1937–2001) Eduardo Muñoz Bachs was born in Havana, Cuba, but spent the end of his life in Spain. The most prolific of all Cuban artists, he published the bulk of his work through ICAIC (see pp.86–89). In addition to poster design, he is well known for children's book illustrations and book covers. He had numerous one-man shows in Havana and internationally, and his work is held in the permanent collections of major museums around the world.

Anselmo Ballester (1897–1974) Anselmo Ballester designed film posters from the early 1930s onward. He worked for the Italian production company Minerva and for the international concern Columbia Pictures, creating campaigns for both Italian and imported movies. Alongside a couple of other designers, Ballester exerted a near monopoly on Italian poster design in the 1940s

Saul Bass (1920–1996) Saul Bass studied at the Art Students League, New York, and at Brooklyn College, where he first came into contact with European Modernist design ideas. He started out as a freelance designer in New York before moving to Los Angeles and eventually setting up Saul Bass Associates. Bass began designing film advertisements in the late 1940s and moved on to title design in the mid-1950s. Working with directors including Otto Preminger and Alfred Hitchcock, he pioneered the coordination of print and screen graphics.

Ercole Brini (1913–1980) Ercole Brini was part of a generation of Italian poster designers that emerged after the Second World War. Working almost exclusively in watercolours, he created campaigns for a number of prominent Italian and imported films.

Reynolds Brown (1917–1991) Reynolds Brown was born in Los Angeles and started his career inking syndicated comic strips. During the Second World War he illustrated technical service manuals and after 1945 he abandoned comics to pursue a career as an illustrator. He began designing movie campaigns in the early 1950s and is best known for his work on horror films.

Roman Cieslewicz (1930–1996) Roman Cieslewicz studied at the Academy of Fine Art in Cracow, Poland, and worked in various design fields, including posters and publications. He won his first design award in 1955 and continued to win domestic and international acclaim throughout his career. His work was the subject of a retrospective exhibition at the Pompidou Centre in Paris in 1993.

Thomas Eckersley (1914–1996) Thomas Eckersley was born in Lancashire and trained at Salford School of Art. From 1937 to 1939 he taught poster art at Westminster School of Art and during the war he did cartographic drawings for the Royal Air Force. After 1945 he worked as a freelance graphic designer, creating work for a number of clients including London Transport and the Post Office.

René Ferracci (1930–1982) In 1954 René Ferracci was appointed as art director of the French distribution company Cinedis. When the company closed in 1963 he became freelance, and during the 1960s and 1970s he was the most prolific of French movie-poster designers.

Juan Gatti (b. 1950) Juan Gatti was born in Argentina and trained at Buenos Aires School of Art. In the mid-1980s he met Spanish film director Pedro Almodóvar and has collaborated on the graphic design and title design for Almodóvar's films ever since. As well as working for film, he also creates graphic design for fashion.

Philip Gips (b. 1931) Philip Gips was born in New York and studied at the Cooper Union School of Art, New York, and at Yale University. After a period working for CBS Radio and Life International Promotion, he established himself as a freelancer. In 1992 he established Gips Associates, a company known for publication design and work for film and television.

Milton Glaser (b. 1929) Milton Glaser was born in New York and studied at the Cooper Union School of Art, New York, and at the Academy of Fine Arts in Bologna, Italy. He is the co-founder of New York's well-known Push Pin studios and has designed for a range of media including books, magazines, records, film, and television. Glaser's I♥NY is among the best-known graphic symbols ever designed.

Wiktor Gorka (b. 1922) Wiktor Gorka is a graduate of the Academy of Fine Arts in Cracow, Poland, and has been a prominent member of Poland's design community since the 1950s. His work has been shown internationally and has received a number of awards.

René Gruau (b. 1910) The real name of René Gruau, born in Italy to a French mother, is Renato de Zavagli. He began work as a fashion illustrator and, moving to France as a young man, he built a career working for both French and international publications. As well as designing for fashion, Gruau produced posters for film and theatre.

Milan Grygar (b. 1926) Milan Grygar was born in Zvolen, Czechoslovakia. His art school education was interrupted by a period in a German labour camp during the Second World War, but he persisted and graduated from art school in Prague in 1950. He works mostly as a fine artist, but he has also produced several film posters.

Hans Hillman (b. 1943) Born in Germany, Hans Hillman designed campaigns for a number of German releases of international films during the 1960s and 1970s. His posters are distinguished by their spare graphic style.

Martin Huxford (b. 1963) Graduating from Middlesex Polytechnic in 1985, Martin Huxford established the company Kunst Art and specialized in the design of posters for film and performance. In 1990 he joined The Creative Partnership, a London-based company responsible for numerous high-profile campaigns. Since 1995, he has run his own Internet design company Networx, creating sites and software.

Andrzej Klimowski (b. 1941) Andrzej Klimowski was born to Polish parents living in London. He studied painting at St Martin's School of Art and poster design at the Warsaw Academy of Fine Arts. He currently lives and works in London. He is well known for his design of posters and book covers and for his editorial illustrations. He is senior tutor of illustration at the Royal College of Art in London.

Jan Lenica (1928–2001) Jan Lenica studied in the Faculty of Architecture at Poznan Technical University, Poland, and worked in poster design from the early 1950s. He was among Poland's most prolific artists, producing satirical drawings, exhibition design, illustration, and animation as well as posters. His work has been shown internationally and has won numerous major awards.

Grzegorz Marszalek (b. 1946) Born in Swinna, Poland, Grzegorz Marszalek graduated from the College of Visual Arts in Poznan. He has been designing movie posters since the early 1970s and has won many awards for his work at various international exhibitions.

John Minton (1917–1957) John Minton was born in Cambridge, England, and trained at St John's Wood Art School. He taught at both St Martin's College of Art and the Royal College of Art in London and is best known as a painter and illustrator.

Bob Peak (1928–1992) Bob Peak was born in Denver, Colorado, and, after serving with the military during the Korean War, he attended Art Center College of Design in California and graduated in 1951. He began his career designing advertisements and his first film poster was for the 1964 movie *My Fair Lady*. In the decades that followed, Peak created the artwork for a number of major movie campaigns.

Paul Rand (1914–1996) Paul Rand was born in Brownsville, New York, and studied design at the Pratt Institute in New York, where he first came into contact with the theories associated with European Modernist design. After an extensive art education, he began his career as magazine art director and later worked in advertising, book-jacket design, and the development of corporate identities. Sadly, he designed very few movie posters.

Antonio Fernández Reboiro (b. 1935) Antonio Fernández Reboiro was born in Nuevitas, Cuba. He won the grand prize at the International Film Poster competition at Cannes in 1976 and he has exhibited in numerous other international shows in countries including Czechoslovakia, Poland, and Italy.

Alfrédo J. Gonzalez Rostgaard (b. 1943) Born in Guantánamo, Cuba, Rostgaard is of mixed ancestry (Jamaican-Chinese-Dutch-Cuban). He earned a degree at the School of Plastic Arts in Santiago de Cuba and immediately after the revolution (1959) he worked as a cartoonist and artistic director of the Union of Young Communists magazine, *Mella*. He designed numerous posters for ICAIC (see pp.86–89) and later became art director of OSPAAAL (Cuba's international solidarity organization) from 1960 to 1975.

Sandro Simeoni (b. 1928) Sandro Simeoni was born in Ferrara, Italy, and studied at the local art school. He worked as a cartoonist on local newspapers before moving to Rome and starting a career in design for the film industry. During the 1950s and 1960s he designed several major campaigns for Italian and American films.

Vladimir Avgustovich Sternberg (1899–1982)
Georgii Avgustovich Sternberg (1900–1933) The Sternberg brothers both studied at the State Free Art Workshops, or SVOMAS, in post-revolutionary Moscow. They worked together for only a decade between 1923 and 1933, when Georgii was killed in a car accident. The brothers were keen revolutionaries and were members of the Society of Young Artists (OBMOKhU) and the Institute of Artistic Culture (INKUhK). As well as film posters, they designed sets for theatre productions and commemorative events.

Peter Strausfeld (1910–1980) Peter Strausfeld emigrated from Cologne, Germany, to Britain as a young man and during the war years he was held in an internment camp. On his release in 1945 he began designing posters for the Academy Cinema on London's Oxford Street. He continued to design advertisements for the same cinema until his death more than three decades later.

Drew Struzan (b. 1946) Drew Struzan was educated at the Art Center College of Design in California. After graduation he worked for the music business and for the film industry. In 1995 Struzan's work was the subject of a touring exhibition and in 1999 his film posters were shown at the Norman Rockwell Museum.

Waldemar Swierzy (b. 1931) Waldemar Swierzy studied at the Academy of Fine Arts in Cracow, Poland. Over his career he has designed a huge number of posters, not only for film but for all sorts of cultural events. He is a mainstay of the Polish poster tradition and teaches at the Academy of Fine Arts in Poznan and Warsaw.

Henryk Tomaszewski (b. 1914) Henryk Tomaszewski studied at the Academy of Fine Arts in Warsaw, Poland, and also taught there for more than three decades, between 1952 and 1985. His work encompasses poster design, illustration, and satirical drawing. He won his first design award in 1948 and has been receiving prizes ever since.

Tomi Ungerer (b. 1931) Tomi Ungerer was born in Strasbourg, France, and his childhood years were marked by the experience of war. In the early 1950s he left Europe for New York, ostensibly to meet the legendary illustrator Saul Steinberg. His career took off soon after his arrival in the United States and for nearly half a century he has created illustrations for magazines, children's books, posters, and much more.

Bronislaw Zelek (b. 1935) Bronislaw Zelek is a graduate of the Academy of Fine Arts in Warsaw, Poland. He is a skilled graphic designer and typographer and was an important force in Polish design of the 1960s. He currently lives in Austria.

Zdenek Ziegler (b. 1932) Zdenek Ziegler is head of the department of poster and graphic design at the Prague Academy of Arts, Architecture and Design, Czechoslovakia. He has won numerous awards for his work and is a skilled graphic designer and typographer.

Index

Acknowledgments

Author's Acknowledgments

Thanks to Tony Nourmand and all at the Reel Poster Gallery
for creating the best place to start any project about film
posters, and to Professor Christopher Frayling for pointing me
in their direction.

Thanks to Stuart Bailey, Lincoln Cushing, and Andrzej Klimowski
for the provision of images and useful information, and to Divia
Patel for her advice on Bollywood.

Thanks to Emily Asquith and Giulia Hetherington at Mitchell
Beazley, and the distant, but ever diligent, copy editor Kirsty
Seymour-Ure.

Photographic Credits

Mitchell Beazley would like to acknowledge and thank the following
for kindly supplying images for publication in this book.

Key: **t** top, **b** bottom, **c** centre, **l** left, **r** right

Artificial Eye Film Company, London: 206l; BFI Stills, London:
157, 164, 165, 184, 201, 204b, 205, 207; Christie's Images,
London: **7r, 9, 13l** and **r, 16, 17, 20, 21, 26-7, 30, 31r, 39, 40l** and
r, 42l and **r, 43, 45l, 47, 48b, 49, 52l, 61, 62, 65l** and **r, 69, 77, 78t,
79, 99l, 100b, 120t, 123l, 128r, 129l** and **r, 134-5, 145**; Docs
Populi/Lincoln Cushing, posters from the archive of Alan Flatt,
Oakland, CA: **8r, 84, 86, 87, 88l** and **r, 89l** and **r**; Michaela
Dvorakova **94r**; Greg Edwards: **106t** and **b**; Empire Design,
London/UGC: **204t**; Juan Gatti: **180, 181, 182l** and **r, 183**; Hyphen
Films, London: **146t** and **b, 147**; ICA Projects, www.ica.org.uk:
poster design Rose Hempton **206**; Icon Film Distribution, London:
208; The Kobal Collection, London/Paramount: **35**; Octopus
Publishing Group/Steve Tanner/Barbara & Rudy Franchi: **48t, 138,
151, 156**; Photo12.com: ARJ **12**, Collection Cinema **197**; Posteritati
Movie Posters 239 Centre Street, New York, NY 10013,
www.posteritati.com: **45r, 76l, 111r, 132b, 158, 159b** and **r, 160,
161t, r** and **b, 162l** and **r, 163l, 167t, 170, 172l** and **r, 173l** and **r,
179r, 185t, 193, 196l** and **r, 199l** and **r, 200, 203, 209, 210r, 212l**
and **r**; The Reel Poster Gallery, 72 Westbourne Grove, London W2
5SH, www.reelposter.com, images courtesy Reel Poster Archive
Company, photography by A J Photographics: **6, 7l, 8l, 14l** and **r, 15,
23, 24, 25l** and **r, 33l** and **r, 34, 37, 38, 41, 44, 46, 50l** and **r, 51,
52r, 53, 54, 55l, 56l** and **r, 58, 63, 64l** and **r, 66l** and **r, 67, 68, 70,
71, 72, 73, 74, 75, 76r, 78b, 82l** and **r, 83, 85l** and **r, 90, 91, 92, 93l**
and **r, 94l, 95, 96l** and **r, 97, 101, 102, 103, 104, 105t** and **b, 108,
109, 110, 111l, 112r, 113, 114l** and **r, 115t, 116l** and **r, 117l** and **r,
118l, c** and **r, 119, 120b, 121, 122, 123r, 124, 125, 126, 127, 128l,
130, 131, 132t, 133, 136, 137, 138r, 139, 142-3, 144l** and **r, 148l,
150l** and **r, 155, 159t, 163r, 166, 167b, 169, 171, 174l** and **r, 175,
176l** and **r, 177, 178l** and **r, 179l, 185b, 186, 188, 189l** and **r, 190-1,
202, 210l, 211, 213**; Ronald Grant Archive, London: **18-19, 22, 140,
154l** and **r, 156r, 198, 214, 215t** and **b**; Skinner Inc, Auctioneers and
Appraisers of Antiques and Fine Art, Bolton, Boston, MA: **31l, 32,
57, 59l, 60, 98, 99r, 100t, 107, 112l, 115b, 141, 148r, 149, 168**.